Colección Támesis
SERIE A: MONOGRAFÍAS, 301

POLITICS AND PERFORMANCE IN POST-DICTATORSHIP ARGENTINE FILM AND THEATRE

PHILIPPA J. PAGE

POLITICS AND PERFORMANCE IN POST-DICTATORSHIP ARGENTINE FILM AND THEATRE

TAMESIS

First published 2011 by Tamesis, Woodbridge

ISBN 978 1 85566 204 9

Tamesis is an imprint of Boydell & Brewer Ltd
PO Box 9, Woodbridge, Suffolk IP12 3DF, UK
and of Boydell & Brewer Inc.
668 Mt Hope Avenue, Rochester, NY 14620, USA
website: www.boydellandbrewer.com

A CIP catalogue record for this book is available
from the British Library

The publisher has no responsibility for the continued existence or accuracy
of URLs for external or third-party internet websites referred to in this book,
and does not guarantee that any content on such websites is, or will remain,
accurate or appropriate

Papers used by Boydell & Brewer Ltd are natural, recyclable products
made from wood grown in sustainable forests

Printed and bound in Great Britain by
CPI Group (UK) Ltd, Croydon, CR0 4YY

La hibridación de café, flores, cereales y otros productos acrecienta la variedad genética de las especies y mejora su sobrevivencia ante cambios de hábitat o climáticos.

Néstor García Canclini, *Culturas híbridas*, 16

CONTENTS

LIST OF ILLUSTRATIONS

The author and publishers are grateful to all the institutions and individuals listed for permission to reproduce the materials in which they hold copyright. Every effort has been made to trace the copyright holders; apologies are offered for any omission, and the publishers will be pleased to add any necessary acknowledgement in subsequent editions.

To B.J., Mz, L.J. and M

ACKNOWLEDGEMENTS

Many people have offered their help during the preparation of this book. First and foremost, I would like to thank Joanna Page, not only for introducing me to Argentine cinema, but for her constructive comments on the manuscript. I am also very grateful to Geoffrey Kantaris and Catherine Boyle for their comments. The Centre of Latin American Studies, the Department of Spanish and Portuguese and Lucy Cavendish College at the University of Cambridge supported several fieldwork trips to Buenos Aires. Special thanks also go to the staff in the library at Argentores and to Carlos Fos at the Centro de Documentación in the Teatro San Martín for his help in locating unpublished dramatic texts and his interest in helping this project along. Others who have played a part in my work and whom I wish to thank are: Katie Earnshaw, Julie Coimbra, Chandra Morrison, Margarita Riela, Sarai Suarez, Ingrid Contreras, Emma Gatland, São Lopes Gordon and Megan Rivers Moore. My family — Michèle, John, James and Bob — have always helped where they can. Last, but by no means least, thanks must go to Mariano for his unfaltering encouragement and patience.

INTRODUCTION

The overriding feature in Argentine theatre and cinema of the post-dicta-torship period is without doubt the anxiety to re-establish their agency as politically and socially engaged art forms: to recover the Utopian sense of passion and engagement that both theatre and cinema had experienced during the 1960s and early 1970s. 'Era una época muy rica, muy llena de pasión,' recalls playwright Ricardo Halac, lamenting the ambivalence of the post-dic-tatorship period, whilst remarking that one of his plays written in the 1960s was even rejected because it failed to represent young people endeavouring to change reality (in Osvaldo Pellettieri 1989: 21). Halac characterises the period when he comments that 'el teatro tenía que tener un gran contenido social porque ayudaba a concientizar a la gente, y ayudaba al cambio social' (20). The 1960s has gained the mythical status of 'la década prodigiosa', during which many young artists throughout Latin America, inspired by the Cuban Revolution, believed that change could be achieved (Blas Matamoro, in Pellettieri 1989: 35). Whether playwrights found themselves influenced by the aesthetics of naturalism and reflexive realism[1] or by the opposing aesthetic of the absurd, such controversies enlivened debate on how to approach what effectively boiled down to the same collective anxiety: 'cómo vincularse con una sociedad tan áspera como la Argentina, tan dura, tan en crisis perma-nente, tan desalentadora' (Kive Staiff, in Pellettieri 1989: 25).

A similar discourse exalting cinema's capacity to incite change was expressed in Fernando Solanas and Octavio Getino's manifesto for an anti-

[1] *Realismo reflexivo* refers to an aesthetic which emerged in the 1960s and is described as the successor to the *realismo finisecular*, which can be found in the work of Uruguayan play-wright Florencio Sánchez and the early work of Argentine playwright Armando Discépolo. The term itself may seem rather contradictory, but is largely aligned with the aesthetics of naturalism and opposed to the aesthetics of the absurd. Mention of reflexivity refers to its questioning of/ tensions with the preceding *realismo finisecular*. The 1960s was characterised by two distinct aesthetic camps: the realists, such as Ricardo Halac and Roberto Cossa, on the one hand and the absurdists, such as Griselda Gambaro and Eduardo Pavlovsky, on the other. Critic Kive Staiff describes the opposition as follows: 'la vanguardia podía aparecer como europeizante y evasiva de la realidad y el naturalismo, que pronunciaba todas las palabras, las de todos los días, las cotidianas, la de los que estaban sobre el escenario y la de los que estaban en la platea, entendía que estaba exactamente reflejando la verdad de la sociedad' (in Pellettieri 1989: 26).

systemic, revolutionary 'Third Cinema' (1997: 33–58). Their words express a similar conviction regarding the political role of art: 'the birth of *third cinema* means, at least for us, *the most important revolutionary artistic event of our times*' (57, original emphasis). These sentiments were brought to fruition in their 1968 film *La hora de los hornos*, which employed a radical cinematography of rough montage editing, frenzied sequences of extreme close-ups and a rather bombastic series of titles denouncing the social injustice of neo-colonialism; enough to shake even the most passive of spectators into engaging with the film's rhetoric.

Yet, this Utopianism was to peter out as the dictatorship took hold (with the exception of the Teatro Abierto[2] movement), which caused the diasporic splintering of intellectual and artistic communities as they travelled into exile or were silenced either by violent means or by self-imposed censorship (Sarlo 1988: 96). The experience of dictatorship wiped out political opposition, ruptured artistic lineages and fragmented creative and intellectual communities. Estimates for the number of victims of state repression —the so-called 'Proceso de Reorganización Nacional'— vary, but the most commonly cited figure is 30,000 citizens brutally arrested and tortured, many disappearing without any further trace. Post-dictatorship, far from a straightforward return to the Utopian marriage of art and politics that underpinned theatrical and cinematic production in the 1960s and early 1970s, theatre and cinema have faced a new, and by no means fixed, set of parameters conditioning what it means to be political.

My investigation sets out to examine the strategies of re-politicisation and socialisation employed in Argentine theatre and cinema since the 1976–83 dictatorship. The films and plays examined in this book, by virtue of their composition as generic and/or media crossbreeds via common codes of performance, demonstrate how a politics of genre, cultural identity and hybridisation becomes instrumental in these processes of re-politicisation and socialisation. What will be foregrounded are the ways in which experimentation with genre —defined here as an historically contingent construct (White 2003: 598)— can be mapped onto experimentation across the boundary that separates art from politics, as theatre and cinema readjust to increasing de-politicisation within society. This shift in the political field can be attributed to

[2] 'Teatro Abierto' is the name given to a theatre movement which staged a series of plays in Buenos Aires during the dictatorship. Participating playwright Roberto Cossa describes the movement as follows: '*Teatro Abierto fue más un fenómeno político que estético, una respuesta masiva de rechazo al régimen imperante, que llevó a la gente a los teatros para nuclearla alrededor del tema de la libertad, y dejó una fuerte marca, especialmente a través de la elaboración de espectáculos en equipo*' (Cossa, in Pellettieri 1989: 88, original emphasis). The effectiveness of the movement has since been reconsidered, not on account of its political objectives, but in terms of the manner in which plays were selected and the programme organised (see Graham-Jones 2000: 99–100). Nevertheless, on a symbolic level, the 'Teatro Abierto' remains emblematic of the possibilities of artistic opposition to authoritarianism.

the collapse of the Left and the fact that politics can no longer be mobilised along specific ideological lines, a result both of Argentina's traumatic experience of dictatorship, as well as of its opening up to policies of neoliberalism and processes of globalisation which are symptomatic of more widespread de-politicising trends in the Western world.

It is important to clarify at this stage that the aforementioned trends disclose a certain aestheticisation of the political and the social (Benjamin 1970: 244), typically echoed in theoretical categories of the postmodern, in which distinctions between politics, culture, economics and processes of social interaction begin to erode (Baudrillard 1992: 9). The relationship between aesthetics and politics, articulated here along what performance theorist Richard Schechner defines as the frontier between 'aesthetic' performance and 'social' performance (2003: 192–3), thus becomes a major point of contention, as theatre and cinema negotiate a politicisation of aesthetics capable of subverting, rather than being subsumed into, the aestheticisation of politics. The dialogue between politics and performance hence represents the guiding frame for my study, which comments on the ways in which performance (in a variety of expressions) provides a postmodern response to ailing modern ideals of historical progress, teleological thought processes, political Utopianism, autonomy of the art object and faith in the construction of the (stable) subject (Hopenhayn 1994: 12).

Each chapter takes as its point of departure a series of what I will argue are politically motivated appropriations made by cinema and theatre from neighbouring genres, art forms or media: from each other, from television, radio, video, from within their own theatrical and cinematic traditions and finally from documentary. These appropriations or citations constitute important self-referential *mises-en-abyme* that are instrumental in testing the limits of the theatrical and cinematic apparatuses and placing the question of artistic identity in relief. Strategies of re-politicisation hence coincide with those of hybridisation in an attempt to revitalise and ensure the survival of theatre and cinema as artistic forms. What I will attempt to prove is that the borrowings made between theatre and cinema ultimately affirm a tacit collaboration between the two art forms, through the codes they share as performance types as well as the appropriations they make from their artistic counterparts, in order to carve out a space for themselves, in between the more dominant forms of literature and television, as legitimate narrators of the nation and vehicles for societal 'convivencia' (see chapter 4).

It is worth noting that both theatre and cinema are victims of a fall in spectatorship and a lack of government investment in independent cultural production during the 1980s and 1990s, perpetuating a sense of urgency to redefine their socio-political role, particularly given the threat posed by television's cultural hegemony. This is not, however, the case for the entire period covered in this book, particularly in terms of film production which, thanks to

the passing of the 'Ley del Cine' in September 1994, recovered from a steady decline in the number of local films produced as well as spectators attending each film. It is not my intention to dwell on the statistics which map out this decline and revival over the course of the 1990s. Diego Batlle (2002: 17–29) gives a thorough statistical account of the Argentine national film industry's fortunes over this period and Jorge Dubatti (1999: 25–40) provides a similar appraisal of theatrical production. What is important to note as a context to this study is that both theatre practitioners and filmmakers need to respond to a dwindling number of spectators in the face of the growing popularity of television.

To avoid subsequent confusion, it is important to clarify at this point that this study deals with a range of borrowings and appropriations, some of which are to do with genre, some with different art forms and others with different media. Be it a question of genre, art form or medium, each of the boundary-crossings is significant in the fact that it represents a borrowing or appropriation from other sets of conventions. It is sometimes not obvious which term should be used due to difficulties in defining exactly what consti-tutes genre, the work of art and a medium (not least within the context of the postmodern and the burgeoning field of performance studies). In each case, I work with accepted definitions of each category of artistic identity and form, employing the term that I believe to be the most appropriate.

My central purpose in this introduction is to map out the theoretical route which I have taken into this comparative study of contemporary Argentine theatre and cinema through the optics of genre and performance. What will be established here is a series of recurring theoretical dilemmas that come to light in the dialectics between different genres/media and between the emerging hybrids and their socio-political milieux: how changes within the field of politics and particularly the way in which politics enters the field of aesthetics encourage a redefinition of the term 'genre' as a measure of prevailing ideological and social issues; how genre should be reconceived, in reference to Jacques Derrida's work, as a performative mark of textual identity, historically contingent and cultivated organically from within the text, rather than a static category with essential qualities imposed critically from outside (1980: 55–81); finally, once genre is released from neo-classical essentialism (White 2003: 601), how the newfound fluidity of its bounda-ries, whilst enabling a more diverse range of (hybrid) forms, triggers a latent anxiety regarding the loss of theatrical and cinematic specificity to surface. This latter point relates to a hangover of modernist ideals, which privileged artistic autonomy and specificity, perceiving these attributes to be the basis for political engagement (Adorno 2001: 105–6). Such difficulties in defining genre and its function ultimately feed into problematising, within a specifi-cally Argentine context, the distinctions usually employed to set modernism and postmodernism apart, whilst the capacity of the performances examined

to traverse the boundaries between different art forms and areas of society tests the interdisciplinary reach of performance theory.

Cultures of Hybridity

It is the common codes that theatre and cinema share as performative art forms that not only facilitate these hybrid artistic formations, but also enable their transgression of disciplinary boundaries. Questions of hybridity are readily cited in the examination of postcolonial Latin American culture and society. In *Culturas híbridas: estrategias para entrar y salir de la modernidad* (2001), Néstor García Canclini suggests that hybridity is a fundamental paradigm in conceptualising Latin America's inconsistent experience of (post)modernity. He defines it as follows: '*entiendo por hibridación procesos socio-culturales en los que estructuras o prácticas discretas, que existían en forma separada, se combinan para generar nuevas estructuras, objetos y prácticas*' (14, original emphasis). This suggests that discourses of hybridisation serve not only to foreground the discrepancies in the region's path towards modernity, but to problematise the very categories upon which mainstream discourses of modernity and postmodernity are based (40):

> concebimos la posmodernidad no como una etapa o tendencia que reem-plazaría el mundo moderno, sino como una manera de problematizar los vínculos equívocos que éste armó con las tradiciones que quiso excluir o superar para constituirse. La relativización posmoderna de todo funda-mentalismo o evolucionismo facilita revisar la separación entre lo culto, lo popular y lo masivo sobre la que aún simula asentarse la modernidad, elaborar un pensamiento más abierto para abarcar las interacciones e inte-graciones entre los niveles, géneros y formas de la sensibilidad colectiva. (44)

Theories of hybridisation or multiculturalism are central to more contem-porary postcolonial discourse which attempts to shake off the binary hierar-chies of earlier postcolonial paradigms (in the 1960s and 1970s) that pitted First World (oppressor) against Third World (oppressed), although these Manichean configurations do nevertheless persist in the work of Solanas into the 1980s and 1990s. Instead, they open up society to a variety of different subject positions which bring together identity traits such as race, gender, and ethnicity as well as more classic categories of class (see Homi Bhabha 1994: 2). What will be demonstrated here is that, contrary to modernist concerns, hybridity by no means signifies the corruption of genre or weakening of the autonomous art object, but a necessary paradigm for reconciling the anoma-lies of Argentina's experience of modernity; resolving 'las contradicciones

entre las utopías de creación autónoma en la cultura y la industrialización de los mercados simbólicos' (García Canclini 2001: 44).

Generic border-crossing for political effect is, however, by no means a new phenomenon in Argentine cultural production. In *Facundo* (1845), one of the founding narrations of the Argentine nation, Domingo Faustino Sarmiento crossed many generic boundaries in a work that hybridised a plethora of different styles and forms, from autobiography to pamphleteering. Sarmiento's written work certainly reflects the variety of roles he took on as educator, politician and *literatus*. *Facundo* laid out a project for immigration —the right kind of immigration— from what he regarded as civilised Northern Europe. This is a project that would eventually be realised —although not quite in the manner proposed by Sarmiento and attracting predominantly Southern Europeans— which would place the issue of hybridity at the very centre of the discourses of Argentine national identity. The ultimate project of border-crossing throughout Sarmiento's work was that enlightened education might incite a migration across the conceptual frontier dividing Argentine society between 'civilización' and 'barbarie' (Sarmiento 2005). His literary exploit was supposed to facilitate this transgression. As will be demonstrated (notably in chapter 3), the civilisation/barbarism dichotomy is a persistent paradigm in Argentine cultural production, even if its constituent concepts have evolved somewhat. Whilst critic/writer Ricardo Piglia argues that Sarmiento's literary excess —his 'laboratory of forms [...] thesaurus of styles and narrative solutions'— ultimately detracts from, rather than enhances, the political message in *Facundo* (1993: 72), suggesting that the ideas and forms that Sarmiento appropriated from the European canon were misplaced in trying to reconcile the tensions at the heart of Argentine society, *Facundo* draws attention to an established history of generic hybridity which is symptomatic of a national (and some would argue, continental) literary tradition that interlaces fiction and politics (Avelar 1999: 11). This is a characteristic that Piglia himself reiterates with reference to Roberto Arlt (Piglia 2001a: 23).

Another important example of this tradition of literary hybridisation would of course be the work of Jorge Luis Borges, which also avidly breaches generic boundaries. Again, Piglia's rereading of Borges as a writer who brings together European traditions with those of the gauchesque points up a literary hybridity which once again reflects the hybridity at the centre of questions of Argentine national identity. Literary criticism in Argentina has clearly taken account of such legacies and what they reveal about the society in which they were created, even if they remain curiously absent from studies of cinema and theatre.

Consideration of any sort of cross-genre approach is curiously absent from analysis of Argentine theatre and cinema as those who have attempted to compare the two art forms seem to limit their analysis to issues of adaptation. My purpose here is to move away from the classic comparative approach to

the study of theatre and cinema via adaptations, for the following reasons: first, there exist relatively few adaptations, which somewhat limits any comprehensive examination of the broader engagements between theatre, cinema and the prevailing context; second, studies of adaptation undertaken in Argentina unfortunately tend to fall into the rather simplistic, clichéd analytical trap of creating a list-in-prose that charts the similarities and differences between the filmic and theatrical versions of a text, employing a rather anodyne 'the play does this ... whereas the film does this' formula (see Cabrejas 1996 and Mogliani 1996). Analysis remains very much on the superficial level of the adaptation's fidelity to the original and fails to consider what translation from one medium to another might reveal, on a more intricate level, about theatrical and cinematic codes of representation, their common status as performance types or their varying functions as art forms (Stam 2000: 12). Neither does it make any theoretical space for hybrid formulae which will be crucial here in re-evaluating contemporary theatrical and cinematic identities and agency. This is not to say that studies of adaptation are not beneficial, and there exists a significant body of work theorising the complex oedipal relationship between the original text and the resulting adaption (see, for example, Millicent Marcus 1993). Current work on adaptation in Argentina, however, is not taking advantage of these more sophisticated ideas. Given the significance of hybrid forms in Argentine cultural traditions, I feel that a broader examination of the borrowings and appropriations made by theatre and cinema will serve as a more fruitful approach to analysing the socio-political role of post-dictatorship Argentine cinema and theatre, as well as mapping out broader developments in the way in which culture is conceived.

Theatre versus Cinema

Whether examining adaptations or hybrid forms, one initial issue must be addressed: how exactly is the relationship between theatre and cinema to be defined? How have theatre and cinema traditionally been related to one another? How did theatrical traditions take account of cinema's inception? What are the codes that unite them and how do they differ? These are key questions in preparing the ground for the analysis to follow.

From its inception, cinema has striven to differentiate itself from its closest neighbour, theatre. Susan Sontag reinforces this idea when she states that

> [t]he history of cinema is often treated as the history of its emancipa-
> tion from theatrical models. First of all from theatrical 'frontality' (the
> unmoving camera reproducing the situation of the spectator of a play fixed
> in his seat), then from theatrical acting (gestures needlessly stylized, exag-
> gerated —needlessly, because now the actor could be seen 'close-up'),
> then from theatrical furnishings (unnecessary 'distancing' of the audiences'

emotions, disregarding the opportunity to immerse the audience in reality).
(1992: 362)

In turn, theatre has had to renegotiate its specificity following the advent of
film. Concepts of theatrical specificity generally return to the most obvious
point of contrast between the two art forms: theatrical presence (366) —or
'convivio' as it is referred to by theatre critics in Argentina (Dubatti 2007:
43)— versus cinema's deferred presence (Metz 1992: 744). Sontag argues
further:

> If an irreductible distinction between theatre and cinema does exist, it may
> be this. Theatre is confined to a logical or *continuous* use of space. Cinema
> (through editing, that is, through the change of shot —which is the basic
> unit of film construction) has access to an alogical or *discontinuous* use of
> space. In the theatre, people are either in the stage space or 'off'. When
> 'on', they are always visible or visualizable in contiguity with each other.
> In the cinema, no such relation is necessarily visible or even visualizable.
> (367, original emphasis)

Articulated in these terms, the relationship between these two neighbouring
art forms seems to be a clear-cut opposition between valuing theatre's aural
presence, on the one hand, and cinema's capacity to mechanically reproduce
the images of a deferred presence, on the other (see Walter Benjamin 1970:
219–46).

My intention here is to complicate some of the assumptions that have
been made in established definitions of the relationship between theatre and
cinema, mainly through the paradigm of performance and performativity,
questioning the supremacy of theatrical presence (or 'convivio') over cinema's
broader spatio-temporal reach and examining theatre and cinema's reaction
to other art forms. To sum up the relationship between theatre and cinema, I
return briefly to Sontag's final and most pertinent question: '[i]s cinema the
successor, the rival, or the revivifier of the theatre?' (1992: 371). My response
to this question, as I hope the ensuing analysis will confirm, would have to
be all of these and the inverse: theatre likewise as 'the successor, the rival
[*and*] the revivifier' of cinema.

A growing body of manifestos and discussion amidst theatre critics and prac-
titioners alike confronts what is perceived to be the current 'crisis' in theatre, as
it has 'reach[ed] yet another break point in its identity, mode of presentation,
and structural efficacy, given the rise of popular forms of entertainment and
instruction like film, television and the internet' (Delgado and Svich 2002: 6).
The suggested antidote: that theatre '*will* be the antithesis of film and televi-
sion', will pick up as an audience anyone who is 'sick of' mass produced
culture (Oliver Mayer, Jorge Ignacio Cortiñas, Neena Beber and Craig Lucas

in Delgado and Svich 2002: 21, my emphasis). Others underline the need to reconnect with the public, to revive theatre's role as 'the place where human beings gathered to examine, debate, and reveal the nature of their experience' and which 'societal disruptions that characterize contemporary life' have undermined (Roberta Leitow in Delgado and Svich 2002: 25–6). Similar debates can be found amongst filmmakers and critics, albeit in relation to television (see chapter 2). Theatre is not perceived to pose a threat.

Reconciling Genre and Postmodernism

Continued use of the term 'genre' might seem odd in a postmodern context. Postmodernism is usually associated with the breakdown of generic boundaries. Jean Baudrillard, arguably the most prominent theorist of the postmodern, describes the 'law […] which we can call postmodern' as 'the law of confusion of genres and genders' (1992: 10). For Baudrillard the postmodern is a huge melting-pot into which aesthetics and politics have been thrown and where they have blended to the point of indistinction. Reinforcing this position, when Ihab Hassan analyses the emergence of postmodernism from modernism, he clearly places the categories 'genre' and 'boundary' in a column of modernist traits, whilst in the corresponding position in the opposing postmodernist column he places the terms 'text' and 'intertext' (1982: 267–8). In the opening pages of his investigation into the key facets of the postmodern, Hassan cites Octavio Paz, who argues that the mixing of genres will lead to their inevitable eradication, in turn placing the integrity of the art object in question (xii). As I will aim to demonstrate throughout this study, within a postmodern context, the clean-cut opposition between pure existence and eradication emerges as a problematic misconception and requires redefinition.

In the most elementary of terms genre derives from the Greek word 'genus' meaning kind (Stam 2000: 13). It denotes some kind of common identity —be it thematic, historical or material— shared between a group of texts (Bordwell and Thompson 2004: 108). Within the field of genre theory, however, there seems to be little consensus over how genre should be defined, only regarding how it might be recognised (108). Nevertheless, critics have become more and more sceptical about the treatment of generic categories as static types endowed with some essential qualities. Instead, an historical approach to genre criticism that sees genre as a product of particular trends in history currently enjoys most prominence. Proffering an historical rather than a theoretical approach to the study of genre, Hayden White argues that it is precisely the contingent nature of genre that resists theorisation (2003: 597). Thus, genre is only really outmoded within postmodernism if it continues to be defined in classical terms, inherited from Ancient Greek philosophical ideas, as a static category defined in terms of its essence (601).

How then is genre still relevant to the study of plays and films which can also be described as postmodern? For further clarity on this matter, I turn to

Derrida's article 'The Law of Genre' (1980), which is particularly instruc-
tive in clarifying genre's unlikely relevance within the context of post-
modernism; bearing in mind the fact that the terms 'genre' and 'boundary'
have been seen to give way to the terms 'text' and 'intertext' (Hassan 1982:
267–8). Derrida bridges the gap between the two by nuancing his concep-
tualisation of genre with poststructuralist ideas of performativity and 'text'.
He argues above all for the continued relevance of genre in literary criti-
cism, although he points to a radical revision of how the term should be
envisaged. '[A] text cannot belong to no genre, it cannot be without or less
a genre,' he argues.

> Every text participates in one or several genres, there is no genreless text;
> there is always a genre and genres, yet such participation never amounts to
> belonging. And not because of an abundant overflowing or a free, anarchic,
> and unclassifiable productivity, but because of the *trait* of participation
> itself, because of the effect of the code and of the generic mark. Making
> genre its mark, a text demarcates itself. If remarks of belonging belong
> without belonging, participate without belonging, then genre-designations
> cannot be simply part of the corpus. (1980: 65)

If the law of genre were supposedly a law of generic essence, then Derrida
subverts this by arguing that the law of genre is inherently one of imperfec-
tion. 'What if there were, lodged within the heart of the law itself, a law of
impurity or a principle of contamination?' he asks (57). The question is of
course rhetorical, as Derrida foregrounds the flaws at the heart of the law
of genre. Far from a wholesale collapse of boundaries between different art
forms, the transgressions of generic boundaries are haunted by what Derrida
terms the 'I'/'we' dichotomy at the heart of this law. ' "I" is a species of the
genre "we",' he suggests (56–7). This law may be governed by what Derrida
terms the logic of 'contamination' —of belonging without belonging— yet the
plays and films examined here also demonstrate a repressed desire/nostalgia
for generic/medium specificity —privileging the proximity between the 'I'
and the 'we'— however naïve this may seem in the light of postmodern
and (post)structuralist thought. In structuralist terms, the 'I'/'we' dichotomy
can be mapped onto the differentiation between *parole* and *langue*. In this
case, each individual text represents a separate *parole*, which only takes
on meaning in relation to other texts and a larger, abstract, structure —or
langue— of conventions that mediate the way in which a spectator interprets
a text. Genre thus contains an element of relativity, signifying that a text only
bears meaning in relation to a broader system. The 'we' in the 'I'/'we' oppo-
sition refers to something outside the text, something I would interpret as
the political or the collective dimension to this dichotomy. The same 'I'/'we'
dichotomy in genre serves as an allegory for the construction of collective

and individual identities. Negotiations between the text (I) and its genre (we) thus echo processes of socialisation.

Instead of a static, solid category, genre should arguably be seen as a liquid construct, to borrow Zygmunt Bauman's metaphor from his work *Liquid Modernity* (2000). Bauman uses the idea of liquidity to define the newfound fluidity in (post)modern society: '"fluidity" or "liquidity"', he argues, represent 'the leading metaphor for the present stage of the modern era' (2); more so if I add to his attribution of fluid dynamics and liquid properties to sociological phenomena the observation that liquids may be free to flow and change shape, but the shape they assume is governed by the container (read 'context') in which they are placed. This provides a fitting metaphor for the need to redefine genre as a contingent construct shaped by prevailing circumstances.

The Changing Parameters of the Political
Political context is an inevitably shifting category. One of the major obstacles in the processes of re-politicisation and socialisation of theatre and cinema in the wake of the dictatorship, as already mentioned briefly, is the changing parameters of what it means to be political. My intention here is to examine such changes through the trope of performance and what Benjamin first described as the aestheticisation of politics (1970: 244). Original footage of public events during the Argentine military junta's 'Proceso de Reorganización Nacional' leaves little doubt about the aestheticised or performative nature of its regime. However, the aestheticisation of politics is by no means a recent phenomenon within the Argentine context; the theatricality implicit in Peronism is evidence enough of this (Rock 1987: 285). However, the experience of dictatorship not only accentuated the intersection between aesthetics and politics, but reproduced it in its most extreme and brutal expression: the 'Proceso de Reorganización Nacional'.[3] Miguel Pérez's documentary film, *La República perdida* (1986), released shortly after the transition to democracy, includes original footage of perfectly crafted military marches during which military leaders on ceremony adopt an unnaturally upright posture. Such public demonstrations of power and order were clearly scripted and staged, as Diana Taylor argues: 'the entire scenario of "national reorganization" or *Proceso* set in motion by the military was highly theatrical [...], the obvious spectacularity of the confrontations, the public marches, the struggle to control public space and attention, the display of instruments, images and

3 The 'Proceso de Reorganización Nacional', or 'Proceso' as it is more commonly referred to, is the official name for the military junta's programme to purify society, using violent means, of its so-called 'subversivos'. The 'Proceso' resulted in the disappearance of an estimated 30,000 citizens between 1976 and 1983, the effects of which are still deeply ingrained in the collective memory.

icons' (1997: 273). Performance theorist Schechner confirms the role of performance within Benjamin's theory of the 'aestheticisation' of politics with his suggestion that authoritarian politics are inherently performative: 'rigid social systems', he argues, 'tend to generate events that concentrate on theater and performance, on spectacular confirmations of the existing social order' (2003: 102). Theatrical metaphors of dictatorship were moreover to persist in the transition to democracy. Ernesto Sábato's introduction to *Nunca más* (1985), the report commissioned by President Raúl Alfonsín on the 'Proceso de Reorganización Nacional', sets up the 'Proceso' in theatrical terms as 'la tragedia [que] tuvo a nuestro suelo por escenario' (Sábato 2003: 15).

The spillage of theatricality out of its conventional home in theatre and cinema, into the streets of Buenos Aires and government institutions —a phenomenon referred to by prominent Argentine theatre critic Jorge Dubatti as 'transteatralización' (2006: n.p.)— is seen to destabilise the boundary that appeared to mark a clear separation between politics and aesthetics. He suggests that

> [e]n los últimos veinte años el teatro se vio en la obligación de redefin-
> irse por una cantidad de fenómenos. El primer fenómeno es lo que se ha
> llamado *la transteatralización*: todo es teatro. Es más teatro el orden social
> que el teatro mismo y, en ese sentido, el teatro ha sido 'superado' por el
> orden de lo real. (2006: n.p., original emphasis)

Yet, the blurring of the boundary between theatre and politics or theatre and life, so succinctly expressed in the well-known Shakespearean maxim 'All the world's a stage',[4] goes back to the early seventeenth century. I would suggest that the boundary between aesthetics and politics becomes more obvious in the post-dictatorship period because it is the object of self-reflexive negotiation. Texts consciously take issue with the aestheticisation of politics and their own relationship to the political.

The increased anxiety about the merging of aesthetics and politics since the dictatorship can also be explained by the concurrent aestheticisation of the social, although neither can this be considered a wholly new phenomenon. The novels and theatre of Manuel Puig give an incisive portrayal of the theatricality of the middle classes obsessed with keeping up appearances, for example.[5] The growth of neoliberalism, free market economy and an explosion in consumerism under President Carlos Menem (1989–99) did, however,

4 This well-known citation is from William Shakespeare's *As You Like It* (1600), Act 2, Scene 7.

5 See, for example, the novels *Boquitas pintadas* (1969) and *La traición de Rita Hayworth* (1969) or the play *El misterio del ramo de rosas* (1986).

further widen the field of aesthetics, turning Argentina into Guy Debord's oft-mentioned 'society of spectacle' (2004). To borrow the words of Fredric Jameson: 'commodification has [an] immediate relevance to aesthetics, if only because it implies that everything in consumer society has taken on an aesthetic dimension' (1992b: 15). This brings me to Dubatti's second point: '[p]or otro lado, está la "usurpación" de la teatralidad por el orden social y la idea de que la teatralidad estaría en todas partes y que sería lo específico del acontecimiento social' (2006: n.p.). Aestheticisation becomes intimately linked with notions of commodification, social theatricality and performance. Theatre and cinema hoping to re-engage with political and social processes after the dictatorship are impelled to deconstruct aestheticisation on political, social and economic fronts, whilst ensuring that a clear distinction is made between the aestheticisation of politics/the social and the politicisation/socialisation of aesthetics. This they achieve by simultaneously attempting to reassert their specificity as autonomous art forms.

Performance

The term 'performance' is already beginning to slip and slide between different fields, disciplines and forms and must at this stage be properly defined in order to avoid subsequent confusion. 'Performance', argues Schechner, 'is an inclusive term. Theater is only one node on a continuum that reaches from the ritualizations of animals [...] through performance in everyday life' (2003: xvii). He defines performance in the broadest sense as 'an activity done by an individual or group in the presence of and for another individual or group' (22). Schechner's two most important contributions to this study are to be found in his theorisation of the boundary between 'aesthetic drama' and 'social drama' (2003: 192–3), as well as in his definition of what transforms a performance into a work of art. The advent of performance theory and the associated field of performance studies has opened up the study of film and theatre to an interdisciplinary body of work on performance which takes a more anthropological direction to incorporate many elements of social life.

Schechner does, however, only place theatre onto this continuum of performance types and, although film and television are mentioned in his *Performance Theory* (2003), he clearly does not perceive them in similar terms of performance. Schechner believes that performance is defined by spatio-temporal continuity between performer and spectator and that the question of presence is vital in achieving a dialectic between them (14). His theory of performance thus conforms in many ways to the traditional and definitive separation between theatre and cinema, something that André Bazin highlights in his essay *What is cinema?*, citing Henri Gouhier's argument that '[t]he stage welcomes every illusion except that of presence' (1992: 375). Schechner perceives film as a vehicle for transmitting performance, in other words as a medium, removed from the performance itself. In contrast to this,

I would argue that film can also be located on the same continuum. Certainly in chapter 4, which looks at theatre and cinema's appropriation of the documentary genre as a means of bringing representation closer to the outside world, theatre's appeal to documentary with the view of performing a greater network of presences somewhat complicates Schechner's definition (partly on account of its use of audiovisual technology in order to forge a greater sense of community). It is also important to bear in mind, however, that whilst theatre and cinema, as performance-based art forms, can be displaced onto a wider continuum of performance genres that spans across sociological, political and aesthetic categories, each performance retains a certain degree of specificity defined by its form. Christian Metz is careful to point out that cinema is composed of a series of both specific and non-specific codes. He states that cinema was not born a 'specific "language"', but became one (1992: 170–1). The founding assumption of my study here is that the most important shared code between theatre and cinema is that of performance, although each is framed in a slightly different manner according to specifically theatrical and cinematic codes, respectively. These shared codes of performance map out the axis across which collaborations between the two art forms are enabled; across which political, sociological and anthropological engagements are forged.

I have already mentioned the central role of reflexivity in bringing questions of performance, aestheticisation and artistic identity to the fore. Robert Stam states, with reference to film, that reflexivity functions in varying ways. '[It] can be grounded in an art for art's sake aestheticism, in media-specific formalism, in commercial propagandizing, or in dialectical materialism. It can be narcissistic or intersubjective, a sign of politically motivated urgency or nihilistic lassitude' (2000: 153), or, as will be argued here, a combination of these seemingly opposing functions. 'Teatrista'[6] Eduardo Pavlovsky (whose work will be discussed in chapter 1) may describe the process of creating the play as a 'máquina anti-narcisista' (2001: 152), but reflexivity in the texts analysed here reveals both a 'politically motivated' *and* 'narcissistic' self-consciousness. It serves as a mechanism for theatre and cinema to test the limits of their own apparatus, borrowing where necessary (as a strategy for survival/renovation) from neighbouring genres. This in a sense reasserts the notion of specificity and the act of borrowing reinforces the assumption that each specific art form performs some functions better than others. Political strategies located in the conscious transgression of generic boundaries and

6 Dubatti defines the term 'teatrista' as follows: 'el término "*teatrista*" […] se ha impuesto desde hace unos diez años en el campo teatral argentino. "Teatrista" es una palabra que encarna constitutivamente la idea de diversidad: define al creador que no se limita a un rol teatral restrictivo (dramaturgia o dirección o actuación o escenografía, etc.) y suma en su actividad el manejo de todos o casi todos los oficios del arte del espectáculo' (1999: 14).

consequent formulation of aesthetic hybrids are at once reflected in the mirror of Narcissus, which reflects an anxiety of contamination, leading in turn to a loss of specificity and autonomy. These apparently disparate drives provoke a revision of the term 'genre', reinforcing the need to untether it from static essentialism. Performativity and reflexivity ultimately coincide and genre is demonstrated to be a contingent construct that attempts to ensure a sense of agency that is based, at the very least, on the illusion of a stable identity and subjectivity that can underpin legitimate political engagement.

Borges' Pierre Menard taught us that the same book could never be written twice, anticipating what would later become known in Roland Barthes' work as the 'death of the author'/birth of the reader (1984), pointing to the importance of context in the construction of meaning and, by association, a questioning of the value of genre as a static, essential category. Yet his characters Herbert Quain and Funes ('el memorioso') also reinforce the human infatuation with order and categorisation, however arbitrary and ultimately nonsensical such categories may be.[7] The juxtaposition of these characters in the collection of short stories, *Ficciones*, somehow captures the dichotomy at play here: on the one hand a decentring of any organising principle in a text that ensures its survival beyond the death of the original author; on the other, human reliance on categorisation, however random such categories may be, of which genre must surely be an example. In an article that attempts to renovate the question of genre by defining it in historical terms, White makes a valid point to this effect.

> Mixture, hybridity, [...] promiscuity —these may be the rule now rather than whatever alternatives we may envisage for them. But as the notions of the 'authentic fake' and the 'real simulacrum' in contemporary (postmodernist) criticism indicate, we are still enthralled by an ideal of purity that promises relief from the contradictions we must live between theory and practice and the paradoxes that attend our efforts to live as both individuals and members of communities. (2003: 602)

It is precisely this desire that drives the policing of boundaries between theatre, cinema and neighbouring genres/art forms, however naïve it may seem. It is this latent desire/nostalgia for artistic autonomy that prevents the borrowings between theatre, cinema and other genres escalating into an evolutionary aesthetic Darwinism in which boundaries are readily collapsed with the sole objective of survival: a kind of survival which would, rather incongruously, realise the postmodern dissipation of art into neighbouring disciplines. Herein lies the contention at the heart of performance studies. The conflict between

7 See the short stories 'Pierre Menard autor del Quijote', 'Funes el memorioso' and 'La obra de Herbert Quain' in Jorge Luis Borges' *Ficciones* (1944).

borrowing conventions from other genre/media/art forms, or a more performative approach to artistic identity, and shoring up theatre and cinema as specific art forms is a common thread throughout this investigation.

Aesthetic Performance versus Social Performance
Chapter 1 explores the confrontations and collaborations between different types of performance, focusing in particular on the way in which theatre and cinema explore the relationship between aesthetic performance and social performance, the prime axis along which their political and social engagement is negotiated. I look at the way in which Pavlovsky's play *Paso de dos* (1990) collapses the boundary between theatrical performance and social performance in the portrayal of an encounter between a torturer and his victim/lover. I observe the role of performance and performativity in contesting the gendered structures of power. Whilst Pavlovsky treads a fine and controversial line between subverting the gendered categories upon which systems of repression are based and subverting such categories from within (see Diana Taylor 1997), my analysis adds to an existing body of research on the work of female writers who attempt to deconstruct the misogynistic paradigms of repression. In *The Subversive Psyche*, Geoffrey Kantaris gives a thorough appraisal of the strategies of subversion employed in six Latin American female writers[8] as they attempt to undertake 'a "feminizing" or "pluralizing" paradigm shift which would disengage masculine sexual identity from its dependency on binary power relations and gender subordination' (1995: 31). Focusing on the potential for resistance from within the space of the Other (44) and referring to Judith Butler's theories of performativity in relation to gender construction, Kantaris explores the potential for subversion from within the female position of subordination. Whilst I would largely concur with Kantaris' study, the introduction of theatre into the equation foregrounds the existence of conflicting layers of performance which must be taken into account.

The other major focal point of this chapter in relation to theatrical and cinematic representations of dictatorship is cinema's appropriation of theatre —more specifically theatrical models derived from the avant-garde— in Fernando Solanas' films *Tangos, el exilio de Gardel* (1985), and *La nube* (1998). I examine the way in which *El exilio de Gardel* juxtaposes different avant-garde theatrical methods (Antonin Artaud's 'Theatre of Cruelty' mixed rather anachronistically with Brechtian alienation) in order to stage a rapprochement between aesthetic performance and a social performance of exile. Finally, I consider how *La nube* (which cites Pavlovsky's *Rojos globos rojos*) allies theatre and cinema in resistance to the ever-expanding 'culture industry' (see Adorno 2001).

[8] Cristina Peri Rossi, Luisa Valenzuela, Armonía Somers, Sylvia Molloy, Reina Roffé and Marta Traba.

In both cases the blurring of the boundary between cinema and theatre represents an alliance between theatre and cinema, although simultaneously bringing latent issues of conflicting aesthetic strategies and specificities to the fore. The chapter discusses how two of the most politically active artists in Argentina since the 1960s attempt to re-engage their theatre and cinema politically in the aftermath of the dictatorship by drawing out the theatricality in the following key social processes: memory, violence, exile and consumerism. This they achieve by highlighting the shared codes of performance between theatre, cinema and social phenomena.

Taking as my point of departure the notion that both collective and individual identities, social subjectivities and agencies are constituted performatively (see Butler 1990), this chapter seeks to elaborate on the political engagements ascertained through the marrying of aesthetic performance and social performance on the one hand and aesthetic representation and political representation on the other. What will ultimately be reasoned is that by drawing a parallel between aesthetic performance and social performance, theatre and cinema not only serve to mobilise alternative artistic/cultural spaces in which subjects can interact socially, but to re-function themselves as socio-political agents in the aftermath of a strict programme of censorship that all but muted the artistic community in Argentina during the dictatorship years. Within these marginal spaces, the social performances of those afflicted by violence and exile can be reiterated, that is to say described and transformed in the Derridean sense. It is the generative nature of this type of performativity that opens up the potential for a politics of performance and performativity. Not only do theatre and cinema work to re-politicise themselves as (performative) art forms, by reflexively negotiating their own specific identity and function, but also to re-politicise certain social subject positions muted during the experience of dictatorship.

The Medium is the Message: the Message, the Ideology
Chapter 2 examines the relationship that theatre and cinema establish with television. Taking its lead from some of the issues raised in the analysis of *La nube* in chapter 1 regarding the threat of television's ideological hegemony to independent cinema and theatre, chapter 2 looks at the way in which theatre and cinema attempt to deconstruct the ideological/cultural hegemony of television. In the age of postmodernity, television represents the primary 'Ideological State Apparatus' (see Althusser 2008) responsible for interpellating its spectators as subjects to the dominant ideology of consumer capitalism: the postmodern 'opium of the people'. This de-mythifying takes two forms: the first looks at the discourse of advertising, which disseminates neoliberal ideology and programmes society to value the new, whilst the old becomes obsolete; the second, unveiling the artifice in television reportage.

The chapter observes how Alejandro Malowicki's film *PyME (Sitiados)* (2005) and Carlos Sorín's film *Historias mínimas* (1998) shore up the division between film and television by contesting the hegemonic ideology of consumer capitalism embedded in the predominant televisual discourse of advertising. I inspect the alliance between radio and theatre in Roberto Cossa's play *Años difíciles* (1997) in resistance to the detrimental ideological effects of television spectatorship on social behaviour, as well as the partnership between film and independent video in Alejandro Agresti's film *Buenos Aires viceversa* (1995), which aims to disclose the artifice at the centre of television reportage. This alliance with video enables the film to demonstrate an awareness of its technological overlaps with television yet juxtaposing the grainy images of independent video-making with the glossy images of the television in order to distance film from television's role as a medium for disseminating political illusion. Threatened by television, both *Buenos Aires viceversa* and *Años difíciles* demonstrate a latent nostalgia for generic purity.

What the ideological hegemony of television also points to is the fact that political engagement can less easily be fought out on ideological grounds after the dictatorship. Dubatti outlines the collapse in ideological oppositions that once informed political engagement in theatre:

> Ya no rigen como en los '60, las polémicas de oposiciones cerradas (realismo-absurdismo, tradición-vanguardia, izquierda-derecha) ni se piensa dentro de los límites de un rígido discurso ideológico (el comunismo, el socialismo, el capitalismo) o científico (el psicoanálisis). Ya no rige la confianza irrestricta en los poderes de la razón como instrumento de comprensión y sistematización de la realidad. [...] Entre 1930 y 1985 una vasta zona del campo teatral 'independiente' se identificó con el progresismo de izquierda. La actual crisis de la representación política se vincula con otros dos aspectos de la nueva visión cultural: la caída del valor social de la militancia y el rabioso cuestionamiento a la clase política como corrupta y desconfiable. (1999: 16–17)

Whilst some maintain that we are now living in a post-ideological world (see Daniel Bell 1965), others assert that we still live in an ideological world, only one governed by a single ideology of consumer capitalism. But if there exists only one ideology governing society, then is it not impossible to step outside the boundaries of this ideology (Žižek 1999: 60)? The play and films analysed in this chapter attempt to challenge television's ideological hegemony by trying to de-mythify (or imagine the possibility of stepping outside of) the dominant ideology. If 'the medium is the message', as Marshall McLuhan famously suggests (2001: 9), and the message the ideology, as I argue here, then by reasserting their specificity as contrasting media/types of perform-

ance, both film and theatre are able to render the ideological transparency of television opaque and thus open to critique.

Promiscuity and/or Incest?
Intertextuality represents another means of drawing attention to the boundaries of generic categories, as well as borrowing from other texts through citation. Chapter 3 focuses on the politics of intertextuality in two postmodern and political science fictions: Fernando Spiner's film *La sonámbula* (1998) and Ricardo Bartís' play *Postales argentinas* (1988), both of which engage in an incestuous borrowing/citation of texts belonging to their own (both national and imported) aesthetic traditions, as they attempt to construct an artistic lineage that compensates for the discourses of failure that have created ruptures in Argentina's sense of history and national identity (see Graciela Scheines 1993 and Nicolas Shumway 1993: x–xi). *Postales argentinas* and *La sonámbula* allegorise Argentine postmodernity in terms of a failed project of modernity. *La sonámbula* portrays the urban decay of Buenos Aires in 2010, whilst *Postales argentinas* depicts Buenos Aires in 2043 on the brink of extinction. In both cases, this discourse of a nation's failed project of modernity is played out in the microcosm of the family and a series of dysfunctional (artificial in *La sonámbula*, incestuous and promiscuous in *Postales argentinas*) family relations. In this chapter, I take Jameson's theory of the 'political unconscious' as my hermeneutic (2002), proposing that, whilst the manifest content of this film and this play represent nothing more than what Scheines would term a metaphor of failure (1993), underneath these metaphors a Freudian 'family romance' (Freud 2001b: 236–41) is being played out in the lattice of intertextual citations that make up each of these texts; the family in this case doubling as genre. The paradigm of the family lies at the interface between the latent and the manifest meanings of this play and this film. Intertextual citation in this case serves as a means of breathing life into theatrical and cinematic genealogies that compensate for the nation's ruptured sense of history.

In many ways this chapter provides a complement to the work of Idelber Avelar (1999) on post-dictatorship literature. He examines the way in which literature not only has to deal with the past, but simultaneously becomes aware of the prospect of its own decay in the present, facing obsolescence within the context of the new global televisual order. Avelar observes the strategies devised in literary works to compensate for this sense of loss. I identify related trends in post-dictatorship theatre and cinema as they face a similar fear of their own demise in the face of televisual domination, although in relation to specifically theatrical and cinematic concerns, as well as modes of performance. If television and its accomplice advertising are programming society into a mindset in which the (obsolete) old is always to be superseded by the new, then older forms such as literature, theatre and even film must

revivify their connection with the past (1999: 2). One of the reactions to this collapse of time highlighted in this chapter is an apparent urgency to resuscitate artistic genealogies, creating a space for these texts in established theatrical and cinematic lineages. Likewise, the ruins portrayed in the two science fictions in this chapter 'offer anchors through which a connection with the past can be reestablished' (Avelar 1999: 2).

Of more general interest to this book as a whole is what Avelar argues is literature's attempt to establish its 'historical vocation' (12) by 'representing the aestheticization of politics' (29), or what he also terms 'a substitution of aesthetics for politics' (29). Again this represents the motivation behind revitalising certain aesthetic lineages that underline this reconfiguration of aesthetics and politics (86). Citing Walter Benjamin in this extract, he affirms: 'Just as nineteenth-century art had sensed the threat unleashed by the advent of reproductive techniques such as photography and "reacted with the doctrine of *l'art pour l'art,* that is, with a theology of art," the boom perceived an analogous decay of the aura and responded with an aestheticiza-tion of politics or, more to the point, a substitution of aesthetics for politics' (1999: 29). No longer disseminating ideology and therefore losing control over society (31–2), this represents the 'terrain on which the current polemic surrounding the status of the literary takes place' (30). I find many parallels with this point of view in the strategies of compensation developed in theatre and cinema that attempt to represent the performativity inherent in politics, or in a similar spin to Avelar's formula, replace politics with performance in an attempt to reassert their role. This is certainly the case in the first three chapters of this work, although chapter 4 offers a perspective on a very different approach to restoring praxis in more recent theatre and cinema.

Recovering the Real

Having examined the way in which a series of plays and films sketch out a growing theatricality in society, which they present in terms of the increasing dissipation of the Real into a series of performances, the final chapter focuses on borrowings from documentary in more recent theatre and cinema, which I read as an attempt to recover the Real. Documentary is a more explicit genre than fiction that aims for transparency. Not only is it associated with times of financial constraint (it requires a much lower budget than the average feature film), but it occupies, as Michael Chanan contends, 'a central position' in the history of Latin American political filmmaking, not least the New Latin American Cinema that emerged in the 1960s and 1970s (1997: 202). The political motivation behind the appropriation of documentary techniques is central to my analysis.

What will be argued in this chapter is that this appropriation of documentary is framed by the imperative to recover the Real (disappeared amidst the plethora of images, representations and performances structuring Argentina's

postmodern 'society of spectacle') and recover the social (all but abandoned under Menem's regime of the 1990s) via biography, a variation on the documentary genre. New Argentine Cinema is broadly cemented as an idea on account of its neorealist traits. In contrast, New Argentine Theatre represents a much greater diversity of aesthetic approaches and can in no way be defined exclusively in terms of a similar appeal to neorealist aesthetics. Critics and playwrights alike instead bind the movement together by maintaining that the diversity to be found in contemporary Argentine theatre can be unified in a politics of multiplicity. Returning to traditional ideas of theatrical specificity, they also underline the manner in which theatre's status as an organic, local art form is able to resist the disembedding forces of globalisation. A complete study of the range of theatrical production currently on offer is beyond the confines of this particular study. I therefore choose to focus on one particular project within the broad and diffuse critical category 'New Argentine Theatre' which does stand out for its documentary traits: Vivi Tellas' 'Proyecto Biodrama' (2001 to 2008).

As part of this biodramatic project, Mariana Obersztern's play *El aire alrededor* (2003) and Luciano Suardi and Alejandro Tantanian's play *Temperley* (2002) engage in biopolitical strategies that attempt to retrieve the Real by recuperating the social. The term 'biopolitical' is adapted from Michel Foucault's negative portrayal of biopolitics as an instrument of '*bio-power*' (1979: 141–4, original emphasis) and given a positive meaning. The subsequent analyses in this chapter focus on the issue of 'convivencia'. 'Convivencia' —best defined as a combination of harmonious cohabitation and conviviality— stands out as a key concern in the aftermath of the Crisis as a socially, politically and economically broken society tries to find new ways of cementing a sense of community and nationhood (see Mauricio Rojas 2004: 119). I look at how the selected plays and films test the potential of theatre and cinema respectively as spaces in which new projects of 'convivencia' can be established. Analysis of Martín Rejtman's film *Silvia Prieto* (1999), Beatriz Catani and Mariano Pensotti's biodrama *Los 8 de julio* (2002) and Lisandro Alonso's film *Fantasma* (2006) is used to problematise the assumption made among theatre practitioners that theatre's organic presence (its 'convivio') automatically makes it a more suitable genre for achieving 'convivencia' (see Dubatti 2007). 'Convivio', as defined by Dubatti, is '[un] encuentro de presencias en una encrucijada espacio-temporal'. What each of these texts does is test the limits of both theatre and cinema's capability of achieving 'convivencia' in relation to the idea of 'convivio'. Dubatti, the most prolific of Argentina's contemporary theatre critics, consistently reinforces not only theatrical specificity, but its superiority in relation to other art forms, on account of its conviviality. He over-relies on the concept of presence and theatre's 'aura'. What is demonstrated is that 'convivio' does not necessarily lead to 'convivencia' and although film cannot achieve an organic

encounter between spectator and actor (only virtual 'convivio'), film is a more suitable medium for exploring more wide-reaching projects of 'convivencia' that traverse class boundaries.

Joanna Page focuses her study of contemporary Argentine cinema on representations of crisis and capitalism, analysing the way in which cinema recounts the nation's controversial experience of neoliberalism and the ensuing economic upheaval (2009: 3). She deals particularly with how cinema both explores and informs subjectivities in relation to the experiences of capitalism. Concurring with the work already done by Page, I also address certain theatrical and cinematic approaches to the construction of subjectivity; this time through notions of (theatrical) presence and performance, commenting upon how theatre and cinema attempt to make a virtue out of their specific modes of representation in order to promote themselves as spaces in which new social projects can be imagined.

Chapter 4 in many ways proposes a differing set of responses to the same social and political experiences of neoliberalism explored previously (appealing to social experience rather than macro-political issues). Recent films and plays provide a different documentary response to what is, nevertheless, the same basic problem dealt with by the de-familiarising, overtly theatrical films and play of chapter 1: how to renegotiate the boundary between reality and representation (between social performance and aesthetic performance) without losing the notion of the aesthetic. Whereas films like *La nube* and *La sonámbula* or plays like *Años difíciles* and *Postales argentinas* privilege allegorical scenarios that refer to macro-political contexts, the more recent films and plays analysed in this chapter appeal to the social experience of the Crisis (Page 2009: 182). Whilst in chapter 1, the plays and films aimed to accentuate their theatricality, society's saturation with glossy image-politics and farcical political theatricality causes both theatre and cinema in the cases analysed to counteract such models of farce and look instead to a neorealist aesthetic.

Re-informing Debates on Performance, Genre and the Postmodern

My hope is that the discussion generated throughout this book will ultimately feed back into debates regarding the status of artistic autonomy and of genre within the framework of performance studies and the postmodern. Rather than catalogue a series of political issues with which theatre and cinema engage, the reflexive foregrounding of genre/medium/aesthetic form focuses instead on the ways in which theatre and cinema dissect the political, demonstrating what their materials and apparatuses —their common codes of performance, that is— can reveal about the processes of constructing political meaning. The texts analysed in this investigation not only comment upon the disciplinary transgressions enabled through ideas of performance, but test the limits of different kinds of performance models. Yet clearly uncomfortable with this

newfound fluidity, the texts also disclose the way in which artistic engage-
ment with the political and the social repeatedly comes up against the mirror
of Narcissus. The residues of modernism, expressed via the apprehension of
losing the notion of the aesthetic and the autonomous art object (as separate
from the political, the social and the economic) will serve as a counterpoint
to the rendition of postmodernism as merely ludic and depthless; more so in
Latin America where the distinction between modernism and postmodernism
and indeed between modernity and postmodernity is by no means clear-cut
(see William Rowe and Vivian Schelling 1991).[9] The terms 'modern' and
'postmodern' bear certain limitations in their transportation to the Argentine
context. What the appropriations examined here suggest is that the idea of
postmodern art as pure surface must be rethought in terms of a palimpsest:
a surface mirage with fissures through which the repressed unconscious of
modernism seeps.

[9] In their investigation of popular culture in Latin America, Rowe and Schelling prob-
lematise any clear-cut distinction between modernism and postmodernism by exploring the role
of 'the popular' in the Latin American experience of modernity (1991: 3). The Latin Amer-
ican experience of cultural and social hybridisation, as explored by García Canclini, suggests
that more conventional, Eurocentric paradigms of the modern and the postmodern should be
re-evaluated (2001: 35–45).

1

'Theatre[s] of Cruelty' and Politics of Performance in the Work of 'Teatrista' Eduardo Pavlovsky and Filmmaker Fernando E. Solanas

Undoubtedly the most obvious point of comparison between theatre and cinema is to be located in their shared status as performance arts. It is these common codes of performance that cement the cinematic and theatrical hybrids that will be examined in this chapter. Richard Schechner's basic definition of performance was given in the Introduction as 'an activity done by an individual or group in the presence of and for another individual or group' (2003: 22). However, Schechner's positioning of film in relation to the performance continuum is somewhat ambiguous. Although in cinema the actors and audience are not in the direct presence of one another, I would suggest that there is still a convincing argument for defining cinema as a performance art. Whilst it cannot be denied that cinema is a medium, it remains a mediated performance, constituting a virtual presence. Cinema still involves the representation of an actor speaking and moving (although in front of the camera, rather than directly before a live audience). Jean-Paul Sartre makes the interesting observation that even if the actors in theatre are alive, in cinema they are closer to the audience (1992: 94). This, I would attribute to certain spectatorial conventions in cinema, developed in relation to the transparency of cinematic realism. One of the arguments that will be developed in this chapter is that cinema and theatre collaborate in order to establish praxis through this shared notion of performance. As Solanas' films engage in a politics of performance, what will be argued is that film's borrowing from theatre marks an attempt to compensate for its lack of direct presence.

Since the 1960s, the term 'performance' has not only become detached from its roots in theatre to encompass a range of aesthetic forms —among these is, of course, cinema— but it has also become a central paradigm in the study of social relations. Erving Goffman, in his work *The Presentation of Self in Everyday Life* (1990 [1959]), employs the concept of performance 'to refer to all activity of an individual which occurs during a period marked by his continuous presence before a particular set of observers and which has

some influence on the observers' (32). '[W]hen an individual appears in the presence of others', he argues, 'there will usually be some reasons for him [or her] to mobilize his [or her] activity so that it will convey an impression to others which it is in his [or her] interest to convey' (15–16).

> A status, a position, a social place is not a material thing, to be possessed and then displayed; it is a pattern of appropriate conduct, coherent, embellished, and well articulated. Performed with ease or clumsiness, awareness or not, guile or good faith, it is none the less something that must be realized. (81)

Goffman's analysis of the performance in processes of socialisation corresponds to a dramaturgical conceptualisation of performance. 'When an individual or performer plays the same part to the same audience on different occasions, a social relationship is likely to arise' (27), he argues. In order for a subject to become integrated into society he or she must perform over and over again the pre-scripted formula for socialisation.

'Performance' is now a term that transgresses disciplines and has styled a new kind of dialectic between art, politics and processes of social interaction, facilitating and in many ways requiring the boundaries of each of the above fields to be renegotiated and new cultural and disciplinary hybrids to be considered. Social, political, theatrical and cinematic performance can all be situated as 'nodes' on the same 'performance continuum' (Schechner 2003: xvii) according to their adherence to the basic definition of performance given above. I would suggest, in addition to this, that a series of frontiers cut through this broader continuum, marking the specific territory of each of these performance types (or 'nodes'). The most important of these, both the focus of this chapter and a principal foundation in subsequent chapters, is the frontier between aesthetic performance and social performance. The engagements between aesthetic performance and social performance represent the key theoretical concern embedded in the processes of re-politicisation and re-socialisation in independent theatre and cinema after the dictatorship. The second boundary at stake here in this chapter —one that also traverses this performance continuum— is that which marks the relationship between theatre and cinema as neighbouring, yet substantially different, types of aesthetic performance.

This chapter will examine the manner in which two plays by Argentine 'teatrista' Eduardo Pavlovsky, and two films by Argentine filmmaker Fernando E. Solanas, draw out the performative nature of some of the key social processes characterising Argentine society during the 1976–83 military dictatorship and its aftermath: (memory of) violence, exile, and the explosion of consumerism within a post-dictatorship society based on the neoliberal model. The theoretical frontier between 'aesthetic' performance and

'social' performance becomes the organising principle for each of these texts (Schechner 2003: 192–3). By drawing out the performative side of social processes, these texts de-naturalise the performativity inherent in such processes, rendering the normally transparent mechanisms of social interaction, as well as those that construct political meaning, visible and open to inspection. What is foregrounded in this process is the manner in which the experiences of memory, violence, exile and consumerism fragment any sense of the unified, stable discourse of (national/individual) identity propagated by the military dictatorial regime.

The subsequent analysis will be divided into three sections: part one will look at the interplay between aesthetic performance and social performance in processes of violence and memory in Pavlovsky's play *Paso de dos* (1990); part two will examine cinema's appropriation of theatrical models in order to draw out the performance in exile in Solanas' film *Tangos, el exilio de Gardel* (1985); and finally part three will return to cinema's borrowing from theatre in Solanas' film *La nube* (1998), which incorporates Pavlovsky's play *Rojos globos rojos* (1994) (Pavlovsky cementing the alliance between film and theatre by playing the protagonist in *La nube* and having played the protagonist in his own play). In this film, independent theatre and cinema enter into a tacit collaboration in opposition to prolific consumerism and an ever-dominant global 'culture industry' (see Theodor Adorno 1997 and 2001) which underpins the (social) performance —read 'simulacrum/illusion'— of Argentina's disparate experience of modernity. This final section explores the alliance between two of Argentina's most actively committed artists both before, during (although in exile) and after the dictatorship. In each case, what will be argued is that the negotiations that take place across the boundaries between theatre and cinema and/or between aesthetic performance and social performance are instrumental in re-functioning theatre and cinema as socially and politically engaged art forms.

Performance becomes the key to transgressing boundaries and the medium via which such re-engagement takes place. Yet, as performance theorist Elin Diamond contends: '[t]he focus on performance has produced provocative debates among theatre theorists about the political status of theatre in relation to performance' (1996: 3). I would advocate that a similar debate can be applied to cinema. Transgressions across the frontier separating aesthetic performance from social performance thus also represent a threat to more conventional notions of genre and the work of art. Beneath this apparent willingness to transcend aesthetic, social and political boundaries lies a latent anxiety regarding the loss of aesthetic autonomy and specificity, which represents a hangover from modernist notions of politically and socially committed art.

'Theatre of Cruelty', Performance of Torture: Pavlovsky's *Paso de dos*.
Staged for the first time in 1990,[1] *Paso de dos* is one of several plays
written by Pavlovsky after the dictatorship which, according to Jacqueline
Eyring Bixler, represent a progression from 'teatro de denuncia', written and
performed during the dictatorship, to 'teatro de la memoria' (1994: 17). No
longer in the grips of dictatorship and with the single imperative of denouncing
those directly involved in the disappearance of citizens, Pavlovsky adopts a
more complex approach to the memory of these disappearances and begins
to explore the intricate and ambiguous nature of the relationships between
collaboration and resistance, between victimiser and victim, in order to
understand exactly how the dictatorship could have taken hold.

This controversial play hit a nerve with spectators. Whilst some described
it as the 'hit of the season', others dismissed the play's political aspirations
of resistance, arguing instead that *Paso de dos* represented a highly prob-
lematic spectacle of violence that achieved nothing more than to reassert
the sexist ideology of active male agent/passive female object on which the
rhetoric of the military discourse had been based (Diana Taylor 1997: 27).
The play takes the form of a dialogue between torturer 'Él' and his victim/
lover 'Ella'. During their re-encounter, the couple attempt to re-enact with
absolute precision the 'intensidades' (Pavlovsky 1997b: 105) of their initial
meetings, which we are led to believe —though this is never confirmed in
the dramatic text itself— took place in one of the many torture centres in
operation during the previous dictatorship.

My analysis of *Paso de dos* takes as its initial point of reference the
permeable frontier between 'aesthetic' theatre and 'social' theatre, in this
instance in order to examine the way in which Pavlovsky's play uses theatre
to draw out the theatricality in processes of torture: 'torture', as defined by
Elaine Scarry, being a carefully crafted spectacle of power (1985: 28). The
couple's re-enactment of their initial encounters also illustrates the perfor-
mativity implicit in memory. Yet as the male protagonist states: '[e]l tiempo
lo modifica todo' (105). In line with poststructuralist ideas of subjectivity
as a performative and historically contingent construct, what I will attempt
to argue here is that when the encounters are *re*-presented in a different
temporal and political context, the act of reiteration facilitates a potential
shift in the previous subject positions defining their relationship as victim and
perpetrator, thus opening up the possibility of a transfer (albeit by no means
complete) of agency and power from Él to Ella. Far from a simple question
of gender stereotyping, *Paso de dos* engages in an intricate negotiation of
subjectivities and agencies that are played out between different layers and

[1] The play was staged for the first time in 1990 under the title, *Paso de dos*, but the
same play had been published a year earlier under the title *Voces* (Jacqueline Eyring Bixler
1994: 30).

models of performance. The reiteration of the original encounters within a different temporal and political context enables the possibility of mobilising a renewed sense of agency and renegotiating the power relations between Él and Ella from within the discourses of power that enabled the dictatorship to take hold. What will become clear in the light of this is that the play cannot be forced into a simple matrix of gendered stereotypes or of collaboration versus resistance. As the accepted opposition between collaboration and resistance is blurred, the gender dichotomy can no longer be seen to align and the play initiates an explosion of meaning in accordance with what Pavlovsky terms his 'estética de la multiplicidad' (2001: 151, and Dubatti 1997: 24).

At this stage, it is important to clarify two key aesthetic concepts which give shape to Pavlovsky's work. The first is the aforementioned 'estética de la multiplicidad', often interchanged with the term 'estética de la ambigüedad', and the second is a 'micropolítica de la resistencia' (Dubatti 2005: 12). The 'estética de la multiplicidad' defines a specific style of acting which privi-leges the pure presence of performance: 'pura multiplicidad. Incapturable. Deviniendo siempre. Nunca en el mismo lugar' (Pavlovsky 2001: 151). In other words, a play should evolve in the transition from text to stage. Minimal use of stage directions ensures that Pavlovsky's plays are hard to pigeonhole into any fixed category. Each performance is another multiplica-tion of the dramatic text which is unavoidably different. His micropolitics of resistance take a slightly different emphasis and focus on the fact that 'los fenómenos micro-políticos, no se definen por lo pequeño, sino porque escapan a la representación' (2002: n.p.). Synonymous with an explosion of meaning and the subversion of conventional linear discourse, both the aesthetic of ambiguity and the micro-politics of resistance align comfortably with the staple avant-garde aesthetics of fragmentation, in which ambiguity and antagonism are seen to enrich, rather than distort, images of reality. Teat-rista, but also a psychiatrist, Pavlovsky uses theatre as a means of excavating into the human psyche; to push beyond the limits of representation, beyond the limits of language and the Symbolic order that structures our perceptions of reality, as a means of getting closer to the Real and to what might provide an explanation of the repressed instincts, drives and desires that provoke human violence. In his work entitled *La multiplicación dramática* (2006), co-written with Hernán Kesselman, Pavlovsky discusses the therapeutic potential of theatre in psychiatry/psychoanalysis. He specifically cites a theat-rical model based on the aesthetics of multiplicity as a medium for reiterating and working through psychological anxieties. It is with these ideas in mind that, I would suggest, *Paso de dos* should be approached.

Another significant influence on Pavlovsky's aesthetics of multiplicity/ ambiguity and his micro-politics of resistance is Antonin Artaud's Theatre of Cruelty (see Artaud 1993: 68–78). Jorge Dubatti reiterates Pavlovsky's interest in the 'theatre of cruelty', describing Artaudian cruelty (and Pavlovsky's

theatre) as 'un teatro "hacia una realidad total", es decir, un teatro que amplía el registro de experiencia del hombre más allá de la perspectiva materialista-objetivista del realismo' (2002: 6). The Theatre of Cruelty represents '[f]undamental theatre,' Artaud manifests: 'a revelation, urging forward the exteriorisation of a latent undercurrent of cruelty through which all the perversity of which the mind is capable, whether in person or nation, becomes localised' (1993: 21). In line with these sentiments, Pavlovsky redefines theatre as a space in which these undercurrents are localised and expressed.

Speaking of cruelty in relation to the portrayal of dictatorship does, however, risk confusing what are in fact two very different definitions of 'cruelty'. Artaud is clear in his separation of theatrical cruelty from the more common definition of vindictive violence usually associated with the term. He declares: 'on a performing level, it [theatrical cruelty] has nothing to do with the cruelty we practise on one another, hacking at each other's bodies, carving up our individual anatomies' (60), a kind of cruelty of course readily associated with dictatorship. Instead, Artaud defines the theatre of cruelty as a radically, socially disordering theatre (17): one that collapses the boundaries between theatre and life, 'a primal theatre sensed and experienced directly by the mind, without language's distortions and the pitfalls in speech and words' (83). It is the kind of theatre, practised also by Pavlovsky, which looks to performance as a means of getting beyond the organising principles of language.

The cruel repression carried out during the dictatorship, as will be argued here, aligns with a meticulously scripted, static dramaturgical model of performance. I will propose, therefore, that the dichotomy between social performance and aesthetic performance can be mapped onto Pavlovsky's juxtaposition of a conventional dramaturgical performance model —based on a conventional model of theatre and static repetition of the dramatic text— against a poststructuralist concept of performance that breaks dramaturgical conventions of scripted performance and as a result, as will be developed further on, opens up a space in the act of reiteration which holds the political potential for change. Pavlovsky draws on Artaudian cruelty here as a means of taking theatre beyond the confines of dramatic convention, into the area of pure performance and a zone in which theatre fuses with life. Theatre and performance in this case must be treated as separate, if overlapping, concepts. Philip Auslander differentiates performance from theatre as follows:

> [P]erformance exists in an antagonistic relationship with theatre, emphasizing that performance specifically deconstructs theatre's essential features: 'Performance rejects all illusion' […] it 'presents; it does not represent'. […] [P]erformance is characterised by fragmentation and discontinuity (rather than theatrical coherence) in narrative, in the use of the body and performance space, and in the performance/audience relationship. Thus

understood, performance deconstructs and demystifies theatre: 'Perform-
ance explores the under-side of theatre, giving the audience a glimpse of
its inside, its reverse side, its hidden face'. (1997: 54)

The social and political theatricality inherent in processes of torture is
conveyed most notably in *Paso de dos* when Ella remembers the violent
encounters which took place between the couple using terms derived from
traditional theatre. Employing words such as 'spotlighting', 'a protago-
nist' and 'scenography', Ella effectively frames the process and experience
of torture in theatrical terms, thus drawing attention to the performativity
therein. She recalls:

> ELLA: Allá en nuestras intensidades, focos de luz deformando nuestros
> rostros, la camilla en posición inverosímil, la electricidad y su protago-
> nismo, los golpes secos, algodones y el olor a la sangre coagulada, desafío
> a los límites del hoy un poco más, la música que parecía nacer de nuestros
> cuerpos. Agonías, los sudores fríos, la muerte acechando, todo eso reunido
> entre nosotros, objetos con fuerza propia, movimientos con ritmos difer-
> entes y allí nuestros cuerpos, formando parte de todo eso [...] descubrimos
> con horror que las pasiones tan nuestras formaban parte de la escenografía
> del acontecimiento. (Pavlovsky 1997b: 118)

The somewhat incongruous combination of rhythm, musicality and passion
with violent blows and coagulated blood presents a rather disturbing spec-
tacle of torture. This same citation is employed elsewhere in Pavlovsky's
theoretical publications as an example of a 'poética de la tortura' (2006b), to
further reinforce the parallel between theatricality and violence.

Elaine Scarry's thorough examination of the mechanisms and effects of
torture confirms this line of thought. She argues that both the staging of
torture and the 'obsessive, self-conscious display of agency' on the part of
the torturer are scripted into a spectacle of power (1985: 27). She further
asserts that

> [i]t is not accidental that in the torturers' idiom the room in which the
> brutality occurs was called the 'production room' in the Philippines, the
> 'cinema room' in South Vietnam, and the 'blue lit stage' in Chile: built on
> these repeated acts of display and having as its purpose the production of
> a fantastic illusion of power, torture is a grotesque piece of compensatory
> drama. (28)

Scarry's analysis of theatricality in processes of torture amounts to a drama-
turgical approach to torture, whereupon the spectacle of power initiated
through torture is a well scripted, well rehearsed re-enactment of the domi-
nant ideology/discourse. The manner in which *Paso de dos* lays bare the

theatricality in torture and memory forms part of the play's own reflexivity as Pavlovsky plays on the proximities between aesthetic theatre and social theatre in order to re-function theatre as a medium through which to deconstruct social performance. Social performance, as Diamond points out, can be interpreted 'as cultural practices that conservatively reinscribe or passionately reinvent the ideas, symbols, and gestures that shape social life. Such inscriptions or reinventions are, inevitably, negotiations with regimes of power' (1996: 2).

The significance of this juxtaposition lies in the different notions of subjectivity that each performance model constructs. 'The question of the subject', argues Judith Butler, 'is crucial for politics' (1999: 5). It is logical, then, that a politics of performance should focus on the different ways in which varying notions of performance define subjectivity. As mentioned briefly already, since the work of the symbolic interactionists and in particular the work of Goffman (1990), theatrical models have become an integral paradigm in the study of social relations. Introducing a dramaturgical approach to sociological study, Goffman argues that theatricality is intrinsic to the way people socialise. Donning his or her 'symbolic armour' (66), a person must act a certain social role along an established front (32). He underlines that

> ordinary social intercourse is itself put together as a scene is put together, by the exchange of dramatically inflated actions, counteractions, and terminating replies. Scripts even in the hands of unpractised players can come to life because life itself is a dramatically enacted thing. All the world is not, of course, a stage, but the crucial ways in which it isn't are not easy to specify. [...] A status, a position, a social place is not a material thing to be possessed and then displayed; it is a pattern of appropriate conduct, coherent, embellished, and well articulated. Performed with ease or clumsiness, awareness or not, guile or good faith, it is none the less something that must be realized. (78–81)

Goffman's ideas here are informed by a static approach to performance whereby social actors draw on established scripts (representing social convention) in order to reaffirm a social role and achieve their desired status. The subject, in this instance, is assumed to be a stable, centred category that exists prior to performance.

In contrast, the poststructuralist use of the term refers to a de-stabilised notion of subjectivity, reasoning that the subject cannot pre-exist the performance. For the likes of Butler, subjectivity is a contingent construct that cannot precede the process of performance as it is constituted within the discursive limits of performativity. With reference to gender, she argues: '[t]his perpetual displacement constitutes a fluidity of identities that suggests an openness to resignification and recontextualization; parodic proliferation deprives hege-

monic culture and its critics of the claim to naturalized or essentialist gender identities' (1999: 176). Certainly this processual approach to the construction of identity seems to be echoed in Pavlovsky's processual approach to theatre, his 'pura multiplicidad. Incapturable. Deviniendo siempre. Nunca en el mismo lugar', as cited previously (2001: 151). Most importantly for establishing the political potential of the performative, Butler makes the distinction between performative repetitions that are subversive —that challenge established discourses through parody— and repetitions that 'become domesticated and recirculated as instruments of cultural hegemony' (177). *Paso de dos* undoubtedly draws a fine line between these two performance types. What I put forward here is that the play juxtaposes these two types of performance employing a subversive idea of performance to deconstruct the latter. As the original encounters are reiterated, Ella is able to negotiate her resistance performatively from within this misogynist military ideology. Butler confirms this potential for subversion from within the dominant discourses of gender when she concludes that '[g]ender ought not to be construed as a stable identity or locus of agency from which various acts follow; rather, gender is an identity tenuously constituted in time, instituted in an exterior space through a *stylized repetition of acts*' (179, original emphasis).

For feminist critic Diana Taylor, however, this is clearly not the case, as she suggests that the play represents nothing more than a duplication of the 'fascist aesthetic' on which the discourse of the military dictatorship was based (1997: 4). Horrified at the spectacle she has witnessed, Taylor contends that '[t]his version of feminine surrender confirms the military's political discourse that relocates the masculinist desire for domination onto the feminized population, claiming that "she" desires to be dominated; "she" willingly offers up her subjectivity, even her life, to the superior power' (6). Taylor clearly believes that the manner in which the discourse of *Paso de dos* lapses into a classic gender paradigm undermines the integrity of the play's supposed opposition to the 'forgive and forget' policy propagated by President Carlos Menem's 'Indulto'.[2] Whilst I do not wish to discard Taylor's point of view completely, I will draw attention to a series of other lines of interpretation which confuse Taylor's rather static and uncomplicated rendition of the play; one that expects a simple, ethically unassailable overturning of the misogynistic paradigm which framed the military discourse.

On one level, there is certainly a basis for interpreting *Paso de dos* in

[2] The 'Indulto' was a law granting impunity to those members of the military junta who had previously been convicted of human rights violations. The other law of impunity granted under President Menem was the 'Ley de Obediencia Debida', which exculpated any soldier who had been acting under orders when committing such crimes. The passing of the 'Indulto' was imminent at the time of the play's release and it was inevitably assumed by spectators, given Pavlovsky's reputation, that *Paso de dos* would be a direct condemnation of this law.

terms of gendered stereotypes, not only in naming the otherwise anonymous
characters according to their gender, but particularly in the words of Él, who
remembers his relationship with Ella in terms of invasion and possession.

> ÉL: Me obsesionaba la idea de poseerte ... adueñarme de vos como un
> trofeo ... Apoderarme de golpe, de improviso como cuando un animal caza
> su presa ... invadirte así ... así. (Pavlovsky 1997b: 107)

Taylor clearly considers the issue of gender to undermine the play's own poli-
tics of denouncing repression, accusing Pavlovsky of achieving no more than
the 'continuity of a misogynist version of Argentine nationhood' (1997: 27).
Yet Taylor's interpretation relies on a fixed dramaturgical model of theatre
within which the fascist ideology is pre-scripted and simply brought to life
through the performance of their encounters. This model, I would argue,
serves only to define Él's behaviour, most evident in the opening monologue
of the play as he mechanically premeditates each gesture like a machine: '[m]
irando al frente. Tal vez de perfil. Ahora me miro la mano. Giro la cabeza
hacia la derecha, ahora hacia la izquierda, puedo mirar otra vez al frente'
(Pavlovsky 1997b: 103). His apparent anxiety to fill every second with some
kind of planned gesture points to an empty sense of being that he feels must
be filled, albeit with meaningless actions.

The play never really attempts to hide this gendered structure in the mili-
tary ideology. Director of the play, Laura Yusem, makes reference to the title
Paso de dos, derived from the dance '*pas de deux*', as 'una metáfora de la
relación sexual donde la mujer adquiere un rol pasivo ante la fuerza física
del hombre' (in Pavlovsky 2001: 135). It was on the basis of this metaphor
that she conceived the *mise-en-scène*, rather drawing attention to the gendered
nature of the military discourse. When Yusem staged the play in 1990, she
divided the character of Ella between the body and the voice. The naked body
of Ella remained on stage in the present, whimpering in the hands of Él, whilst
the voice was positioned anonymously among the audience, retrospectively
describing the intense encounters the couple had experienced and appar-
ently enjoyed (Taylor 1997: 7). Yusem modified the original dramatic text by
creating a disjunction in the verbal confrontation between Él and Ella. It must
be noted here that this disparity between the dramatic text and the performance
text renders interpretation of the play even more problematic. The splitting
of body and voice adds yet another source of ambiguity, whereupon the text
functions on two conflicting levels and the spectator is left in dilemma. Is he
or she to read the play through the body or the voice? As the voice was posi-
tioned among the audience, echoing their perspective on the stage, the audience
was perhaps encouraged to echo the voice of resistance, rather than accept the
shocking reality of Ella's submission on stage. Yet Pavlovsky's style of theatre
clearly privileges corporeal gesture over words, surely giving precedence to the

action the spectator would have seen on the stage rather than the anonymous commentary that accompanies it. Once again, the aesthetics of ambiguity make it almost impossible to make a single reading of the play and the potential for transformation between text and performance is reinforced.

If *Paso de dos* seems to reiterate the gender paradigm on which the military discourse was structured, it is because Pavlovsky highlights the continued existence of the gender dichotomy in post-dictatorship society, at risk of being reiterated once again in the impending 'Indulto'. The play makes mention of the repressors still freely walking the streets of Buenos Aires while continuing to conceive their collaboration in the dictatorship in terms of heroism. This is evident in Él's desire to be named as repressor, something that Ella denies him by refusing to break her silence:

> ÉL: ahora no te entiendo podés nombrarme a gritos y otra vez preferís callar y no hablar
> confesá hija de puta gritá quién soy quién fui gritá lo nuestro no me niegues más porque yo existí. Fui. [...]
>
> ELLA: [...] Sé que así te sentirías mejor, orgulloso de que todos sepan que me tocaste
> querés ser héroe como todos los demás orgullosos otra vez de lo que hicieron orgullosos de andar sueltos desafiando y acechando siempre [...]
> ahora el tiempo es mío.
> No voy a hablar.
> No te voy a hacer HEROE nunca
> vas a seguir esperando encerrado en mi silencio
> No te voy a nombrar ... (1997b: 119–20)

And so the play ends with Él prisoner in Ella's silence, in Yusem's version prisoner forever as Ella passes away at the end of the play to become another haunting symbol of the disappeared (although this is never confirmed in the dramatic text).

In her criticism of the play, Taylor homes in on Ella's decision to remain silent and deny Él any recognition of his role in their past encounters. She equates Ella's silence quite simply with submission. Incensed by Ella's decision to remain silent and refuse Él's plea for recognition of their relationship, Taylor concludes that the political conviction of *Paso de dos* collapses, as Ella seems to collaborate (1997b: 1–11). 'No voy a hablar', threatens Ella, '[n]o te voy a hacer HEROE nunca vas a seguir esperando encerrado en mi silencio': these words hardly seem passive or defensive. Instead they are expressed as a conscious act of opposition to his wish to be named and are representative of an established tradition of silence as a means of resistance. In her silence, Él's existence is left without meaning —in dramatur-

gical terms, without a script— and he struggles to re-script his actions. The opening monologue of the play demonstrates Él's anxiety as he attempts, rather mechanically, to re-script his behaviour in order to produce impressions of spontaneity and thoughtfulness. As Bixler argues, 'Él is not recalling past gestures but rather performing new ones to fill the vacuum of his present existence' (1994: 24).

> ÉL: [...] Pausa. No. Tengo que hacer algo, golpeo el nudillo sobre la rodilla izquierda. Me levanto [...] Trato de que cada gesto tenga sentido, quiero decir que adquiera una dimensión de espontaneidad. No quiero huecos. Miro hacia adelante, hacia atrás bruscamente. [...] Necesito más actos. [...] Todo como si fuera normal. [...] Hago que pienso algo concreto que me preocupa. Hago gestos de descubrir algo. [...] Simulo que olvido una cosa y ahora la recuerdo. (Pavlovsky 1997b: 103–4)

The repetition of verbs such as *simular* and *hacer que* highlight the artifice in his apparently meaningless actions. The monologue also exposes the distance between reality and its representation and the artifice involved in social interaction as Él desperately tries to perform a series of actions that take the place of his voided sense of existence. His script has been removed from him by her refusal to respond.

There is also another, more complex possible explanation for Ella's silence which lies in the schism between violence and words; not only the incapacity of language to capture violence, but the separation of body and voice which takes place during the process of torture (Scarry 1985: 28–33). Scarry argues that in situations of torture

> [o]ne cannot betray or be false to something that has ceased to exist and, in the most literal way possible, the created world of thought and feeling, all the psychological and mental content that constitutes both one's self and one's world, and that gives rise to and is in turn made possible by language, ceases to exist. (30)

Ella certainly seems to dismiss the value of words as a vehicle of memory, instead urging Él to remember the intensity of their initial encounters with his body:

> ELLA: [...] Tenemos que intentar recordar cada detalle de los acontecimientos con la misma intensidad original [...]
> El problema de los conceptos es el olvido de las intensidades el olvido de la experiencia de la vida [...]
> Hablamos de cosas, de palabras que aluden a otras palabras
> tenemos que volver a las intensidades
> volver a recordar todo segundo a segundo con nuestros cuerpos. (111)

In her search to draw out a clear and perhaps overly idealistic political discourse in the play, Taylor also fails to consider the effect of torture on the body and on the mind's ability to express itself in language. Again, Scarry sheds light on the schism between violence and words in her appraisal of torture:

> [i]t is the intense pain that destroys a person's self and world, a destruction experienced spatially as either the contraction of the universe down to the immediate vicinity of the body or as the body swelling to fill the entire universe. Intense pain is also language-destroying: as the content of one's world disintegrates; as the self disintegrates; so that which would express and project the self is robbed of its source and its subject. (1985: 35)

I would argue that where the play does undermine its own politics is in the use of a classic psychoanalytic exploration of Él's childhood and an attempt to rationalise his behaviour as he recalls an incident with his father that obviously left him scarred for life. The pathological exploration into the mind of the torturer is another defining characteristic of Pavlovsky's theatre since the dictatorship. He also plays a cameo role in *El exilio de Gardel* as a collaborating member of the regime. *Potestad* (1985) is another example: a play written and performed from the point of view of a doctor who signed death certificates during the dictatorship and who has appropriated a child, Adriana, from one of the murdered militant couples (see Pavlovsky 1997a). In *Paso de dos* Pavlovsky employs a classic psychoanalytical technique, tracing Él's violent disposition back to the scars of his childhood experiences. In a role reversal Ella encourages a confession from Él as he admits to the incident which made him a coward in his father's eyes. Él recalls his father encouraging him to retaliate against a gang of bullies both older and larger than him: '[l]o tenés que pelear, andá pelearlo andá no seas cagón', he insists. He remembers how he could not pluck up the courage to stand up to his adversaries, much to his father's disappointment:

> ÉL: [… r]ecuerdo sus ojos. Su expresión denodada,
> su frustración infinita. Su hijo era cobarde…
> Aún después de muchos años siempre tuve la sensación de que papá nunca
> me perdonó esa achicada. (1997b: 110)

The term 'a*chica*da' captures perfectly the notions of gender that are inscribed into language and the male conception of power and weakness. The fact that Ella forces a confession from Él regarding his painful childhood certainly initiates a subversion of the torturer (interrogator)/victim (confessor) dichotomy. But at the same time, when delving into the pathos of the torturer, Pavlovsky

uncovers a latent instinct towards violence, one that contrasts with and can almost be said to exculpate Él's violent behaviour. In doing this, he naturalises the violent instinct as something intrinsic to humankind and seems to confuse it with the calculated, institutional violence of the dictatorship. This, I would suggest, is the most problematic of Pavlovsky's ambiguities, more so than his treatment of gender, although gender does indeed play a part in psychoana-lytical concerns. As Geoffrey Kantaris is swift to point up in the introduction to his study, with reference to the work of Malcolm Bowie, Freudian and Laca-nian psychoanalytical ideas are fraught with gendered structures that involve a dismissive or subordinating portrayal of the female (1995: 6).

Nevertheless, I would still maintain that *Paso de dos* contributes, albeit in an unorthodox and polemic fashion, to a wave of artistic production in Argentina that has attempted to revise the binary between good and evil, which had there-unto dominated representations of the dictatorship. The publication of *Nunca más* was arguably the defining narrative in creating this polarisation between military perpetrators of violence on the one side and society as the innocent victim on the other. Since then, such a Manichean opposition has been revised in order to fully appreciate how the 'Proceso' could have taken place. Hugo Vezzetti outlines the revisionist approach to this good/evil binary:

> Ese episodio de barbarización política y degradación del Estado no hubiera sido posible sin el compromiso de muchos. La trama de relaciones, compli-cidades, oportunismos, no puede estar ausente en una exploración de la memoria en la medida en que, precisamente, constituye el punto ciego de una recuperación que vuelva sobre las responsabilidades de la sociedad. Se trata entonces de mirar el rostro visible de la acción dictatorial a la luz de una trama menos visible de condiciones que la sostenían. (In María Teresa Gramuglio 2000: 14)

It is the ambiguity and multiplicity of the aesthetic in *Paso de dos* that achieves this kind of revisionism, blurring the facile dichotomies of collaboration and resistance on which many representations of the dictatorship are based. Fern-ando Reati (1989) reinforces this imperative when he describes the major concern within Argentine society after the dictatorship as being to find a non-Manichean, non-authoritarian elucidation of society. He contends that '[i]t does not suffice to blame the Other without recognizing traits of the Other in the Self' (34). This is the theme par excellence of Pavlovsky's 'teatro de la memoria', which refuses binary oppositions in favour of a more nuanced portrayal of society, for it is these traits of society's violent other —of what Pavlovsky calls 'Masseritas'[3] (2006a: n.p.)— that explain the proliferation of micro-political

[3] Admiral Emilio Eduardo Massera was Commander-in-Chief of the Argentine Navy and part of the military junta that ousted President Isabel Martínez de Perón in the 1976 coup.

spaces of cruelty throughout society. If the spectator is shocked, as indeed Taylor was, by what he or she has seen, this can be explained by a specific strategy devised to shake the spectator out of the comfortable and complete subversion of gender dichotomies that governed the military discourse, a kind of comfort that would signify a cathartic closure on the issues of dictatorship despite their continued pertinence. It is this kind of closure that Pavlovsky is consistently trying to upset in his theatre.

In *Paso de dos*, Pavlovsky manipulates different theatrical and performative models in order to explore not only the theatricality inherent in processes of torture, but the ways in which theatre can deconstruct such processes, complicating accepted notions of collaboration/resistance and perpetrator/victim. Far from initiating the collapse of this frontier, Pavlovsky tests the limits of theatre and through an aesthetic of 'cruelty' pushes theatre beyond words, beyond representation in order to capture the complexities of the liminal experience of torture. The boundary between aesthetic performance and social performance is transgressed for political purposes, but ultimately restored, and theatre avoids losing its social function and being subsumed into social processes and the ideology that scripts them. The re-functioning of theatre in *Paso de dos* is undoubtedly located in a politics of performance. By drawing on the theatre of cruelty, Pavlovsky pushes theatre into the area of pure performance, a performance that takes place in the here and now, which cannot be repeated and which necessarily means that Pavlovsky refuses to constitute Él and Ella in terms of stable subjects.

Paso de dos certainly tests the deconstructive potential of performance, whilst confirming the interdisciplinary scope of performance as a concept which transcends the boundaries between art, politics and human interaction. But to what extent does the use of a dynamic performativity, which focuses on the potential for transformation in the here and now of the performance, really only serve to ensure the constant erasure of the past, thus perpetuating the official politics of forgetting?

'Theatre of cruelty', Performance of Exile: Fernando Solanas' *El exilio de Gardel*

Solanas' film *El exilio de Gardel*, released in 1985 during the early years of Argentina's return to democracy, also structures its political message around the juxtaposition of different performance types; this time in the hybridisation of theatrical and cinematic conventions. This section will thus address the aesthetic and political strategies behind Solanas' appropriation of theatrical models in the film.

Having argued so rigorously for the revolutionary potential of cinema, 'the most valuable tool of communication of our times', alongside Octavio Getino in both *La hora de los hornos* and his cinematic manifesto 'Towards a Third Cinema' in 1968 (Getino and Solanas 1997: 33), it seems strange that Solanas

should turn to theatre as a tool of political activism within the diegesis of *El exilio de Gardel*. However, the fusion of theatre and cinema in *El exilio de Gardel* invites consideration of the differing roles played by both theatre and film in opposition to dictatorship. In the film, theatre is employed as a signifier of political opposition, undoubtedly citing the period of dictatorship, during which theatre proved to be a much more successful vehicle of opposition than cinema, by virtue of its less public quality. The most famous example of this is, of course, the 'Teatro Abierto' movement which between 1980 and 1985 put on a series of plays with the direct political objective of opposing the dictatorship.[4] Paradoxically, cinema's mass appeal, facilitated by film's potential as a medium and industry for widespread distribution —'*a national event for the masses*' (Getino and Solanas 1997: 53, their emphasis)— proved to be the source of its relative weakness against the censors.

However, beyond a straightforward reference to theatre's activism in Buenos Aires during the dictatorship, I will also argue that cinema's appro-priation of theatrical models in this case points to deeper structural concerns about how best to capture the complex realities of exile. What will be exam-ined is the way in which film borrows from theatre in relation to the issue of presence. Presence, or the spatial continuity and temporal simultaneity of actors, spectacle and audience, is often cited as the defining difference between cinema and theatre. Themes of presence and absence are of course also fundamental to the experience of exile and the disappearance of loved ones as a result of the 'Proceso'. The subsequent analysis will focus on the way in which Solanas appeals to theatrical presence within his film as a tool of resistance.

Set in Paris in the winter of 1979/1980 when Argentina was still in the grasp of this violent dictatorship, the film recounts the struggles of a group of exiled Argentine artists as they attempt to find both financial and moral support to stage their production named 'la Tanguedia'. The Tanguedia is composed of a generic hybrid of dance (tango), *comedia* and *tragedia* which rejects theatrical conventions of textually scripted dialogue in favour of extreme corporeal expression, reminiscent of Artaud's 'theatre of cruelty' (1993: 68–78). Outside the boundaries of this performance the group's quest to stage their Tanguedia is also constructed as an overtly theatrical perform-ance, as María (daughter of the Tanguedia's protagonist) and a group of friends perform their experience of exile in a hybrid four-act musical/mime around the streets of Paris. The use of opera and mime as a means of de-familiarising the performers' actions and words, accompanied by a series of titles that guide the spectator thematically through the film, creates a distancing effect

4 Whilst it does not fall within the scope of my analysis here, Jean Graham-Jones under-takes an in-depth study of the Teatro Abierto movement in her work *Exorcising History: Argen-tine Theater under Dictatorship* (2000).

that points clearly to the influence of Bertold Brecht's 'epic' theatre (see Willet 2001: 37 and 91–9).[5] As performance is layered upon performance and the semblance of conventional narrative realism is disrupted, the film sandwiches the reality of exile in a liminal space between two distinctly theatrical performances: the Tanguedia and the film-structured-as-theatre.

What will be explored below is the way in which a series of anti-realist devices, largely drawn from the Brechtian and Artaudian branches of the avant-garde, can be seen to offer a more intricate portrayal of the following realities of exile: tensions between a collapsed sense of national identity and the construction of new extra-national identities; issues of cultural exile, marginality and belonging; guilt at having abandoned the home country; and in the case of politically induced exile, forging opposition to the incumbent regime from abroad. As previously explored in relation to Pavlovsky's play, the interplay between aesthetic performance and social performance is crucial to my analysis as it forms the axis of this film. It is via a strongly reflexive level to the filmic discourse that Solanas discloses the way in which the theatrical performances structuring *El exilio de Gardel* draw out the inherent performativity of exile, not only giving a problematic inflection to how the reality of exile is to be represented, but also directly intervening in the processes of re-socialisation and identity reconstruction implicit in the experience of exile.

Once again, the influence of Artaud's 'theatre of cruelty' is of central importance in initiating a rapprochement between cinema (albeit circuitously via theatre) and life, by asserting pure theatrical presence. Artaud is cited in the film via the director Peter Brook, often considered to be the director who has come closest to truly putting Artaudian poetics onto the stage (Sontag 1992: 374) and who is mentioned briefly in the film itself as having worked with the Tanguedia's initial director, Ángel. The writings of both Brook and Artaud, to which I will return shortly, help explain the progression from conventional forms of theatre to more contemporary concepts of performance. In his essay 'The Theater of Cruelty and the Closure of Representation', Jacques Derrida (2001: 292–316) paves the way for the postmodern/poststructuralist theorisation of performance by setting up the theatre of cruelty as a bridge between theatre and performance: highlighting dismissal of the dramatic text in favour

⁵ Brecht discusses the use of titles in terms of theatrical '[f]ootnotes', which he argues, alongside 'the habit of turning back in order to check a point, need to be introduced into playwriting too' (in Willet 2001: 44). Brecht makes a similar point regarding the use of screens: 'the use of screens imposes and facilitates a new style of acting. This style is the *epic style*. As he reads the projections on the screen the spectator adopts an attitude of smoking-and-watching. Such an attitude on his part at once compels a better and clearer performance as it is hopeless to try to "carry away" any man who is smoking and accordingly pretty well occupied with himself' (44).

of a type of performance that gives precedence to pure corporeal presence. He states: '[The theatre of cruelty] announces the limit of representation. The theater of cruelty is not a *representation*. It is life itself, in the extent to which life is unrepresentable. Life is the nonrepresentable origin of representation. I have therefore said "cruelty" as I might have said "life"' (294).

A collapse in the frontier between performance and life is assured right from the opening sequence as we see a dance performance, which we would normally expect to see in a designated performance space, being performed on the streets. A couple is shown dancing a tango on the *Pont des Arts* in Paris. The same couple is then filmed walking along the banks of the river Seine to the rhythm of the same tango. The man carries a briefcase in his hand, suggesting that he may be on his way to work. Yet the couple stops and begins to dance, giving the impression that performing tango is part of their everyday routine. The music to which the couple dances is replicated and amplified in an extradiegetic sound track, which is overlaid flawlessly onto the sequence in perfect accord with the characters' movements, suggesting the harmonious coming together of 'aesthetic' theatre and the reality, or 'social drama', of everyday life as an exile in Paris (Schechner 2003: 192–3).

The sequence then cuts to the film's second layer of performance, which frames the group's experiences of exile: the film-structured-as-theatre. In this scene, we see María and her friends coming out onto a rooftop plateau. The fact that the camera seems to look secretly on from inside the building, its gaze disrupted by the window frame, serves to distance/alienate the film spectator from the performance. The sequence is then disrupted by obvious cinematic intervention as it halts in a freeze-frame; the characters disappear and reappear in a different position ready to start their show. The girls sing a semi-operatic introduction to the film and the story they are going to tell about 'los tangos del exilio de Gardel'. This layer of performance frames the initial performance and a rather less fluid boundary between theatre and life is restored. In a contrasting style of theatre, reminiscent this time of Brechtian alienation rather than Artaudian cruelty, the audience is now positioned at a critical distance from the performance. The performance in this second layer of the narrative is de-naturalised, and so, obviously staged in a way that lays bare the seam between theatre and film.

Deliberate discussion of the Tanguedia's philosophy throughout *El exilio de Gardel* establishes the engagement between avant-garde aesthetic strategies and the politics of exile. The most important of these moments is when Pierre, the new director of the Tanguedia, is presented with the dramatic text. To his amazement, he is presented with a briefcase somewhat randomly stuffed full of small pieces of paper, each one containing a snippet of the performance's aesthetic philosophy; to which he replies: 'c'est ça la pièce?' (is that really the play?) as if expecting a single unified dramatic text. Much of what is written or sketched on these pieces of paper directly engages with

the Brechtian idea of textual 'montage', according to which 'one can as it were take a pair of scissors and cut it [an epic work] into individual pieces, which remain fully capable of life' (Brecht, in Willet 2001: 70). The idea that the 'Tanguedia' should fight against imitation, 'tirar por la ventana las reglas estéticas, mezclar los géneros, romper las fórmulas' reflects the 'epic' theatre's philosophy that mimetic Aristotelian poetic formulae will not serve to incite 'risk', 'resistance' or any sense of political activism in the spectator, all of which are fundamental objectives of the Tanguedia's aesthetics.

The idea that political engagement is subject to breaching the limits of convention is a staple argument in theories of both political theatre and film-making, an idea already introduced in relation to *Paso de dos*.[6] In *The Empty Space* (1990), Peter Brook advocates moving beyond what he calls 'Deadly Theatre'. 'Deadly Theatre', he says, is a theatre trapped in the 'repetition' of 'old formulae', a style of theatre which makes no 'challenge' to convention (44). In what could be characterised as the initial steps towards defining what we now know as performance or the Happening,[7] Brook encourages a move towards what he defines as the 'Holy Theatre' —alternatively 'The Theatre of the Invisible-Made-Visible' (47)— which he is quick to associate with Artaudian methods of cruelty (60). Furthermore, the idea that a certain style of theatre can render the invisible visible again is an obvious concern to those in exile, negotiating their own agency as citizens in their adopted country, as well as finding a space in which their disappeared loved ones can be at least symbolically resurrected.

The bond between aesthetic form and the politicisation of narratives is clearly outlined by Solanas. He and Getino contend: '[t]he possibility of discovering and inventing film forms and structures that serve a more profound vision of our reality resides in the ability to place oneself on the outside limits of the familiar' (1997: 48–9). It is important, therefore, to differentiate here between a kind of performance that represents the political thematically, yet deals with it in an almost 'accidental' way, and a kind of performance that engages politically through its form as well as its content (Holderness 1992: 1). The aesthetic strategy of the Tanguedia is based on the latter, as it refuses to conform to theatrical conventions which condition the

[6] For a more detailed account of these, see any of the following: Getino and Solanas (1997), Jean-Luc Comolli and Jean Narboni (1992), Artaud (1993), Brecht in Willet, ed. (2001).
[7] Peter Brook states that '[a] Happening is a powerful invention, it destroys at one blow many deadly forms, like the dreariness of theatre buildings, and the charmless trappings of curtain, usherette, cloakroom, programme, bar. A Happening can be anywhere, any time, of any duration: nothing is required, nothing is taboo. A Happening may be spontaneous, it may be formal, it may be anarchistic, it can generate intoxicating energy' (1990: 61).

spectator's expectations. The 'tanguedia' tests not only the limits of theatre, but also the very limits of representation.

Defined by its creator as a tool of opposition and resistance, the Tanguedia and exile are both presented on these snippets of paper as a conscious political decision. 'Tomemos la decisión. La decisión es el exilio,' is just one of the philosophies of the 'Tanguedia'. Its aim is made quite clear: 'racconte[r] ce qui se passe [...] à Buenos Aires' (to recount what is going on in Buenos Aires). It is through performance that the group will reveal their own reality, metaphorically traversing the geographical boundaries which separate them from Buenos Aires through a performance space which they in turn try to insert into the new cultural context in which they find themselves, by staging the play for a local French audience.

It is important at this stage to reiterate the interdisciplinary scope of performance as a concept. Johannes Birringer's work entitled *Performance on the Edge* (2000) looks specifically at the role performance plays in negotiating geographical, socio-cultural and political boundaries: 'contest[ing] borderlines of inclusion and exclusion' (4); structures of 'belonging'; 'demarcations of difference' (8). Echoing the assumption that performativity is intrinsic to processes of socialisation, he argues that performance encapsulates

> the repetitions and rehearsals through which we organize time and being, our bodies, genders, fantasies, experiences, and our representations of the world and our location in it. To speak of 'location' in reference to politics, returns us to the dilemma of borders, to their paradoxical constructions of sites of difference, contact, inclusion, exclusion, crossing and transmission. (9)

He goes on to define performance as a trans-disciplinary vehicle for initiating processes of negotiation across such borders, for effecting 'cultural strategies of *squatting*' (10, original emphasis). Such 'strategies of *squatting*' —of occupying an unauthorised or uninhabited space between one culture/ society that has rejected you and another that does not fully accept you— are of course played out in the performances of the Tanguedia. The political, cultural and social border-crossings associated with the experience of exile are echoed in the generic border-crossings which take place in *El exilio de Gardel*.

Writer Tomás Eloy Martínez underpins this dialogue between performance and exile with a fitting description of his own exile as a 'drama' (1988: 192). He comments on the way in which the experience of exile inevitably reconfigures not only the concepts of reality and belonging, but also the ways in which they are best represented. He recalls how reality and representation coalesced: 'los argentinos terminamos [...] por hacer de la representación nuestro estilo de vida, por fingir una realidad que no era la Realidad [... y] representar a una patria que no teníamos, que nos era negada' (187). What

ensued, he recalls, was a sense of inexistence, 'suspendido de la nada: sin espacio, en ninguna parte, inexistiendo' (192). In the case of *El exilio de Gardel*, performance is used to fill the void left by the sense of cultural *desarraigo* (literally 'uprooted*ness*') experienced by the group. The use of Artaudian theatrics enables the group to collapse the boundary between reality and representation, by stretching beyond the limits of representation and finding a sense of agency/existence in the here and now —the presence and the 'presentness' (Auslander 1997: 51)— of the performance. It is worth citing Derrida at some length in order to appreciate the complex ways in which the theatre of cruelty collapses representation.

> The general structure in which each agency is linked to all others by repre-
> sentation, in which the irrepresentability of the living present is dissim-
> ulated or dissolved, suppressed or deported within the infinite chain of
> representations —this structure has never been modified. [...] The stage,
> certainly, *will no longer represent*, since it will not operate as an addition,
> as the sensory illustration of a text already written, thought, or lived outside
> the stage, which the stage would then only repeat but whose fabric it would
> constitute. The stage will no longer operate as the repetition of a *present*,
> will no longer re-present a present that would exist elsewhere and prior to
> it. (2001: 297–9, original emphasis)

The theatre of cruelty 'is life itself' (294) and it is corporeal gestures and expression that are crucial in divesting theatre of its status as a representation —'of [the] primary logos which does not belong to the theatrical site and governs it from a distance' (296).

Derrida's reading of Artaud's 'theatre of cruelty' is undoubtedly a precursor to the postmodern concept of performance, a concept which presents itself as the antithesis of theatricality (Auslander 1997: 55). Performance, Auslander underlines, rejects mimesis, evades 'illusion' and repudiates 'representation' —all inherent traits of theatricality— in its search for a perpetual present, without repetition, without a past and without a future (55). Auslander is, however, careful not to confuse the term 'theatricality' with the term 'theatre', which, he argues, has a much broader scope, citing both Artaud and Brecht as examples of anti-theatrical theatre (51). One of the features distinguishing theatricality from pure performance is performance art's dismissal of the dramatic text and focus on corporeal expression.

The body is a crucial vehicle of expression in *El exilio de Gardel*. Not only is it emblematic of an ongoing discourse in the film on the political value of experimental aesthetics, but it is vital in portraying the physically damaging effects of exile. Devoid of any kind of verbal communication, the 'Tanguedia' embodies this spectacle of exile and non-existence through an aesthetic remi-
niscent of the 'theatre of cruelty'. Artaudian 'gesture and expressive meta-

physics' (1993: 69) are shown to be fundamental to representing exile. In the Tanguedia, tango provides the 'rhythm' for a series of sequences that portray kidnappings and sad farewells into exile through 'mime' and 'gesture' (Artaud 1993: 28). The exaggerated, sometimes mechanical and therefore de-familiarised movement suggests that the Tanguedia's 'spatial language' has the direct political objective of 'transgress[ing] the ordinary limits of art and words', as the 'theatre of cruelty' prescribes (71).

Without doubt, it is the body, rather than words, that governs expression in performance art. Moreover, returning to Eloy Martínez's account of his exile, he contends that the body bears testimony to the experience of exile: 'sería grave olvidar que nos han inscripto tal cicatriz en el cuerpo: suponer que seguimos siendo los mismos de hace diez años y contar la historia desde afuera, como si estuviéramos mellados, gastados, desgarrados por esa marca' (192). The struggle to stage the 'Tanguedia' shows these scars quite literally in the making. As Ángel, director of the 'Tanguedia', becomes more and more frustrated that after three years it is still uncertain as to whether the performance will be staged, he leaves the rehearsal in a rage. Reality and representation coalesce in a surreal scene, governed by a distinct sense of pathetic fallacy, in which bolts of lightning illuminate the theatre from within and Ángel's arm literally tears itself off as he cries about failure and inexistence. Metaphysical distress reaches his 'mind through the body' (Artaud 1993: 77) in just one of many moments in the film in which an indecipherable boundary between reality and performance is transmitted through the body. This motif of physical distress recurs: musician Juan Dos's body literally deflates with disappointment when the Tanguedia appears once again to have been rejected, and the second director, Pierre, explodes in a rage as metallic robot-like insides spill out of his chest. His unwillingness to transcend the limits of Western theatrical conventions by not having an ending to the spectacle —ending read in conventional terms as closure or resolution— is manifested physically. It is suggested that his body is programmed to theatrical convention like a robot. The Artaudian idea of the body as a vehicle for recording and asserting existence —as the only tangible ground for a discourse of truth— is confirmed.

The most controversial rupture in theatrical limits, the most unbearable, as we have seen for Pierre, is undoubtedly the fact that the 'Tanguedia' does not have an ending. Still in exile and with no prospects of return in the foreseeable future, the performers of the 'Tanguedia' can envisage neither outcome nor solution to their situation. It would, therefore, be ridiculous to represent a conclusion, as in political terms this would signify cathartic closure of the issues raised in the performance, rather than inciting an urgent need for activism against the crimes committed against humanity. The importance of the Tanguedia as part of the group's activism is reinforced by the 'Comité de Solidarité' which they attend. The Comité, we are informed, meets in a

theatre in the outskirts of Paris. This voice-over remark affirms, although in a less sophisticated manner, the importance of theatrical spaces in defining the group's activism, as well as their position on the edge of society. The Comité is clearly fighting a general trend of de-politicisation and the debate which takes place during one of its meetings questions why old forms of protest are no longer capable of inciting interest in the cause. Society is accused of becoming politically indifferent. What is proposed, therefore, is that new forms of protest must be invented. It is theatre, of course, that takes up this role. This is one of the crucial ways in which Artaudian and Brechtian theatre coincide: in the desire to initiate a rapprochement between art and life. In this sense there exists, therefore, a synergy between the different levels and types of performance in the film.

The cool reception given to the Tanguedia by the French artistic community is not, however, explained in terms of political indifference, but rather cultural ignorance. It is rejected on the grounds that it is 'un peu incompréhensible' (somewhat incomprehensible) because 'il n'y a pas de fin' (there's no ending), and therefore, 'il faut en trouver un' (one must be found). As the audience is unable to draw on established codes of performance, or indeed common cultural signifiers, it is unable to make sense of the Tanguedia and is therefore uninterested in it. Contrary to the Brechtian idea that breaking down conventional narrative structures should encourage the spectator to think at a rational distance —the so called '*Verfremdungs*' or 'alienation' effect (Brecht, in Willet 2001: 37)— the nature of the French reaction to the play indicates nothing more than pure bewilderment. This reaction leads to several assumptions. First, that the audience is indeed alienated, but beyond the bounds of any comprehension of the issues involved, something that suggests that Brecht takes an overly idealistic view of the spectator's capacity to critically engage with a play from an alienated distance. Second, it suggests that cultural boundaries are of utmost importance in appreciating the show. With solid roots in the tradition of tango and Carlos Gardel's status as a national icon, the film emphasises the fact that the 'Tanguedia' depends on specifically Argentine cultural conventions. In which case, a foreign audience would be left without any conscience of these culture-specific conventions having been placed in question. This would seem to confirm Schechner's argument that 'different cultures mark the boundaries [of performance] differently' (2003: 70). Likewise, it would confirm Reati's reading of post-dictatorship cinema in Argentina: that 'underneath the universality of certain themes and obsessions, the particular cultural codes employed by art in a given place and time will constitute a specific and unique way of dealing with reality' (1989: 25). Such boundaries and specificities form a figurative barrier between performers and spectators of the Tanguedia, reinforcing, rather than breaking down, the cultural boundaries which must be transgressed if the exiled artists are to be allowed to integrate.

Yet, in the light of what has been discussed above, the Tanguedia is clearly inspired by aesthetics developed within the European avant-garde, for which Paris provided an important centre. It seems hardly credible that the play be branded 'un peu trop argentin' (a bit too Argentine). Birringer is right in reminding us that Solanas 'was mixing Third World politics with First World models of cinematic or theatrical representation', of which, he claims, Solanas was 'aware' (2000: 169). He must surely then have been aware of the potential impact these rather uncomfortable bedfellows would have on the integrity of his discourse against neo-colonialism.[8]

Likewise, the specificity of the cultural codes of the Tanguedia can also be questioned. The spectacle may hinge on the intrinsically Argentine dance of tango, yet at the same time the group is performing in a city which also has a strong tradition of tango and in which it is possible to attend a *Milonga* on most nights of the week. The final director of the spectacle, though he collapses under the pressure for an ending, is French. Furthermore, with a total absence of dialogue in the spectacle, the French/Spanish language barrier can hardly be used as an excuse for cultural specificity. Solanas seems to be mistaken in his perception of cultural specificity, and the discourse of cultural aliena-tion woven into the film's narrative hardly stands up to scrutiny. A hybrid of mime, music, tango, 'comedia' and 'tragedia', the Tanguedia certainly does resist conventional critical labels. Certain motifs of exile are, however, blindingly obvious: the almost constant presence of mutilated mannequins serves as an evident symbol of the tortured and the disappeared, the use of suitcases clearly evokes departure into exile and, likewise, the Gestapo-like figures pursuing a writer need little deciphering. It is hard to imagine a savvy Parisian audience not picking up on these referents.

That having been said, if the film spectator is in no doubt over the political message of the Tanguedia, it is because Solanas does not leave this to chance. The way he frames performance of the Tanguedia leaves no room for ambi-guities. The Gestapo-like figures pursuing the writer appear straight after a title stating 'Juan Uno en Buenos Aires', making sure that this scene from the Tanguedia is interpreted as the pursuit of its creator, reinforcing the dangers of producing subversive theatre in Buenos Aires and justifying the exile of the others.[9] This undoubtedly undermines the Artaudian 'end of interpreta-

8 A recurring discourse on the films of Solanas clearly maps out a link between Argentina (and indeed Latin America as a whole) at the mercy of colonialism and its subsequent subjec-tion to neo-colonialism. Both the dictatorship and neoliberalism are core elements of the latter. Key examples of this can be seen in Solanas' original cinematic manifestation, *La hora de los hornos* (1968), and later on in *El viaje* (1996), *Memoria del saqueo* (2004) and its complement *Argentina latente* (2007).

9 Liliana Heker outlines the debate that arose within the intellectual community between those who chose to stay in Buenos Aires during the dictatorship and those who took the deci-sion to go into exile. This debate is not explicitly addressed in the film, but it is nevertheless

tion' and a performance in which 'no master speech [...] will have permeated and leveled in advance', as prescribed by Artaud (Derrida 2001: 300). Solanas uses the reflexive structure of the film to impose a 'master speech' on the Tanguedia and thus construct a reception for the spectacle. The spectator is not empowered in a Brechtian sense to make his or her own judgement and although the political message may be disguised in the performances of María and her friends, it is no less didactic than the trademark voice-over narration Solanas performs in almost all his other films. Gerardo, the writer exiled following the disappearance of his daughter and granddaughter, also takes on the role of reproducing Solanas' unmistakable rhetoric. Whilst writing, he tells us: '[e]stas notas intentan recordar a San Martín y el exilio de la gran nación inacabada. [...] Los pueblos latinoamericanos han vivido exiliados dentro y fuera de su tierra por la imposición de los proyectos neo-coloniales.' San Martín, the celebrated *Libertador* himself, ended his days in exile in the northern French coastal town of Boulogne-sur-Mer. Solanas' message is crystal clear: these artists' exile is yet another instance in a long history of exile suffered by the nation's heroes.

The way in which Solanas structures his film clearly anticipates the audience's reaction to the Tanguedia in a way that suggests that he himself does not believe that the Tanguedia alone is able to get his message across. The radical performance of the Tanguedia is thus placed within a safer interpretative frame which forces it into a single discourse, rather hampering the explosion of meaning outlined in Artaudian performance. The critical distance that is afforded by the second layer of performance sits uncomfortably alongside the Tanguedia's aesthetic, effectively neutralising the more radical political effect of blurring the boundary between theatre and life. This safety barrier arguably represents an anxiety about the collapse of the aesthetic. Although Solanas flirts with the radically disordering aesthetic of cruelty, he ultimately needs Brecht to win over Artaud.

The Tanguedia's radical aesthetic also has another drawback. An important observation that should be made is that if the aesthetic strategies are mapped onto the experience of exile, the theatre of cruelty not only captures the sense of inertia inherent in exile, but rather paradoxically perpetuates

worth outlining the contentious nature of a person's decision either to stay or to leave Argentina. Heker contends: '[n]o puedo negar que, sólo con cierto malestar, vuelvo hoy al tema del exilio; más precisamente, al tema de los intelectuales ante el exilio. Tantas generalizaciones, malentendidos y acusaciones mutuas trajo en su momento, que replantearlo hoy acarrea el riesgo de encender una rivalidad que tiene muy poco que ver con el debate ideológico y que, si durante la dictadura militar fue insensata, hoy se ha vuelto grotesca. Expresiones como "colaboracionistas", "neofascistas", "cómplices del Proceso", por una parte, o "la patota del exilio" y "la mafia de los que se fueron", por otra, aplicados indiscriminadamente y sin justificación no contribuyeron precisamente a que los intelectuales argentinos se entendieran en una época en que la censura y la distancia ya dificultaban bastante toda comprensión mutua' (1988: 195).

this condition. As pure performance, the Tanguedia leaves the group trapped in a perpetual present, with neither a past nor a future, as the conditions of performance dictate. Instead they are stuck in an endless succession of rehearsals that, it seems, will never reach a conclusion. The Tanguedia's aesthetic represents a veritable catch-22: in moving beyond representation towards a more complex presentation of the reality of exile, the group exacerbates its condition of non-existence.

Solanas' decision to appropriate the ideas of Brecht and Artaud initiates a complex and at times contradictory re-functioning of cinema via theatre; contradictory in that this process of re-functioning seems to depend on two antagonistic theatrical models. Brecht and Artaud are more often than not considered antithetical participants of the avant-garde movement. Whilst Artaud advocated the collapse of the boundary between theatre and life, Brecht upheld the idea of theatre as an institution, arguing only for a need to renovate it in order to redefine its social and political function. They do, however, coincide in their blurring of the distinction between art and politics. Their emphasis on theatre as a creative process, rather than the completed work of art, is also an important political tool in both strategies and a means of avoiding the stagnation of established theatrical forms. By incorporating techniques such as the *Verfremdungseffekt* via Brecht, this film forges an alliance between theatre and cinema which serves to demonstrate and uphold the (social) purpose of art as an institution. Yet via Artaud, the film stages the death of theatre, as theatre in the Tanguedia is pushed beyond the realms of representation into what poststructuralists/postmodernists have defined as pure performance. The Tanguedia suggests that performance is the paradigm through which the political engagement of theatre and cinema should be approached. The function of the filmic apparatus or that of cinema as an institution are, as such, never questioned. Attention is rarely drawn to the apparatus, save through the odd freeze-frame or explicit use of montage editing and a single shot in which the camera shutters close in on the characters of the film, exposing cinema's aesthetic frame. Narrative continuity is severed by theatrical devices, rather than the montage editing which was so fundamental to Solanas' revolutionary 'Third Cinema' of the late 1960s (*La hora de los hornos* relies heavily on montage editing). Instead, he appeals to the aura of theatrical presence, rather than cinema's capacity to mechanically reproduce and disseminate images among the masses (see Benjamin 1970: 219–46). This loss of the aura can be tentatively equated to the loss of identity or the disappearance of a loved one which are experiences intrinsic to exile and dictatorship. Mechanically reproduced presences would simply perpetuate the sense of distance and loss.

Espejismos y realidades/realidades y espejismos: Multiplications of Modernity in Solanas' *La nube* and Pavlovsky's *Rojos globos rojos*

The final section of this chapter examines another alliance between theatre and cinema: Solanas' appropriation of extracts from Pavlovsky's play *Rojos globos rojos* (1994) in his film *La nube* (1998). In *La nube*, Solanas teams up with Pavlovsky, this time in defence of independent cultural production against the ever-expanding and overbearing 'culture industry' (see Adorno 2001). The alliance between cinema and theatre in *La nube* is fundamental to the film's politics of culture, as Solanas sets theatre (and by association cinema) up as a space of resistance to the market-driven culture industry which is dominated by theatre's cultural and cinema's cultural/audiovisual adversary: television. *La nube* maps the crisis of a small independent theatre onto a broader crisis in Argentina's experience of modernity, which is progressively demonstrated in both the film and the play to be nothing more than a depthless *espejismo*: the disappearance of public space, a corrupt justice system and representation of a state that has relinquished any social responsibilities it once had. The film follows the fate of the Teatro Espejo in the Barracas neighbourhood as it tries to combat the falling number of spectators, a desperate lack of funding and the threat of closure under a government plan to redevelop the area. The growth of the culture industry, coupled with diminishing state support for independent cultural production, is just one motif of Argentina's experience of neoliberalism under President Carlos Menem in the 1990s.

Rather than an adaptation, *La nube* constitutes what Pavlovsky terms 'una continuación amplificada' of *Rojos globos rojos* (2001: 200). The play itself represents only a fragment of the film as it is being staged at the independent Teatro Espejo represented in the film. The film nevertheless extrapolates several key themes from the play, all of which contribute to Solanas' bleak, quite literally washed-out image of Buenos Aires engulfed in a permanent rain cloud: the infamous 'nube' which becomes a metaphor for a plethora of evils associated with the effects of neoliberalism and *menemismo*. Like the play, the film shows deference to popular Argentine theatre, as opposed to mass culture and the big shows lining Avenida Corrientes (Buenos Aires' equivalent of Broadway). The film also points to another crisis, this time of a political/ideological nature, at the heart of the Argentine Left. It confronts a crisis in socialism which has resulted from the growing dominance of a conservative neoliberal model and the progressive de-politicisation of society. This trend is by no means exclusive to Argentina. Frank Furedi confirms the link between de-politicisation and neoliberalism when he states that '[t]he erosion of the distinction between left and right and the decline of the contestation of alternatives is frequently attributed to the triumph of 'neoliberalism' (2005: 12).

La nube seems to be structured upon Adorno's opposition between the

commodification of culture (the culture industry) and preservation of the autonomous sphere of high art. Adorno purports that '[t]he culture industry intentionally integrates its consumers from above. To the detriment of both it forces together the spheres of high and low art, separated for thousands of years' (2001: 98). What will be argued here is that *La nube* borrows from theatre in relation to this dichotomy, once again appealing to avant-garde (notably Brechtian) techniques as well as the aura associated with theatrical presence and performance in order to shore up the boundaries of high culture against the ever-encroaching low culture, here epitomised by television and North American-style shopping malls. Solanas attempts to resist commodification by effecting a nostalgic reconstruction of the aura and restoring the high/low culture divide.

Once again, cinema and theatre collaborate in *La nube* through the shared notion of performance. Performance is the main organising principle in the film in representing and deconstructing the way in which society interacts. The way in which cinema ensures its social function in this film, allying itself with theatre, once again depends on the juxtaposition of two different theatrical models: the first is the dramaturgical model of socialisation according to which society is scripted to follow unquestioningly the dominant ideology of neoliberal, capitalist consumerism; the second is the aesthetics of the marginal *teatrito*, influenced heavily by the theatre of the absurd and post-theatrical notions of performance. Thus the marginal theatre and the independent film are set up as spaces of resistance to the market-driven culture industry and its dominant ideology of consumerism.

Pavlovsky's words demonstrate the extent of this cultural crisis, commenting upon the way in which culture extends far beyond the confines of artistic production to affect the manner in which subjectivities are constructed.

> No es sólo cultura la producción de una obra de arte, sino también la producción de subjetividad como maquinaria montada, que intenta hacer creer que la entrega de nuestro patrimonio y de nuestra identidad es el camino necesario y forzoso para la felicidad futura de los argentinos. Cultura de subdesarrollo de los recursos humanos para las dos terceras partes de la población. Cultura es también la obscenidad con que se trata de evitar el juicio de los Yoma,[10] junto al efecto de silencio cómplice que fabrica a su alrededor. Adormecimiento de la ética ... (2001: 157).

If cultural phenomena are intimately linked with the construction of social subjects as Pavlovsky suggests, then it is logical that this film and the play represented within the film, attempt to set themselves up as spaces of expres-

[10] The Yoma family is a powerful family in the Province of La Rioja, infamous for its corruption. Carlos Menem married Sulema Yoma.

sion outside the confines of the culture industry, in which alternative subjec-
tivities can be constructed.

'[T]he entire practice of the culture industry transfers profit motive naked
onto cultural forms,' states Adorno, one of the original critics of the culture
industry, in a phrase that captures the essence of the culture industry so
succinctly (2001: 99). The members of the Teatro Espejo come up against
the rhetoric of the culture industry on several occasions when they visit the
Ministry of Culture in an attempt to protest at plans to demolish the Teatro
Espejo and build a shopping centre in its place. Max and Cholo are shown a
model of the plan to transform the La Boca and Barracas areas of the Capital
Federal. It consists of a very uninspiring, uniform brown sprawl of build-
ings, which conforms to a standard (albeit rather uncomplicated) perception
of globalisation in Argentina as a homogenising force (Dubatti 2005: 10).
The plan is justified by the need to recuperate land that is unproductive. It
is not only time that is money, but also space. Measured in market terms,
the Teatro Espejo no longer has any value. In contrast, the shopping centre
that the government plans to build on this land is clearly a more profitable
enterprise, although the plan itself is dressed up in the democratising rhetoric
of a cultural space for all the people. Cholo retorts, pointing out that culture
should not be measured according to its exchange value: 'si vas a medir las
obras por el público tenés que tirar media historia del arte'. The officials to
whom this argument is directed are never in disagreement with Max and
his supporters, the most common answer from them being a rather resigned
and inert 'tenés razón'. Reason does not, however, seem to enter the equa-
tion, merely profit. Alfonso, the National Theatre Director, and his colleagues
are comfortable in their government positions, a comfort reproduced in the
sumptuous, ornate offices of the Ministry of Culture, reminiscent of colo-
nial architecture. Solanas' trademark shots taken by a camera angled sharply
upwards elongate these institutional buildings, accentuating the gap between
corrupt official institutions and powerless marginal theatres such as the Teatro
Espejo. Those within these daunting structures are content to conform with
the official line, despite their rather feeble argument that they are fighting for
the theatre from within. We gradually see a change in Cholo's attitude as he
becomes resigned to the fact that culture has changed irrevocably and now
constitutes 'lo que es producto y se paga, como los grandes espectáculos',
or 'cultural commodities […] governed […] by the principle of their reali-
zation as value, and not their own specific content and harmonious forma-
tion' (Adorno 2001: 99). In many ways Cholo is right. To save the Teatro
Espejo, Enrique (a writer and friend of the Teatro Espejo) even sells one of
the canvases painted by his wife Margarita. Having vowed he will never sell
her paintings, he ends up trapped in a vicious circle, commodifying one work
of art in order to preserve another. Moreover, Cholo's initial statement that
the value of culture cannot be measured by the number of spectators is ulti-

mately upheld in the film. The only solution to the crisis at the Teatro Espejo is a renewed and more abundant audience, evoked in the final scene of the film when (quite literally) a cloud of spectators enters the theatre.

Several instances in the play parody this idea of commodification. At one point during the play, Cardenal appeals to the audience for donations: 'Si pueden tirarnos por ahí un rosarino, un argentino, un colombiano, lo que venga, un cachito de moneda, algo … para que nosotros podamos recibir ese dinero, posponer la medida, abolir la caída de la cultura y seguir haciendo teatro' (Pavlovsky 1997c: 80). His omission of the dollar is almost certainly deliberate. '[Q]ueremos postergar la medida de la abolición de la cultura' (91), he reaffirms, before defiantly declaring '[a] mí no me van a privatizar la alegría ni la pasión ni las ganas' (100). Cardenal reminds us that the survival of culture (and consequently of his little theatre), is nothing more than a question of funding, as he thanks a member of the audience for the cheque he has donated: 'la gente es mala, dice cualquier cosa … Hubieran dicho que por causas antisemíticas, […] políticas, culturales, por cualquier cosa, hubieran sacado el teatro éste. En cambio, tu cheque anónimo solucionó el problema' (95). Any kind of ideology or political/cultural affiliation, however morally questionable it might be, is demonstrated here to be subordinate to the economic.

The medium par excellence that epitomises the 'culture industry' or what Guy Debord (2004) would term the 'Society of Spectacle' is television. Television is a cultural medium which occupies a private space in the home. In the film it is shown to be implicated in the disappearance of public space. Cholo continues his evaluation of the transformations in culture, suggesting that 'la cultura hoy es la televisión, lo que se puede consumir rápido como una hamburguesa. No es un bife, pero …'. Having trained as an actor with the Teatro Espejo, Cholo is now making a handsome living from his work in television, which at one stage in the film is officially recognised when he receives the award for 'Best Actor' at the annual television awards. As Cholo watches people walking by, their heads hidden under their umbrellas, he claims that when people get home in the evening, they no longer want to think. Adorno's observations on the 'culture industry' resonate in Cholo's sentiments: '[t]he total effect of the culture industry is one of anti-enlightenment', he maintains. '[E]nlightenment,' he continues, 'that is the progressive technical domination of nature, becomes mass deception […]. It impedes the development of autonomous, independent individuals who judge and decide consciously for themselves' (2001: 106). The following extract from the play (also performed in the film) reiterates this:

Era un país curioso, la mayoría de la gente inteligente dependía de un grupo de idiotas. Era asombroso observar cómo este grupo de idiotas supervisaba la suerte de los talentosos. Pero lo más increíble de todo es que los inteli-

gentes para contentar a los idiotas ¿sabés lo que hicieron? [...] Comenzaron a empobrecer sus ideas. [...] Y comprendieron que la única manera de progresar en esa comarca era transformarse poco a poco en idiotas. La idiotización de la comarca llegó lenta e inexorablemente, porque las ideas cada vez más idiotas de los talentosos producían una enorme aceptación por parte de los idiotas que premiaban a los talentosos idiotizados con cargos cada vez más prestigiosos. (Pavlovsky 1997c: 81)

Television's effect on people's behaviour, particularly its role in dumbing down society, is developed as a central theme of the following chapter.

Debord's theory of the 'Society of Spectacle', which was supposed to be coexistent with the modern state, has grown in pertinence with society's passage to the postmodern condition and since the explosion of the mass media. More than a simple proliferation of images, the 'Society of Spectacle' outlines a damning shift in social relations: notably, the degradation of knowledge and critical engagement among citizens and a shift in the fundamental parameters of existence. Intimately linked to Marxist ideas of commodity fetishism and with echoes of Adorno's theory of the 'culture industry', 'the world of commodity' reduces being to having and having to nothing more than the appearance of having (Debord 2004: 19). Debord argues that 'The first stage of the economy's domination of social life brought about an evident degradation of being into having —human fulfilment was no longer equated with what one was, but with what one possessed' (10–11). Reality is replaced by its representation and culture undergoes a progressive homogenisation. Debord states that

> Understood in its totality, the spectacle is both the result and the goal of the dominant mode of production. It is not a mere decoration added to the real world. It is the very heart of this real society's unreality. In all of its particular manifestations —news, propaganda, advertising, entertainment— the spectacle represents the dominant *model* of life. (2004: 8, original emphasis)

What Debord captures in his theory in addition to Adorno's theorisation of the culture industry is the role of performance (spectacle) in processes of cultural commodification.

Both *La nube* and *Rojos globos rojos* provide an accurate reflection of Debord's ideas and can be read as alternative spectacles of Argentina's inconsistent experience of (post)modernity. Underneath the proliferation of images reflecting progress and prosperity, both the film and the play represent the impoverishment of culture. 'La modernidad es vista [...] como una máscara,' affirms Néstor García Canclini, '[u]n simulacro urdido por las elites y los aparatos estatales, sobre todo los que se ocupan del arte y la cultura, pero que por lo mismo los vuelve irrepresentativos e inverosímiles' (2001: 41).

Theatre and cinema fashion themselves as two further images of reality, images projected through a deliberately distorting lens, whereupon the simulacrum —or spectacle— of Argentine modernity is effectively deconstructed by another subversive kind of spectacle. This film and this play serve not only to combat the evils of the 'society of spectacle' or the 'culture industry' but also to distance this play and this film from any involvement therein.

Solanas' portrayal of modernity is framed in a dramaturgical model of performance. The film certainly shows society scripted to the same bleak, monotonous daily routine. In several scenes, cars, people and clocks are moving backwards. The very deliberate, awkward nature of this action which is replicated obediently by everyone in the street draws attention to the way in which society's behaviour is directed by a single master-script. It is as if citizens are no longer masters of their own actions, echoing Adorno's reminder that '[t]he power of the culture industry's ideology is such that conformity has replaced consciousness' (2001: 104). Another example of scripted behaviour is when Max's assistant Cachito wants to get a job. Max prepares him a script, which he then rehearses and recites flawlessly during his interview in a slick performance which gives the perfect impression of professionalism and efficiency; the answer to the interviewer's every need. Cachito indeed gets offered the job, although perhaps not quite the job he was hoping for as it involves dressing up as a sheriff and posing with a dog at the entrance to a shopping centre, a bastion of the culture industry. This is, of course, another blatant metaphor of the impoverishment of Argentina's national culture as it becomes superseded by global (namely North American) mass cultural emblems and spaces. Solanas sets up the Teatro Espejo as an alternative cultural space in which such dramaturgical performances can be deconstructed. This alternative performance takes the form of a series of citations performed from *Rojos globos rojos*.

Rojos globos rojos is a product of what Pavlovsky calls his '[t]eatro del balbuceo' and 'textos "antiposmodernos"' (in Dubatti 1997: 28), both of which establish a significant dialogue with the Theatre of the Absurd but largely resist classification in either aesthetic or thematic terms. The play is structured as a monologue (or the 'balbuceos') of the principal character Cardenal. It portrays the plight of an ageing actor, who despite feeling an immense sense of exhaustion, continues to perform with the same passion every day in his tiny, provincial 'teatro marginal y precario' as a means of resisting the collapse of culture and preserving the Utopian faith in theatre's ability to contest the status quo that was so prominent in the 1960s and 1970s (Pavlovsky 1997c: 77). *Rojos globos rojos* is itself structured as a play-within-a-play and Cardenal seamlessly slips in and out of his role. Once again this serves to place the nebulous boundary between aesthetic performance and social performance in relief, as Pavlovsky styles theatre as a peripheral space in which alternative subjectivities can be constructed

outside the dominant cultural ideology: 'un lugar para hablar de las cosas trágicas, existenciales, desesperantes, como la locura, la droga, la pobreza, la impotencia, la desesperación' (92). Within Cardenal's little theatre, the micro-politics of resistance reign and theatre is re-functioned via the avant-garde and postmodern notions of performance.

Pavlovsky bears a long-standing affiliation with the Theatre of the Absurd, through his admiration for playwrights such as Samuel Beckett, Eugène Ionesco, Harold Pinter and Jean Genet. He describes how seeing Beckett's *En attendant Godot* persuaded him to continue taking to the stage (2001: 23). Indeed, the influence of the Absurd can be seen in Pavlovsky's own theatre. '[I]rreducible ambiguities […], bewilderment, […] anxiety when confronted with the human condition, and […] despair at being unable to find a meaning in existence' are, according to Martin Esslin, all features of *En attendant Godot* (2001: 45), that are also very much present in Pavlovsky's work. Esslin argues of the Theatre of the Absurd, in general, that it 'tends toward a radical devaluation of language, toward a poetry that is to emerge from the concrete and objectified images of the stage itself' (26), a description that could also be applied to Pavlovsky's own 'teatro del balbuceo', which also diminishes the importance of language in search of irrational, pre-linguistic *balbuceos*. It is through this decon-struction of reasoned existence that Pavlovsky sets theatre up as a space in which alternative subjectivities can be conceived outside the boundaries of the familiar, the rational and the linguistic conventions usually employed to mediate experience and identity (Giddens 1991: 23); most significantly perhaps (as will be developed in the following chapter) beyond the domi-nant ideology of consumer capitalism governing society and state policies towards culture.

One particular example from the avant-garde seems particularly relevant to my analysis of *La nube*. In Jean Genet's *Journal du voleur* (1949), a man finds himself trapped in a hall of mirrors, unable to escape either from his own distorted reflection or from the gaze of those who have managed to get through the labyrinth of mirrors and glass and now look on with laughter. At every turn, the man is faced with a different version of the warped spec-tacle of his own entrapment. Esslin cites this in order to exemplify Genet's contribution to the concept of the Absurd, as he describes the protagonist of the *Journal du voleur* as

> confronted with the despair and loneliness of man caught in the hall of mirrors of the human condition, inexorably trapped by an endless progres-sion of images that are merely his own distorted reflection —lies covering lies, fantasies battening upon fantasies, nightmares nourished by night-mares within nightmares. (2001: 226)

In this Theatre of the Absurd, he argues that '[r]eality is an unattainable goal' (222) and 'theatrical performance' ends up being 'more real than the pretended reality' (226).

It is hardly surprising that the mirror trope is important in the game of *espejismos* and *realidades* played out in *La nube*. The modern cityscape in Buenos Aires is turned into a hall of mirrors, a perfect reaffirmation of the society of spectacle and the idea that Argentina's project of modernity is nothing more than a simulacrum. The incessant rain leaves the streets constantly damp, reflecting images of the streets from below, whilst the modern skyscrapers mirror their surroundings rather than reveal any interior substance. There are periodic overhead shots of reams of traffic moving down the *Avenida 9 de Julio* choreographed to a sinister pulsating beat in the soundtrack. One of these shots stands out in its portrayal of the lack of substance in the neoliberal mirage of affluence and modernisation. In this shot, we are shown only the image of cars moving in fast-motion through the streets, as the camera films their reflection on the side of a modern glass-fronted building. The soggy road surface below the cars provides reflections from underneath as the streets of Buenos Aires start, quite literally, to look like a hall of mirrors: a city of spectacle, in line with the ideas of Debord (2004). Beatriz Sarlo describes television as part of a '[c]ultura espejo' (2004: 80). As mentioned previously, it represents a prime medium in disseminating the ideology of neoliberalism and the culture industry. Yet, buried in this hall of mirrors lie two positive reflections of the city: the Teatro Espejo and what Solanas himself terms his '*película-espejo*'. 'El cine es un espejo: ayuda a vernos', he contends (in Claudio España 1997: 5, original emphasis).

Pavlovsky admits that one of his most pressing concerns is that '[e]l fracaso del socialismo real y el auge del proyecto neoliberal conservador —con sus éxitos electoralistas— han tenido efectos que no parecen fáciles de evaluar en la izquierda argentina' (2001: 153–4). The sentiments outlining the de-politicisation of society traverse both the film and the play. He continues:

> Esta era está marcada por la pérdida de la solidaridad y del sentido de ciertas utopías, y por la agudización de la introspección y el narcisismo, el mirar hacia dentro olvidando siempre el afuera. Una época marcada por la muerte de la política militante, desplazada por los grupos de poder económico que manejan *lobbies*. Existe la idea de que para que el mundo funcione un poco mejor hay que excretar un sector de la población fuera de la producción capitalista. Un mundo basado en individualismo, la introspección, el ego-centrismo. (2001: 147)

Both the film and the play represent nostalgia for a time when a Utopian marriage existed between art and politics. Cardenal makes reference to 'la época en que todavía teníamos esperanza' (83) and endeavours to live on in

this spirit. '¡La pasión!', he shouts, '[e]n este teatrito que no para nunca, ni por accidentes, muertes de parientes, lluvias persistentes o amenazas recurrentes, en este teatrito de la vida, el mejor teatro del mundo, el Shangrilá argentino' (85). The 'lluvias persistentes' that fall from the 'nube' in the film show the 'Teatro Espejo' resisting these adverse conditions. The persistent rain can also be read as a citation of Gabriel García Márquez's novel *El Coronel no tiene quién le escriba* (1958), in which never-ending rainfall becomes a metaphor for the Coronel's endless wait to receive his pension. Enrique of course suffers the same fate in *La nube*, unable, even with the support of a legal document stating his entitlement, to collect his pension. Unlike the indomitable Cardenal, however, Max is bitter about the threat to his theatre and is shown to be intransigent towards any suggestion that he or his theatre should renew itself. What will progressively become clear throughout my analysis of theatre and cinema's various borrowings from other sets of conventions is that, in contrast to this, theatre and cinema must constantly revitalise their praxis. In *La nube*, this is attempted in the alliance between theatre and cinema via the shared codes of performance, although one can hardly imagine the character of Max making such concessions.

If there exists a fissure in this alliance between theatre and cinema, however, it lies in the question of the conditions for political commitment in the work of art. Joanna Page argues that

> [w]ithin *La nube* this overlapping of theatrical and cinematographic languages provides a further instance of the reflexive embedding of performances within other performances in the film, such that many of these textual layers are potentially both the object and source of critical comment: do the citations of Pavlovsky's play comment on Solanas's film, or vice versa? (2009: 25)

I would argue, however, that if the play were allowed to comment on the film, as I am enabling here in my analysis, then cracks would soon materialise in the coalition between *La nube* and *Rojos globos rojos*, not on a thematic level, but in the conflicting aesthetics of Solanas and Pavlovsky, their use of varying models of performance and their differing approach to culture.

Page argues further that '[f]or all their striking imagery, Solanas's films establish a hierarchical relationship between word and image in which the word enjoys primacy. [...] This hierarchical relationship reflects, of course, the clear dominance of the political over the aesthetic in Solanas's filmmaking' (26). No such hierarchy exists in Pavlovsky's theatre, affirmed by Cardenal's declaration: '¡En el teatro de vanguardia no hay moraleja!' (1997c: 88). Pavlovsky actively rejects any form of hierarchy, particularly the primacy of words, something which has already been explored in relation

to *Paso de dos*. The aesthetics of 'balbuceo' and 'del aullido' (Dubatti 2005: 17) allude rather to a pre-linguistic mode of expression that seeks beyond the confines of words: '[y]o quisiera que me contaran la historia de los decires balbuceantes, con las dicciones de los grandes tormentos y tartamudeces de la noche', Cardenal exclaims (1997c: 79).

Words are clearly of secondary importance in Pavlovsky's aesthetic. As demonstrated in the analysis of *Paso de dos* above, he privileges corporeal expression embedded in theatre's organic presence. Cardenal tells the spectator how he will 'contar la historia a vos con mi cuerpo, hermano, con mi cuerpo, con mis gestos, mis ritmos, mis dolores, mis risas [...] con el cuerpo, sin hablar. [...] Mi cuerpo es mi propia escenografía. Exorcizo con mi cuerpo' (1997c: 79–80). Solanas's filmmaking may assure the 'dominance of the political over the aesthetic' as Page suggests, but aesthetics and politics cannot be separated out hierarchically in Pavlovsky's theatre. The aesthetics of multiplicity, ambiguity and 'balbuceo' constitute his politics. The subordination of the aesthetic to the political in the film forces the play into a single discourse which rather undermines the multiplicity of Pavlovsky's work.

In contrast to Solanas' Adorno-like protection of high culture, for example, *Rojos globos rojos* makes an interesting (and rather paradoxical) engagement with the Benjaminian ideas of mechanical reproduction (see Walter Benjamin 1970: 219–46). This takes place when Cardenal parodies the announcements usually made at the beginning of a performance asking the audience not to film, or take photographs of the play, and to turn off their mobile phones:

> CARDENAL: Para todos aquellos que tengan aparatos radioeléctricos, videos, video casseteras, largometrajes y todo que suena, y también cámaras filmadoras pequeñas, les vamos a pedir que por el rato que dure esto ... filmen y graben todo lo que quieran. Porque en este teatro nunca nos filman nada. Así que saquen las grabadoras, a mí me encanta mucho que nos filmen. Les agradezco infinitamente la filmación. (1997c: 77)

Pavlovsky's parodying of the polite announcements usually given out at the beginning of a standard theatre performance works to snub high art, not because of its aura (an issue I will return to shortly), but its elitism and conservative reliance on convention. Cardenal duly parodies conservative criticism of performance:

> CARDENAL: ¡No, esto no es teatro! (*Al público.*) Pero querido, no hay estructura, no hay teatro. Los personajes se deshacen. Esto es pura performance. [...] Ahora hacen cualquier cosa, viste, y dicen que es teatro. No hay principio aristotélico. ¡Hay una crisis de la representación de la puta que los parió! [...] La culpa la tienen ustedes, que quieren hacer Shakespeare y Molière con el culo. (1997c: 89)

On initial inspection, Cardenal's words seem to critique performance art and defend theatre based on Aristotelian convention. However, *Rojos globos rojos* is punctuated by parody and counter-parody, meaning that it is almost impossible to interpret the play in terms of a single discourse. It should be clear by now that Pavlovsky's theoretical writings certainly illustrate his engagement with theatrical models (such as the Theatre of the Absurd and the Theatre of Cruelty) that actively break with Aristotelian conventions. A series of additions and subtractions take place with the adaptation of the play to the film. Solanas uses the play to emphasise the impoverishment of culture and the threat that low culture poses to high culture. Pavlovsky, in contrast, seems uninterested in the low culture/high culture divide, or at least unconcerned with forcing the play into this single paradigm.[11] There is something rather grotesque, or carnivalesque, about the idea of performing Shakespeare and Molière 'con el culo', which again shows up a clear subversion of elite or high cultural forms. Whilst Pavlovsky's main focus seems to be on his aesthetics of multiplicity which playfully opens up *Rojos globos rojos* to a plethora of different interpretations, Solanas is rather more didactic in his approach and imposes this single dichotomy on the play.

The play's parody of 'mechanical reproduction' also draws attention to a potential contradiction in the film's politics of culture. Whilst Solanas promotes the potential of high culture to engage politically, he cleverly displaces the film's cultural politics onto the axis between theatre and television, and theatre and radio (one of the characters in the film runs an independent, roving street radio fittingly named 'Radio Esperanza') in order to dissimulate the ambiguous position of film in relation to the culture industry. That is not to say that he makes any effort to camouflage the cinematic apparatus and feign transparency. Evidence of cinematic intervention is obvious in the reversed movement of traffic and people on the streets of Buenos Aires, as well as the way in which the camera circles around the stage in the Teatro Espejo, injecting pace and movement into the performance. What is absent from the film is any reflexive consideration of film's relation to the market.

Film is more commonly associated with Benjamin's theories of mechanical reproduction which oppose the aura of high, or the art for art's sake, aestheticism. Benjamin's controversial essay 'The Work of Art in the Age of Mechanical Reproduction' (1937, in 1970) argued in favour of the political potential of mechanical reproduction in order to release art from 'its parasitical dependence on ritual' (226), re-temporalising and re-functioning it as

[11] Pavlovsky states that '[e]videntemente, la primera sensación (que provoca el teatro de vanguardia) es confusa, pero no deja de ser una imagen *real*. El espectador teme la confusión, por eso quiere obras claras y concretas, donde cada personaje se delinee perfectamente. Por eso prefiere a Wesker y no a Pinter, a Cossa y no a Gambaro. Yo me pregunto: ¿quién es más realista? La vanguardia es abrir brechas, buscar y sumergirse sin temor a la confusión' (2001: 21).

a socio-politically engaged work of art (Hammer 2006: 128). The essay was a particular source of concern for Adorno, who argued against the destruction of the autonomous art object's aura. Benjamin associated the *l'art pour l'art* ideal with the 'negative theology in the form of the idea of "pure" art, which not only denied any social function of art but also any categorizing by subject matter' (1970: 226). Adorno believed that aura and autonomy were pre-requisites for effective commitment and a vital means of resisting commodification (Adorno 2001: 105).

Although Pavlovsky and Solanas may not coincide in their fear of low culture, they do coincide in their valuing of theatrical presence and the notion of aura. As in *El exilio de Gardel*, Solanas appeals to theatrical presence as a means of conserving the aura of the work of high art and I would further argue that he is careful not to point up cinema's lack in this domain. Both seem to coincide with Adorno's argument that the auratic nature of the work of art and its autonomy constitute its 'mark of freedom' and independence (2007: 121). Pavlovsky redefines theatre, via the idea of the postmodern notion of performance, in a manner that attempts to recover the aura and to distance theatre from the 'deadly' forms of theatricality (Brook 1990: 61) that have spilled out of theatre and now direct the way society functions. These deadly forms are demonstrated by Solanas to be scripting Argentine society. As already explored in relation to both *Paso de dos* and *El exilio de Gardel*, performance art has defined itself in opposition to theatricality: 'performance needed to defeat representation and assert presentness in order to assert its specificity as a medium (that is, to distinguish itself from theatre)', as Auslander argues (1997: 56). Pavlovsky's own theoretical writings on theatre confirm this emphasis on the 'presentness' of performance: '[e]l público que va a ver el espectáculo está "involucrado" en la función. No está viendo algo que pasó. La función se construye en el aquí y ahora' (2001: 151–2). Pavlovsky's theatre places emphasis on the process of performance, rather than achieving a finished hermetic work of art; he works to disrupt conventional forms of representation, and refuses to lock his dramatic text in any single meaning, promoting instead the aesthetics of multiplicity and placing emphasis on the corporeal nature of performance, something already explored in his citation of Artaudian theatrical strategies in *Paso de dos*.

If, as Susan Sontag argues, the 'traffic' between cinematic and theatrical conventions in a contemporary context 'seems, with few exceptions, entirely one way: [from] film to theatre' (1992: 371), then both *El exilio de gardel* and *La nube* constitute such exceptions. In these films, theatre revitalises cinema, rather than the currently more common reverse scenario. It is through the revitalisation of 'deadly' theatrical conventions via notions of performance that this is achieved. 'Films' contain a 'pathos of mortality', argues Sontag, concluding that they 'age (being objects) as no theatre-event does (being always new)', although the term 'theatre-event' should be replaced by the

term 'performance-event' here in order to avoid confusion (1992: 370). It is the performativity of theatre that ensures its currency. The hybridisation of theatre and cinema through the notion of performance in Solanas' films can be seen as a strategy to revitalise film by incorporating the aura of theatre's presence. The pluridisciplinary nature of performance as a concept likewise enables the spectator to perceive the social and political engagements of these texts.

This is exploited by theatre practitioners who, by placing emphasis on the performance stage of the theatrical process, assert theatre's ability to constantly renew itself through performance. A variation exists in theatrical repetition that cannot exist in repetition of the same film. Repeated reference will be made to the most vocal advocate of this practice, Ricardo Bartís, who sees in the rejection of the dramatic text and the privileging of group creation through a series of rehearsals, a means of exploiting the specificity and the aura of pure performance in political terms. Texts indeed exist of Bartís' theatre, for which I am most grateful for this study, but they are transcribed post-performance and thus bear no influence over the performance itself (see chapter 3). The reinvention of theatre through this idea of contingency and performativity means that theatre (the older aesthetic) is able to constantly renew itself in a way that cinema cannot. Theories of spectatorship may indeed argue conversely that a film is constantly renewed in the mind of each spectator, but what I am focusing on here is the raw material of the cinematic and theatrical performance with which the spectator engages. The film material, which is already prepared before the spectator enters the cinema, is 'mechanically reproduced'. In the kind of theatre proposed by Pavlovsky and Bartís —which Solanas cites in the two films examined here— the material is constantly being renewed organically as the performance takes place. The politics embedded in their approaches to performance is located herein.

2

De-mythifying the Postmodern 'Opium of the People': Theatre and Cinema versus Television

No puedo leer, no puedo dormir, no puedo respirar. Cierro los ojos y veo carteles de neón que dicen: 'COMPRE UNA CASA, UN AUTO, UN BEBÉ Y SEA FELIZ ...' Es como si mi cabeza fuera una máquina repleta de frases de la publicidad, de la televisión, de otras personas ...

Lola Arias, *Striptease*, 11

If one were to define a cultural institution, industry or medium as paradigmatic of postmodernity —although arguably not of postmodernism, which allows for a greater diversity of media— it would more likely than not be television.[1] For not only is television emblematic of consumer society 'mediocrac[ies]' (Hal Foster 1983: xi) —that is, of the commodification of cultural production and the consequent propagation of (image-)signs throughout society— but, as will emerge here, it plays a fundamental role in constituting its specta-tors as both social and ideological subjects. A hyper-medium of communica-tive, epistemological, political and, not least, entertainment value, television is the 'Ideological State Apparatus' (see Althusser 2008: 1–60) which both informs and renews the myths of consumer capitalism on which postmodern 'societ[ies] of spectacle' are based (see Debord 2004).

Given the ascendance of television, it is hardly surprising that theatre prac-titioners and filmmakers have felt the need to scrutinise not only the way in which television functions as a medium, but its role in shaping (postmodern) society. This chapter will examine how a series of plays and films in Argen-tina challenge television's cultural and ideological hegemony by exposing the manner in which TV manipulates the reality we perceive.

The adherence of television to the discursive model of advertising will provide the central argument for the first part of this chapter. What will be

[1] For a more prolonged discussion of the ascendance of television as the prime medium of postmodernity see Fredric Jameson (1991), Jean Baudrillard (1998), Beatriz Sarlo (2004) and Neil Postman (2005).

examined is the way in which Alejandro Malowicki's film *PyME (Sitiados)* (2005[2]) and Carlos Sorín's film *Historias mínimas* (1998) use television advertisements to map out Argentina's subjugation to the logic of a consumer society. In both cases, film distances itself from the governing ideology by aligning itself with those elements of society that suffer at the hands of the dominant ideology or remain on its peripheries. Despite its undeniable links to the 'culture industry', image-culture and circuits of capital, film nevertheless sets itself up as a force of resistance.

The second part to this chapter will focus on the manner in which television 'interpellates' its spectators (Althusser 2008: 54–6) as subjects of the dominant consumer ideology. Roberto Cossa's play *Años difíciles* (1997) forges an alliance between theatre and radio in resistance to the damaging effects of television spectatorship on social behaviour. Meanwhile in Alejandro Agresti's film *Buenos Aires viceversa* (1995) a pact is made between film and video in order to disclose the illusory nature of television reportage, in particular the way in which it acts as a cover-up to continued state violence and political corruption.

Néstor García Canclini (2001) argues that in Latin America, although the domination of television in mass culture as an apparatus for cultivating power is statistically well documented —there exist ample raw figures denoting the number of television sets owned and the number of viewers each programme totals— there is little to indicate how television spectatorship works on a discursive level. García Canclini contends that it is only by analysing the processes of television viewing that television's impact on daily social practices can be gauged. He encourages that 'conocimientos directos en las microinteracciones de la vida cotidiana [...] pueden ayudar a conocer cómo los discursos de los medios se insertan en la historia cultural, en los hábitos de percepción y comprensión de los sectores populares' (244). Agresti's film and Cossa's play fill this notional gap, by illustrating the way in which television 'interpellates' its spectators into ideological subject positions, impacts on their knowledge, their day-to-day behaviour and ultimately informs the 'imagined political community' to which they belong (Anderson 2006: 6).

Once again, it is the shared concept of performance that enables theatre and cinema to take on television. Theatre, cinema and television can all be placed on a continuum of performance-based media, which are similar in their capacity to 'enculturate' (Baudrillard 1992: 12) life and politics in a series of performances. These films and this play seem to suggest that theatre's and cinema's aesthetic forms therefore provide a privileged insight into the way in which television can distort reality. Yet, different media shape ideology and discourse in accordance with their specific forms. Marshall McLuhan's

[2] It is worth noting that this film was made in 1998, but it was not released until 2005.

catchphrase, 'the medium is the message', may seem rather hackneyed, but it is still relevant (2001: 7). Theatre and cinema's ability to 'enculturate' life and politics, in a different way from television, combats the idea that there are no longer alternatives to the prevailing ideology. A formal struggle is thus turned into an ideological one. The generic boundaries separating theatre, cinema and television become formal, perceptual and political boundaries; breaches of conflict where theatre and cinema attempt to reconcile, on the one hand a latent nostalgia, albeit a somewhat naïve one, for generic 'purity' —a time when culture derived its authority to challenge from its own 'inner logic' (Foster 1983: x)— and, on the other hand, a realisation that it must adapt to the current context and somehow derive its seditious agency as a contingent construct from within this context.

What will be posited, in the light of this examination, is that the preoccupation of these texts with television's role in (re)shaping social relations —ultimately in dislocating the conceptual boundaries of the nation in favour of transnational networks of association— uncovers a latent anxiety regarding the socio-political agency of theatre and cinema. This question of agency is negotiated in relation to issues regarding the specificity of each as an art form, as well as the boundaries each shares with television.

Such anxiety no doubt stems from the fact that, as Jameson argues, 'cultural hegemony today' —in the era of postmodernity or 'late capitalism', as he otherwise refers to it— lies in the sphere of 'video, in its twin manifestations as commercial television and experimental video' (1991: 69). The main focus in this chapter will, however, be on the ideological hegemony of commercial television, as opposed to the rather less mainstream experimental video. Certainly in the case of Agresti's film *Buenos Aires viceversa* the coupling of television and video as concurrent hegemonic media would be somewhat problematic, as documentary-style video is employed within the filmic discourse as a means of contesting television's ideological grip on society.

Beatriz Sarlo's account of postmodern life in Argentina clearly situates television at the hub of a society experiencing severe inequalities and fragmentation:

> Como otras naciones de América, la Argentina vive el clima de lo que se llama 'posmodernidad' en el marco paradójico de una nación fracturada y empobrecida. Veinte horas de televisión diaria, por cincuenta canales, y una escuela desarmada, sin prestigio simbólico ni recursos materiales; paisajes urbanos trazados según el último *design* del mercado internacional y servicios urbanos en estado crítico. (2004: 5)

Sarlo's message is clear: television and the new style of 'video-política' (88) that it begets are glossing over societal fragmentation with a homogenising, de-contextualised, de-politicised, global cultural offering (5). Her juxtaposition

of a society flooded twenty hours per day by television but with a failing educa-
tion system likewise alludes to the fact that it is television, rather than schools,
which is educating the population.[3] Sarlo's analysis nevertheless largely focuses
on urban society. Sorín's film *Historias mínimas*, which will be examined in
the earlier part of this chapter, develops its critical agency of urban televisual
societies by aligning film with non-televisual spaces in a remote Patagonian
settlement. Although television can be found in certain public spaces, such as
the local convenience store, its presence remains rather anachronistic.

Television and Discourses of Advertising
Television constitutes a huge global industry that epitomises the commodifi-
cation and massification of culture into the 'culture industry'. As an industry,
much of its revenue, even in the case of Argentina's state channel Canal 7,
relies on advertising. Advertising not only funds, but punctuates television
programming, fragmenting the narrative integrity of individual programmes.
Television functions as a major outlet for the advertising discourse that
Baudrillard argues informs our socio-cultural patterns of consumption.
Advertising accents the arbitrary 'secondary' value of objects. It constitutes
a spectacle of signs in which the 'inessential', connotative value of objects is
paraded in preference to the 'essential' functions of the object (2005: 6–7):

> Advertising in its entirety constitutes a useless and unnecessary universe.
> It is pure connotation. It contributes nothing to production or to the direct
> practical application of things, yet it plays an integral part in the system of
> objects, not merely because it relates to consumption but also because it
> itself becomes an object to be consumed. (178)

It is in *The System of Objects* (2005 [1968]) and *The Consumer Society* (1998
[1970]) that Baudrillard outlines the emergence of a socio-cultural model of
consumption. He achieves this through his examination of the shifting value
invested in objects. Baudrillard argues that it is simply not enough to consider
objects in terms of a 'technological system', whereby it is the 'essential'
properties of an object —those that define its functionality— which grant
the object its value within the system of production (2005: 6–7). Instead, he
places accent on the 'secondary meanings' of these objects —their symbolic
value within a 'cultural system' (6) or, in Marxist terms, their exchange-value

3 Louis Althusser (2008) argues that, in the capitalist period, schools are the 'dominant
Ideological State Apparatus', in that 'no other ideological State apparatus has the obligatory
(and not least, free) audience of the totality of the children in the capitalist social formation,
eight hours a day for five or six days out of seven' (30). Sarlo's reference to television broad-
casting twenty hours per day clearly alludes to a similar scale of ideological saturation. With
terrestrial television in Argentina in 1996 present in 97.8% of households (Getino 1998: 194),
it certainly reaches the totalising coverage of school.

(as opposed to use-value)— which elucidate 'the processes whereby people relate to them and with the systems of human behaviour and relationships that result therefrom' (2). What Baudrillard is interested in is the object's status as a 'sign', a 'sign' which embodies an arbitrary 'external' relationship to the essential qualities of the object and its primary function (218). Indeed, many of these objects —those he dubs 'gadgets'— contain no 'essential' function (7). Instead, they possess 'non-essential' qualities which bear significance within a system of consumption (7).

The term 'consumption' should not be confused with the simple process of supply and demand. In this sense, society has always been governed by patterns of consumer needs. Baudrillard argues that '[i]t has to be made clear from the outset that consumption is an active form of relationship (not only to objects, but also to society and to the world), a mode of systematic activity and global response which founds our entire cultural system' (2005: 217). Baudrillard's theoretical step 'towards a definition of "consumption"' (217) is worth quoting at some length in order to appreciate his particular use of the term:

> Consumption is not a material practice, nor is it a phenomenology of 'affluence'. It is not defined by the nourishment we take in, nor by the clothes we clothe ourselves with, nor by the car we use, nor by the oral and visual matter of the images and messages we receive. It is defined, rather, by the organization of all things into a signifying fabric: consumption is *the virtual totality of all objects and messages ready-constituted as a more or less coherent discourse*. If it has any meaning at all, consumption means *an activity consisting of the systematic manipulation of signs*.
> Traditional symbolic objects (tools, furniture, the house itself) were the mediators of a real relationship or a directly experienced situation, and their substance and form bore the clear imprint of the conscious or unconscious dynamic of that relationship. They were thus *not arbitrary*. Although they were bound by connotations —pregnant, freighted with connotations— they remained living objects on account of their inward and transitive orientation with respect to human actions, whether collective or individual. Such objects are not consumed. *To become an object of consumption, an object must first become a sign*. That is to say: it must become external, in a sense, to a relationship that it now merely signifies. (218, original emphasis)

The 'system of objects' is shored up by the 'discourse *about* objects', which is integral to this system. This discourse takes the form of advertising (178, original emphasis).

Whilst we may not be drawn into unqualified acceptance of the information adverts provide us about certain objects, advertising as a whole possesses what Baudrillard describes as an 'underlying leitmotiv of protection and gratification' which promotes a societal picture of prosperity and safety (181). It serves to justify and legitimise our daily routine. Malow-

icki's film *PyME (Sitiados)*[4] and Sorín's film *Historias mínimas* both take issue with the discourse of advertising. They examine the way in which the objects advertised reveal a national fascination with imported goods, which undermines not only the qualitative value of locally produced objects, but the conceptual value of the nation as a cultural and discursive entity.

PyME is Alejandro Malowicki's second feature-length film. It deals with the devastating effects of neoliberalism on Argentina's small businesses. Prompted by reading about the plight of a small business owner forced to sell up, as well as the director's own struggle as a firm owner in Argentina in the 1990s, *PyME* is firmly rooted in the socio-economic struggles of the context in which it was produced: 'la tragedia de unos protagonistas sitiados por un modelo económico neoliberal brutal e injusto', to cite the film director's own words (cit. Pablo O. Scholtz 2003, n.p.). The film represents a day in the life of a small firm that manufactures plastic chairs. With its prices being undercut by cheap foreign imports the business is struggling to survive. The owner faces usurers and trade union action as the company teeters on the brink of collapse.

What is interesting about Malowicki's film is that it is framed by an advert. The advert provides the discursive model through which the neoliberal, free-market ideology is propagated. The opening sequence of the film replays an advert aired by the Finance Ministry in 1977, as the subtitle informs us. The advert begins with a close-up shot of a blue wooden chair. Hanging on the back of this chair is a sign stating 'Industria Nacional'. When the suited man sits down on this locally produced chair, he is horrified to find it collapse beneath him, shattering to smithereens in the most dramatic and exaggerated manner. In reaction to this disaster, a voice-over narration informs us of the following: 'Antes la competencia era insuficiente. Teníamos productos buenos, pero muchas veces el consumidor debía conformarse con lo que había, sin poder comparar.' The man gets to his feet again and a smile is restored to his face when he turns round to discover a whole range of chairs of different colours, shapes and sizes laid out in front of him. Some are labelled 'Industria Nacional', others 'Made in', indicating their status as imported goods. 'Ahora tienen para elegir,' the voice-over celebrates, as the camera zooms in on the imported chairs: 'aprovechen esta situación y comparen'. The sequence then cuts to a series of black-and-white shots (footage which appears to have been taken from television archives) that typify the exaltation of imported goods. One shot provides a close-up of an imported toy robot; another, a shop window publicising its stock of foreign products with the sign 'Artículos import', the Anglicisation of this sign alluding to the appropriation of a North

[4] 'PyME' is the abbreviation used to classify small and medium sized businesses in Argentina. It is short for 'Pequeño y Mediana Empresa'.

Nationally-produced chair in Alejandro Malowicki's *PyME*. By courtesy of Alejandro Malowicki.

A close-up of the sign 'Industria Nacional' leaves no doubt as to the origins of the fragile chair in *PyME*, giving a damning portrayal of the quality of nationally-produced goods.

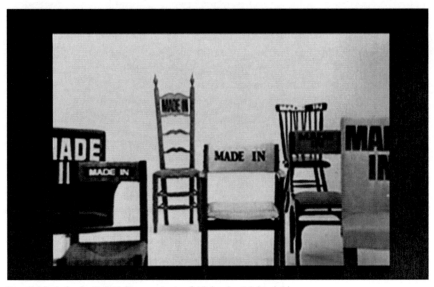

Imported chairs in *PyME*. By courtesy of Alejandro Malowicki.

To compensate for the faulty chair's failings, the client is presented with a wide range of imported chairs from which he can choose

American financial model and rhetoric; another on Martínez de Hoz, Minister for the Economy from 1976 to 1981, and his speech hailing the start of a new chapter in Argentina's economic history which, he asserts, is to shake off 'el intervencionismo estatal agobiante' in favour of neoliberal policy.

Not only is this advert obviously symptomatic of a neoliberal market ideology, but it provides an interesting viewpoint on the status of the nation within this neoliberal ideology. As an object, this nationally produced chair is clearly not functional. None of the other chairs are, however, tested for their functionality. Rather, what is promoted is an abundance of choice, a plethora of chairs representing a series of 'inessential' properties —different colours, styles, sizes and origins— which serve as signs. All too often in Argentina, status is achieved through the consumption and possession of imported goods, rather than home-produced commodities. When, in Martín Rejtman's film *Silvia Prieto* (1999), Silvia takes a present for one of the other women named Silvia Prieto, she insists on buying her an imported shampoo, for what Silvia wants most is to make a good impression on her namesake (this film will be examined in greater detail in relation to its borrowings from documentary and its engagement with patterns of consumption in chapter 4).

What is quite perplexing about the advert in the opening sequence of *PyME* is that although it might encourage the purchaser to be 'at one' with consumer society (Baudrillard 2005: 183), it by no means encourages him or her to be 'at one' with the nation. Whereas one might think it most logical for a government to emphasise the added value and quality of locally produced objects, here the case is quite the opposite. Not only does Malowicki's film make a significant statement about the role of publicity in conditioning society to a neoliberal model of consumption, it also inscribes into this discourse a certain conceptualisation of the nation.

In his analysis of the symbolic value accorded to objects in society, Baudrillard argues that the 'secondary meanings' (2005: 6) embodied in an object define the consumer's status as a 'citizen of industrial society' (183). Coincidentally, Baudrillard uses the armchair to exemplify this. An 'armchair', he argues,

> cannot just be an armchair. Its purchaser must feel himself at one with technological society [...] The armchair makes him into a citizen of industrial society [...] today all the structures of society are embodied in the qualities of this armchair, qualities which themselves come together in his own individual personality. (183)

If the object reveals as much about the subjectivity of its owner, one wonders what psychological impact telling a nation that the objects they produce have no use —in either 'essential' or 'inessential' terms (7)— has on a sense of

national identity. This leads to a paradoxical scenario in which a schism develops at the heart of the nation-state, as the advertising discourse of television, the most prominent 'Ideological State Apparatus', chips away at the cultural and ideological value of the nation.

The principal message of Malowicki's film can be recapitulated perfectly in Alejandro Grimson's emphatic statement: 'LA ARGENTINA HA SIDO DESCONSTRUIDA por el neoliberalismo' (2004: 177). A shot of a bank notice offering high rates of interest on deposits in US dollars, portrayal of a workers' protest and series of stills depicting dilapidated and abandoned industrial sites at the end of this opening sequence certainly emit a similar sentiment. The manifesto contained in the extra material available on the DVD version of *PyME* leaves no further room for doubt about the film's message: 'La industria PyME en la Argentina ha sufrido en los últimos años un proceso de extrema pauperización aún no culminado.'[5]

Without a doubt, *PyME* treats the ideology of global consumer capitalism with great cynicism as it recounts the demise of a small factory producing plastic chairs, struggling, as we can imagine, against the range of imported chairs which have been presented to us previously in the advert. The workers in the factory, several of whom have been loyal employees for many years, have not received their fortnightly pay cheques for several months. They are holding a series of urgent union meetings in order to occupy the factory and take strike action against this injustice. On the other hand, the factory owner is fighting a series of final reminders for paying off bank loans and the basic utilities (gas, electricity) to keep the factory functioning. The factory is portrayed as being trapped well and truly in a vicious circle. If the owner chooses to pay his workers in preference to making debt payments or paying the electricity and gas bills, the workers will be made redundant. Yet, as the factory employees rightly point out, the director's family never goes hungry, so why should their families suffer? Only one simple solution is presented: to sell the plastic chairs to a multinational firm. Succumbing to the power of the multinationals goes against the owner's personal convictions, as he tries to resist the dominant ideology of global consumerism in favour of protecting local industry. The ultimate and some might argue rather defeatest message of the film is that there is only one viable ideology: that of global capitalism/consumerism. If the company does not conform to this dominant ideology and if it rebels, it will sink, as indeed it finally does. Although the film remains cynical, the ideology of consumer capitalism is left firmly intact, its de-politicising force realised

5 As previously mentioned, *PyME*, although released after 2001, was in fact filmed prior to the crisis. The destructive nature of neoliberalism is nevertheless the theme par excellence of a host of films and documentaries produced in the aftermath of the 2001 economic meltdown. See, for example, Fernando Solanas' *Memoria del saqueo* (2004), and its sequel *Argentina latente* (2007) or Jorge Lanata's *Deuda* (2004).

in that no feasible alternative is presented. Only a small glimmer of hope for redemption is suggested in the final scene when Gustavo, the late owner's son, returns to the deserted factory with the aim of reviving production. This glimmer remains nevertheless somewhat faint.

The impact of advertising on society is also probed in Sorín's film *Historias mínimas*. The film's understated plot follows the journey of three inhabitants of the isolated Patagonian settlement Fitz Roy to the nearest town of Puerto San Julián: ageing Don Justo journeys to San Julián in order to retrieve his dog Malacara which, he is informed, has been spotted in the town; María Flores travels there to appear on a television game show; meanwhile, Roberto embarks on an expedition to deliver a birthday cake to a client's son, a cake he must have transformed from a football to a turtle, having realised that he is unsure whether René, the child in question, is a boy or a girl. As the spectator accompanies these characters on their personal missions, Sorín uses the road movie format to carefully map out the increasing penetration of the city, as well as more global influences, into this rural and peripheral Patagonian society (Joanna Page 2009: 120). One of the key instigators of this overflow of the urban into the rural is television, a feature in the background (and on occasions the foreground) of many scenes in the film.

The issue of advertising is introduced in the character of travelling salesman Roberto. Roberto's belief in advertising as a means to success is revealed in the conversation that he has with fellow salesman García. When Roberto asks García how he is, García replies that in the current situation life is 'so-so'. He attributes this to certain changes that have taken place in the business for which he works. When the previous owner was in charge, the business imported tools and it sold a lot of products. Now, the owner's sons import bric-a-brac from China: elastic bands, luminous stars and other objects which are superfluous in the process of production. Once again, we can see the shift from the sale of objects with an 'essential' value, or specific productive function, to the sale of objects with an 'inessential' value, which are consumed as much for what they signify as for the function that they perform. For this remote Patagonian society still very much on the periphery of consumer society, the sale of such objects is more challenging. The market is necessarily smaller in a rural community —the demand therefore more limited— even if the film registers the progressive ideological penetration of consumerism amongst the inhabitants of Fitz Roy and San Julián.

What is made clear is that, given their unproductive nature, these objects can no longer be sold on the pure value of the function that they will execute. Roberto demonstrates that the sale of objects must now be accompanied by a performance in which the salesman must persuade the customer through gestures and rhetoric that he or she cannot live without the product that is

being sold, however illusory the salesman's argument may ultimately be. The film suggests that the way in which society is conditioned to follow certain patterns of consumption can be understood through concepts of performance. Roberto demonstrates this as he performs a sale of his new Swedish slimming product 'Fat Away' in order to show off his sales techniques to García. Again, the object being sold by Roberto has no direct function in any model of production and conforms to his own observation that they are now living in a society dominated by images. He remarks that nowadays, 'todo es visual', which is reinforced by the series of close-up shots of the torsos of Brazilian carnival dancers being shown on the television. What is also significant is that, during the sale, Roberto legitimises the effectiveness and quality of the product by indicating to his potential customer that the product has been promoted on television. Again, no proof is given of its use value. It is television that ultimately has the power to authorise and legitimise the exchange value of objects.

The film maps out the collapse of established categories of time and space. There are many instances throughout the film which demonstrate the incursion of global symbols into the local context, even if they remain rather obviously out of place. The general store run by Don Justo's family is called 'Ramos Generales California', one of the bakers visited by Roberto is following cake decorating courses on the Internet, glitzy yet somewhat tacky images of Manhattan adorn the set of the local television game show and close-up images of scantily clad torsos dancing samba transport the exotic images of Brazilian carnival to a Patagonian audience. At various moments during the film, however, I would suggest that Sorín subtly employs a contrasting cinematography as a counterpoint to these global/televisual invasions. A series of long shots gazing out over the seemingly interminable and uninhabited expanses of the Patagonian landscape serve to restore a sense of distance and contrast. In the opening sequence the camera is angled down to the ground and follows a pair of feet walking briskly along a disused railway track. Not only does this composition suggest that modernity has somehow passed this settlement by, or been and gone at the very most, but it also hints that the relationship between time and space should be measured in more primitive terms of the speed of walking. This is reinforced once again when Don Justo sets out for San Julián on foot and the spectator is presented with another long shot of his hunched figure traipsing alone across the barren landscape along the only available road, accompanied by a surge of diegetic sound evoking the relentless gusts of wind. The only sign of civilisation is a lone road sign. For the inhabitants of Fitz Roy, San Julián may be the nearest major town, but for them it remains at the edge of their world. Don Justo's rootedness is made clear with his affirmation 'hace cincuenta años que vivo en la zona'. This is certainly not the relationship that television establishes or promotes between time and space.

These mythical shots over the Patagonian landscape are reminiscent of a rendition of Patagonia as a Utopian space outside the reach of global communication circuits (something I will return to in the following chapter). Although the character of biologist Julia, who is taking time out in Patagonia to escape from the frustrations of undertaking scientific research in Argentina, may suggest this kind of reading of the film —news of scientific advance arrives only via the television documentary— Sorín's illustration of Patagonia is far more complex and the surface impression of innocence is upset by a somewhat darker side; something that can be attributed to the contamination of the countryside by the city (Page 2009: 120). Don Justo's dog allegedly ran away from its master after he was the perpetrator of a hit-and-run accident that made Roberto's client and love interest a young widow. On one of his stops along the way, Don Justo and Roberto meet in a doctor's surgery where a handcuffed man awaits treatment for his bloody wounds whilst being watched over by his police escort. Although the scene bears little weight in the development of the plot, the pulsating, discordant music and the fact that the camera zooms in on the wound increases the impact of this unpleasant scene, undermining the friendly, innocent tone that prevails elsewhere.

Sorín makes a strong statement about television's capacity to reach even the remotest elements of society. María Flores squats with her husband and baby in the abandoned railway station. Yet even without electricity, María has sent many letters to the television station in San Julián in order to appear on the game show, despite her apparent ignorance as to exactly what the show involves. When she finally appears on the show, María is mesmerised to the extent that she is unable to react to the presenter's questions. The lively, energetic attitude of the presenter is no more than a façade put on while the camera is rolling, and the show is demonstrated to be nothing more than a performance of success and affluence punctuated by regular commercial breaks to advertise the programme's sponsors. María ironically wins the prize, an electric food processor ('una multiprocesadora') which of course is useless to her without electricity, and fellow contestant Gladys is quick to pounce upon the opportunity to aggressively wrestle the appliance from an unsuspecting María in exchange for a turtle-shaped makeup set; the turtle being a recurring symbol of life's pace in these Argentine backwaters. I will focus more on the effects of television on its viewers' behaviour shortly; however, the behaviour of those involved in the television show —contestant Gladys's single-mindedness and her desire to win at all costs, the television presenter's prima-donna-style behaviour as he receives a massage after a 'hard' night's work and refuses to be bothered by the contestants— provides a foretaste of the way in which certain films and plays perceive the effects of television on people's attitude towards one another.

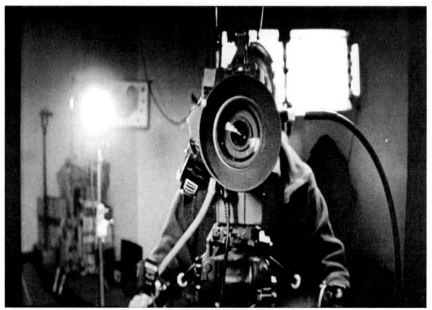

Cine-camera facing the television camera in *Historias mínimas*.

María is faced with the camera in this intimidating close-up in *Historias mínimas*. Film comes face-to-face with its own apparatus, although the confrontational composition of the shot ensures that a clear boundary is nevertheless marked out between cinema and television

Both *PyME* and *Historias mínimas* use film to create a breach in the ideologies of consumption disseminated by the television. In the case of *PyME*, this is achieved by contrasting the style of filming used in advertising with a less intrusive and more transparent style of documentary cinematography in the rest of the film (the appropriation of documentary as a political device in recent Argentine film and theatre will be explored in greater depth in chapter 4). In *Historias mínimas* film aligns itself with a social and geographical space which is firmly on the periphery of urban televisual societies. The frequent panoramic long shots portraying the uninterrupted landscapes of Patagonia align film with a pre-technological, unmediated world where inhabitants, in some cases living without even electricity, must travel on foot to communicate with their neighbours; where television is present, but occupies only a marginal position in public spaces and still mesmerises its spectators, instead of dictating their every move. The isolated settlement of Fitz Roy becomes an area of resistance to the fragmented social relations of Buenos Aires, to be examined in part two of this chapter.

Television Spectatorship and the Interpellation of Ideological Subjects

Ideology has a significant impact on how individuals are constituted as social subjects. It constitutes 'the system of ideas and representations which dominate the mind of a man or a social group [...] a 'Representation' of the imaginary Relationship of Individuals to their Real conditions of Existence' (Louis Althusser 2008: 32–6). In short, ideology, as materialised in a series of 'state apparatuses', is an instigator of social and political 'harmony' (24). These Ideological State Apparatuses (or ISAs), of which television is one, attempt to cultivate state power by subjecting individuals to the political state ideology.

Having mapped out the way in which television gives shape to public discourse via the model of advertising, as well as serving as a barometer of the transition from state to market, this chapter will now examine the way in which television viewers are not only 'interpellated' into a certain spectator position, but simultaneously 'interpellated' as social and ideological subjects of the state (Althusser 2008: 54–6). Alejandro Agresti's film *Buenos Aires viceversa* and Roberto Cossa's play *Años difíciles* engage precisely with this issue. Not only do they demonstrate the way in which television 'enculturate[s]' reality (Baudrillard 1992: 12), but also the way in which it conditions the knowledge, thought and behaviour of its spectator-subjects.

Buenos Aires viceversa portrays the parallel lives of a variety of characters all related spatially through the city of Buenos Aires and whose paths cross by chance periodically throughout the film. Continually flitting between its various narrative threads and employing an aesthetic which disintegrates any clear sense of a conventional storyline, the film depicts, above all, a city beset by social fragmentation, miscommunications and solitude. Society is still tormented by the memory of the 1976–83 dictatorship, institutional violence continues to play a role in everyday life, albeit under the (rather tenuous) banner of democracy, and the only interrelation between the lonely characters is through their desperate search for affection or individual pleasure. They are living —to quote one of the characters— 'un naufragio cotidiano [...] personal y colectivo', a social decadence in which 'cada uno tiene su psicosis'. The inclusion of two blind characters, one played by the director himself, draws attention to the metaphorical blindness of society as a whole to this distorted reality evoked in the film's title. Broadcast television plays a key role in the film, as representative of this fragmented society, glossing over the real, packaging it as a commodity and producing this allegorical loss of sight. In various shots the presence of television aerials in the foreground significantly obstructs our view of the cityscape in the background, mapping the way in which television warps society's vision of reality on the streets.

The capacity of television to distort the way in which we perceive reality is also a major theme of *Años difíciles* as Cossa gives a cynical message regarding how the media influences the ways in which we interact —or rather

fail to interact— with one another. Set in the household of brothers Alberto and Federico Stancovich and Federico's wife Olga, the play looks at how television and radio addictions mediate the knowledge, beliefs and every action of all three characters, to their detriment and ultimate downfall.

Two paradigms are crucial to understanding how the process of television spectatorship functions in this film and this play: first, television's role in the aestheticisation of society; second, the way in which performativity —a derivative of this process of aestheticisation— infiltrates social relations, enabling a shift in the conceptual boundaries of reality. The boundaries between reality and performance are hence blurred and TV is able to pass itself off as reality. I will argue that what these texts seek to elucidate is that the performativity encoded in the television news points to the construction of dangerous political illusions.

The central role of television in this process of aestheticisation is more easily appreciated in conjunction with Jameson's theory of 'commodity reification' (1992b: 15). 'The ultimate form of commodity reification in contemporary consumer society', he argues, 'is precisely the image itself.' Consumer society can, therefore, be characterised by 'the universal commodification of our object world, the familiar accounts of the other-directedness of contemporary conspicuous consumption and of the sexualization of our objects and activities' (15). 'It is clear', he continues, 'that such an account of commodification has immediate relevance to aesthetics, if only because it implies that everything in consumer society has taken on an aesthetic dimension' (15). Baudrillard argues much the same, when he declares that 'the state of the arts has generalized itself to the extreme and does not leave us with any other alternative. Everything is sexual. Everything is political. Everything is aesthetic.' If '[e]verything is political', he continues, then ultimately nothing is political (1992: 9). Jameson, on the other hand, maintains that the potential for political engagement still exists. However, neither Jameson's analysis nor the texts studied in this chapter attain the levels of Baudrillard's later more radical theories, according to which society has imploded into hyper-reality and a perpetual series of simulacra (see Baudrillard 1981). This is something that will be addressed in the analysis of two science fictions in the following chapter. Governed by a 'ratings mindset' (Pierre Bourdieu 1998: 28), which renders it a prime commodity of the 'culture industry', television both epitomises and multiplies this process of cultural commodification.

To grasp the role of performance in this process of aestheticisation, Jameson's argument must be placed in dialogue with Richard Schechner's concept of 'social drama' (2003: 192). In the previous chapter, I explored the way in which both the experience of dictatorship and society's transferral to a neoliberal model can be better understood in relation to the trope of performance. Derived from the ideas of symbolic interaction, 'social drama' defines the manner in which everyday situations are 'inherently

dramatic'. 'Actions', argues Schechner, 'take on a reflexive and performed-for-an-audience aspect' (2003: 186). For Argentine 'teatrista' Ricardo Bartís (2003a), it is this overspill of theatricality into social and political exchanges —a phenomenon referred to as 'transteatralización' (Dubatti 2006: n.p.)— which causes 'everything in consumer society [to take] on an aesthetic dimension' (Jameson 1992b: 15). Reacting to his experience of President Carlos Menem's regime, Bartís contends that theatre has invaded the field of politics (or vice versa); something he associates with political corruption of the truth. Argentina is experiencing, he suggests, '[una] farandulización de la política', which originates from a class of 'políticos stanislavskianos'[6] (2003a: 144–6). The principal outlet for this overspill of theatricality out of theatre and into society, in Bartís' view, is television: '[d]esde el punto de vista teatral, si aparece un político en televisión, después no hay cómico que aguante' (146). It is the process of 'transteatralización' that informs the second argument in this section: that the incursion of performativity throughout social relations facilitates the construction of illusory socio-political realities and reduction of politics to a two-dimensional image-politics rather lacking in substance.

Yet, to interpret *Buenos Aires viceversa* and *Años difíciles* solely as critiques of a society ideologically conditioned by televisual style performances would undermine a deeper issue at stake: that of the uses of certain forms of media within other media and the politics of self-reflexivity implicated in policing the nebulous boundaries between cinema or theatre and the competing, although related, medium of television. As *Buenos Aires viceversa* and *Años difíciles* demonstrate an interface with television, they enter into a negotiation over the specificity of theatre and cinema as art forms, indeed into a negotiation of the concepts of genre and form in more general terms. For, if 'transteatralización' is collapsing the boundary between art and life, the boundaries between different art forms also become liquefied and the compartmentalisation of texts into genres or isolated forms no longer seems relevant. There exists, argues Jameson,

> a word that has tended to displace the older language of genres and forms
> [...] this is, of course, the word *medium*, and in particular its plural, *media*,
> a word which now conjoins three relatively distinct signals: that of an
> artistic mode or specific form of aesthetic production, that of a specific

6 When Bartís describes political actors as 'stanislavskianos' he is referring to a particular theory of acting whereby the actor should become absorbed totally in the psychological/ emotional depths of his or her character (see Stanislavski 1980). Bartís deliberately chooses Stanislavski to describe political theatre in order to underline the naturalness with which political spectacle is staged and artifice rendered transparent.

technology, generally organized around a central apparatus or machine; and that, finally of a social institution. (1991: 67, original emphasis)

He subsequently adds:

> It should be evident that most traditional and modern aesthetic concepts —largely, but not exclusively, designed for literary texts— do not require this simultaneous attention to the multiple dimensions of the material, the social and the aesthetic. (67)

What Jameson is pointing to with his use of the term 'medium', in preference to the term 'genre', is a certain fluidity between the traditionally separate fields of art, politics and society, fluidity —in Marxist terms— between the 'infrastructure' and the 'superstructure'. It is worth noting here that the field of performance studies likewise registers a kind of (disciplinary) fluidity. Within this context, there is inevitable fluidity between the various genres, or aesthetic forms, which have traditionally constituted the field of art.

A tension thus arises, as this play and this film attempt morally to distance cinema and theatre from television and reinvent themselves as significant cultural arenas for deconstructing the artifice —in the case of *Buenos Aires viceversa*— and performativity —in the case of *Años difíciles*— involved in broadcast television. The fact that they draw on televisual strategies, as if resigned to the fact that the viewing habits of their own spectators and their own aesthetic are irrevocably conditioned by television, should be interpreted perhaps as an attempt to reveal from the inside what theatre and cinema can tell us about television's impact on the formation of society. As neighbouring performance arts/media, theatre and cinema seem to be underlining their privileged position of elucidating the social and ideological effects of television.

In *Buenos Aires viceversa*, one narrative thread, in particular, foregrounds television's capacity to replace reality with televised images. Cristina, otherwise referred to in the film's credits as 'Loca TV', is a television addict obsessed with watching the daily news, on account of her fixation with the newsreader. She makes a habit of rolling her dilapidated television set up to the table, laying a place for the newsreader and serving him *milanesa* and wine so that they can eat together while he presents the nation's news. In her eyes, the newsreader's presence is actual rather than virtual and she converses with him as such.

Cristina represents an exaggeration of the stereotypical television viewer, one, as John Ellis argues, 'very far from being in a position of producing a totalising vision of the truth […]. For broadcast TV the regime of viewing is rather one of complicity with TV's own look at the passing pageant of life' (1982: 160). Cristina's behaviour replicates this collusion. She consumes the

information given to her by the television news and mechanically regurgi-
tates statistics, which are largely out of context, without questioning their
reliability. Implicit in this 'complicity with TV's own look' is also complicity
with the official version of events and Cristina falls victim to the illusions
constructed by television reportage, or what Pierre Bourdieu refers to as the
'*reality effect*' (1998: 21, original emphasis). 'The political dangers inherent
in the ordinary use of television', argues Bourdieu, 'have to do with the fact
that images have the peculiar capacity to produce what literary critics call
a *reality effect*' (21). It is not until the final stages of the film that Cristina
qualifies the mediated reality she views on television with the one she has
witnessed first hand on the streets, finally understanding that television is
producing a false account of reality.

This is just one example of the way in which *Buenos Aires viceversa* pits
illusion against reality. It is this distinction that formulates the film's political
message, as Agresti brings to light the illusion of television reportage (the
official version of events), by juxtaposing it with a harsher reality on the
streets of Buenos Aires, a reality captured in a rival documentary-style video
footage. This dichotomy is, therefore, also crucial in plotting the boundary
between television and film as, both of them, video-based media, an issue
which will be examined in greater depth further on.

In both *Buenos Aires viceversa* and Cossa's *Años difíciles*, it is the daily
news —the reporting of socio-political reality— that epitomises televi-
sion and radio broadcasting and serves as the gauge by which the disparity
between reality and its referent can be measured. The wholesale consump-
tion of television news as reality is a major theme in Cossa's play. Alberto
and Olga spend their days watching television, whilst Federico spends his
listening to the radio. As Federico and Alberto each recount the facts they
have heard on television and radio respectively about the same events, we are
able to examine the discrepancies in the information disseminated and ques-
tion the value of television in recording reality and producing knowledge.

In the opening section of the play, Alberto declares: 'mataron a diez mil
tipos en Ruanda' (Cossa 1999: 14). Federico contests this by declaring: 'no
fueron diez mil. No llegan a siete mil. Fue una mentira de la televisión. La
televisión exagera todo. Escuchá la radio' (14). The debate which ensues
regarding the relative value of visual and aural information media initiates a
negotiation of the boundaries distinguishing radio from television. What is
suggested is that radio is a more serious medium than television. Cossa juxta-
poses the visual impact of what Alberto sees on the television, 'los cadáveres
apilados en el desierto … los cuerpos negros y la sangre roja' (14), with the
greater complexity of information Federico claims to receive from the radio.
'Había viejos y chicos … mujeres viejas y mujeres jóvenes. Y una mujer
embarazada. Lo contaron por la radio. La radio te da más detalles' (14). This
allegedly more detailed account of events is nevertheless clearly limited. The

information given by the radio remains descriptive rather than analytical, placing a question mark over the depth of reportage in general.

It is Bourdieu, once again, who provides an insight into the reductive nature of television reportage, although it could be argued that his comments are equally relevant to radio. 'This vision', expounded by the television news,

> is at once dehistoricized and dehistoricizing, fragmented and fragmenting ... a series of apparently absurd stories that all end up looking the same, endless parades of poverty-stricken countries, sequences of events that, having appeared with no explanation, will disappear with no solution —Zaire today, Bosnia yesterday, the Congo tomorrow. Stripped of any political necessity, this string of events can at best arouse a vague humanitarian interest. (1998: 7)

Bourdieu's arguments are echoed in Postman's investigation on television (2005). Postman traces the shift from typography, as the major communicative and epistemological medium in society, to television: a phenomenon, he argues, which began with the invention of the telegraph and photography.

> The telegraph [and by extension television, he goes on to argue] made a three-pronged attack on typography's definition of discourse, introducing on a large scale irrelevance, impotence and incoherence. These demons of discourse were aroused by the fact that telegraphy gave a form of legitimacy to the idea of context-free information; that is, to the idea that the value of information need not be tied to any function it might serve in social and political decision-making and action, but may attach merely to its novelty, interest, and curiosity. The telegraph made information into a commodity, a 'thing' that could be bought and sold irrespective of its uses or meaning. (65)

The distinction between radio and television remains nevertheless important, not only in defining television as a specific medium, but above all in entertaining the possibility that each medium will inevitably shape its message —or discourse— differently. The distinction made in the play between radio and television engages in many ways with McLuhan's appraisal of them in his work *Understanding Media* (2001). McLuhan's argument that radio is a 'hot medium', whereas television is a 'cool medium' (24), throws light on the different ways in which each medium engages its spectators. Radio, as a 'hot medium', argues McLuhan, 'is one which extends one single sense in "high definition"' (24). Federico certainly supports this with his statement that, 'los que escuchamos la radio tenemos otra mentalidad. Desarrollamos el oído' (Cossa 1999: 18). 'High definition', McLuhan argues further, 'is the state of being well filled with data' (24). Federico certainly boasts that the

radio leaves him better informed than the television, although as has been demonstrated, the profundity of this information is questionable. He then explains the negative impact not listening to the radio is having on social interaction: 'La gente ya no se escucha,' he continues, 'se la pasa mirando la televisión y no se escucha' (18).

In contrast, television represents a 'cool medium', which involves both the visual and aural senses and thus 'creates audience involvement in depth'. 'TV', argues McLuhan, 'will not work as background. It engages you' (McLuhan 2001: 340). It is the 'low definition' (348) of the television image which draws the viewer in, as he or she must complete the image. The definition of television images is never demonstrated in the play, as the television set remains in Alberto's room —an offstage space only ever alluded to and from which Alberto and Olga emerge periodically. The flickering, grainy television images shown in *Buenos Aires viceversa* are, however, clearly 'low definition'. They are incorporated into the film in order to be contrasted with the sharper definition of the film's own cinematography. This contrast is foregrounded when the shot frame is aligned precisely with the television screen being filmed. The film spectator is suddenly forced into the position of the television viewer, whereupon he or she can tell the striking difference in quality between the televised image and the filmic image the sequence subsequently cuts to.

Television, as represented in these two performances, certainly reflects what McLuhan describes as an 'implosion', whereby 'our central nervous system is technologically extended to involve us' (5). When Cristina's television set breaks down, she demonstrates the kind of involvement generated from this 'implosion'. Although her screams of 'socorro' and 'neurología' out of her apartment window are referring to the television set, which she caresses and comforts as if it were human, her trembling and acute sense of panic suggest that it is she who needs neurological treatment. This is further reinforced when the television is fixed and Cristina rejoices with cries of '¡vive, vive!'. The farcical nature of this instance is reiterated in a subsequent shot of the technician who has come to repair the ailing TV set. The man, who will eventually coax Cristina away from her infatuation with the news reader, is perched directly behind the TV set. As his head protrudes slightly above the box and his feet poke out beneath, we are given a brief, but humorous, image which sketches out the supposed human qualities of the television set in a ridiculous coming together of man and machine.

Much like Cristina's, Alberto and Olga's involvement with what they see on the television is such that they are no longer able to think independently. The discussion of Rwanda again confirms this when Olga asks Federico if those who have died are '¿todos negros?' (Cossa 1999: 14), to which Federico replies sarcastically: 'Supongo que sí. Es en Ruanda' (14). Olga unfortunately does not detect the tone of sarcasm in Federico's voice and takes his answer

literally: 'Suponés. Si lo vieras por la televisión en colores lo sabrías. El que es negro aparece negro y el que es blanco aparece blanco. Y la sangre se ve roja, como dijo tu hermano' (14). Both Olga and Alberto are shown to be so dependent on the television that they become literally incapable of thinking 'outside the (little black) box'. Just like Cristina, they are unable to view television with any sort of critical distance.

Federico may seem to be less absorbed by the radio than his wife and brother are by the television, but he is gradually revealed to be just as conditioned by media stereotypes as they are. Once again, Bourdieu's analysis of television reportage illustrates television's capacity to cultivate a fear of the Other.

> [T]he journalistic evocation of the world does not serve to mobilize or politicize; on the contrary, it only increases xenophobic fears, just as the delusion that crime and violence are always and everywhere on the rise feeds anxieties and phobias about safety in the streets and at home. (1998: 8)

Federico, in turn, represents a stereotype of the Argentine middle class, which Cossa caricatures in many of his plays. As Federico recounts the incident in which a Bolivian was killed outside his home, he makes one of several slips which reveal that underneath the liberal façade, he is imbued by the same media-generated prejudices as his brother and wife: 'Y casi nos matan a todos,' he recounts, with relief that no one of importance was killed. He then goes on to make the slip: 'gracias a Dios al único que mataron fue el boliviano' (18). Having criticised Alberto for calling the police when the Bolivian knocked on the door for the simple reason that he was Bolivian, Federico's attitude is shown to be no different.

It may seem strange that Cossa goes to such lengths to set apart radio and television, only to reason ultimately that they cultivate the same prejudices in their spectators. In other words, their spectators are clearly consumed by the same ideology. However, as previously mentioned, the differentiation of television and radio as genres is crucial in implying that different media (or performance types) can adopt a different and potentially subversive, discursive position. The negotiation of boundaries between radio and television in *Años difíciles* can be mapped onto the less palpable, yet arguably more significant, demarcation of the boundary between television and theatre hinted at in the play. This process of demarcation emerges when the play is examined through the paradigm of performativity.

The incident involving the Bolivian is just one instance where Cossa draws out the performative nature of television reportage, demonstrating that televised reality is staged. This is obvious as Federico recounts the farcical television coverage of the incident. He explains:

En la televisión todo es falso. Como cuando mataron al boliviano. Los de la radio llegaron enseguida. La televisión, ¿quiere creerlo?, dos horas después. ¿Sabe qué hicieron? Contrataron al hermano del boliviano ... le dieron unos pesos ... y le hicieron hacer de cadáver. Falso. Todo falso. (1999: 19)

The issue of theatricality in Argentine television is an enduring concern often, although not uniformly, associated with artifice. One of the articles in the *TV Guía Negra*, a collection of articles written about television in Argentina in the early 1970s, refers to this as 'el periodismo como [un] show […] en el que el entretenimiento le quita lugar a la verdadera información' (in Silvia Walger and Carlos Ulanovsky 1974: 103). For it is television's value as entertainment that governs ratings and thus defines it as a viable commodity (Bourdieu 1998: 6; and Postman 2005: 14). It is not unusual on Argentine television for the latest news items to be marketed in the same sensationalising tone as the afternoon 'telenovelas'.

In *Años difíciles*, the staging of reality on television is shown to infiltrate the process of spectatorship and impact on the way viewers behave. Here, Cossa echoes the ideas of symbolic interaction, highlighting what Schechner outlines in his *Performance Theory* as the 'coexisten[ce]' between 'phenomena called … "drama," "theater," "performance,"' and 'the human condition' (2003: 66). The characters in the play behave as if performing continually in front of a television camera. Never is this clearer than in the final stages of the play, as Federico's repeated exclamation, 'envenenáte con la televisión', literally becomes true (Cossa 1999: 15). When Mauricio, Alberto's long lost son, comes to the family home in search of his father and his uncle, he comes to poison them for having broken his mother's heart. Mauricio has, of course, found the inspiration for his elaborate plot of revenge from no other source than a television programme. He recalls: 'Tenía mis dudas de cómo hacerlo hasta que apareció en la televisión la historia del propóleos' (37). 'Aquella vez no murieron todos. Pero no se preocupen ... Yo hice una mezcla con arsénico diluido en alcohol metílico y clorhidrato de potasio. Es rápido e indoloro' (38). Not only has the television influenced his behaviour and his revenge, but he also desires that his actions be staged on television. '"To be is to be perceived"' —as George Berkeley's spin on the Cartesian maxim 'cogito ergo sum' reads— '[s]o the television screen today becomes a sort of mirror for Narcissus, a space for narcissistic exhibitionism' (Bourdieu 1998: 14). Hence, Mauricio reaches for the telephone and calls a television station. '¡Hola …! ¿Canal? Ah, sí señor. Me llamo Mauricio Valdés. Acabo de envenenar a mi padre, a mi tío y a la mujer de mi tío. Manden cámaras. Al barrio de Colegiales. Frente a la estación' (38). The farcical nature of the scenario escalates when Olga rejoices that, although she is in fact about to die, she will appear on the television: '¿Van a venir de la televisión? ¿Oíste,

Federico? ¡Van a venir de la televisión!' (38). Alberto is equally excited at the prospect, and when he and Mauricio realise that they have both seen the same North American series which inspired the plan, they embrace. Mauricio tells his father lovingly: 'Hubiera sido lindo que usted y yo mirábamos el programa abrazados. Como ahora. Me hubiera gustado conocerlo antes de matarlo' (40).

The fact that Cossa draws out the (rather melodramatic) theatricality in television and consequentially in human behaviour using traditional forms of theatre renders the boundary between theatre and television somewhat hazy. By hemming the performances of these media addicts into the well-established formulae of the '[reality] deforming' *sainete* and 'black humour[ed]' *grotesco criollo*,[7] Cossa introduces an essentially unpleasant scenario into a comic structure which causes his audience to laugh, albeit 'uneasily' (Gail Bulman 2002: 5) and realise a cathartic cleansing of the evils of middle-class *porteño* life. These cathartic mechanisms nevertheless place a question mark over the political efficacy of the play. *Años difíciles* may represent what Bulman describes as 'the type of comic agony', through which 'the actual state of Argentina and its citizens' is acutely felt (10–11), but this canonical mechanism of catharsis, typical of Cossa's work, seems to serve ultimately to purge, through laughter, the audience's conscience of the issues raised.

The decision to insert the play into the traditional comic structures of the *sainete* and the *grotesco criollo* can, however, be read in two disparate ways: on the one hand, to invoke a sense of catharsis and ultimate closure on the issues raised; on the other hand, to bolster a long-established tradition of socially engaged popular theatre in Argentina (see Osvaldo Pellettieri 1989: 80–3). What is really at stake is the latter, the play's own position in culture and within an established pedigree of home-grown theatrical genres. The politics of culture in *Años difíciles* represent theatre's attempt to re-establish its own social agency, more than produce an effective critical assessment of television viewing habits. Although the apparent catharsis could be argued to interfere with any enduring impact in the play's critique of television spectatorship, the inclusion of these two important Argentine comic theatrical traditions belongs to the play's reflexivity, which serves to assert its own status as theatre. By drawing out the theatrical side of television —theatre effectively highlighting characteristics of itself in its Other— Cossa not only aligns theatre with television, but cannily attempts to subordinate television through his critique of televised realities. The fact that the television set remains offstage forms without doubt part of this subordination. Theatre is

7 The *sainete* is a popular, early twentieth-century form of one-act play, often considered to be a form of fiesta, which developed among poor Italian immigrants to Buenos Aires. As the expectations and illusions of immigration wore thin, the *sainete* progressively transmuted into a grotesque form of theatre, termed the *grotesco criollo*.

allowed to invade television, but theatre resists being invaded by television insofar as it is able to do so. 'El teatro lo ha invadido todo,' affirms Bartís, '[e]ntonces el arte teatral necesita cierto recogimiento para salvar lo que le es propio' (2003a: 146). *Años difíciles* certainly replicates this generic anxiety and attempts to reaffirm theatre's specificity as an art form.

Recent studies which take an overview of theatre production in Buenos Aires have focused on the issue of 'convivio' as key to understanding what sets theatre apart from other forms of artistic expression. Jorge Dubatti, the most prominent commentator on the topic, defines 'convivio' as follows:

> La base de la teatralidad debe buscarse en las *estructuras conviviales*. Sin convivio —reunión de dos o más hombres, encuentro de presencias en una encrucijada espacio-temporal cotidiana— no hay teatro, de allí que podamos reconocer en él el principio —en el doble sentido de fundamento y punto de partida lógico-temporal— de la teatralidad. (2007: 43, original emphasis)

Harking back to ancient ideas of theatrical conviviality expressed in Plato's *The Banquet* and later reiterated in Dante's *Convivio*, Dubatti uses ancient theatrical traditions, effectively claiming ancestral rights, in order to shore up theatre's (superior) status as the original sociable art form. Within a more recent context, the idea of 'convivio' can be equated with debates over theatrical specificity which differentiate theatre from film and other audiovisual media with respect to audience/actor presence, a brief history of which was given earlier on, in the Introduction. *Años difíciles* plays with this idea of 'convivio': the pure here-and-now of the performance. Whereas television and film rely on technology to simulate presence, be it the presence of the performer in the space occupied by the spectator or the presence of the spectator in the performance space, theatre usually takes place in a space occupied simultaneously by both performers and spectators alike (although exceptions to this rule will be considered in chapter 4). It is made very clear throughout the play that television thwarts 'convivio' in both the artistic and social senses of the word. Television audiences are diffuse, meaning that culture is no longer a pretext for public gatherings. Cossa reminds us that the Stancovich family hardly ever leaves the house, for fear of the street outside. What progressively becomes clear is that the type of communities which have emerged since the advent of the telegraph and subsequently the television 'may have made the country [and indeed, as McLuhan would argue, the globe (2001: 3)] into "one neighbourhood", but it [is] a peculiar one, populated by strangers who [know] nothing but the most superficial facts about each other' (Postman 2005: 67). Television may enable the virtual interaction between the residents of the 'global village', but only theatre can achieve actual presence (although even within

the theatre the degree of interaction enabled between performer and spectator depends on the permeability of the 'fourth wall'[8]).

In many ways television is also subordinated to film in *Buenos Aires viceversa*. The strong critique of corruption and political cover-ups that punctuates the film relies very much on distinguishing film from television, the latter being portrayed as an inferior medium. The reality of the street, as portrayed by film, is placed in stark contrast to the way this reality is masqueraded on television. This is most evident at the end of the film when many of the characters converge in a shopping gallery and witness the murder of the young street boy, Bocha. It is, rather poignantly, the only moment in the film when the various protagonists all appear in the same place at the same time (Gunderman 2004: 87). Bocha has befriended Daniela and accompanied her in her task of filming the city for the old couple, who have commissioned a video because they are too afraid to go out and see for themselves. He provides encouragement and inspiration for her and she in turn offers him affection, food and a roof over his head. In the final stages of the film he accompanies Daniela to the shopping gallery, where she is trying to locate a piece of classical music which reminds her of her disappeared parents. Bocha soon gets bored with this activity and goes off to look around by himself, eventually leaning into a shop window and taking a video camera. The security officer in the gallery is alerted and proceeds to shoot the defenceless little boy in the chest from a balcony. The security guard's crime far outweighs the crime committed by Bocha. Upon witnessing this incident, Tigre, a boxer, is compelled to assault the security guard in search of some kind of justice, as well as a demonstration of his obvious outrage.

The official version of this incident is, however, very different, as Cristina realises when she compares the shooting she has witnessed in the afternoon with the report her beloved newsreader gives on the evening news. Once again the artifice involved in television reportage is shown to be a key mechanism for upholding the dominant ideology. Tigre, allegedly under the influence of alcohol, is accused of launching an unprovoked attack on the security guard who, whilst trying to defend himself, accidentally shoots Bocha, claimed to be an innocent bystander. Tigre is thus remanded in custody and blamed for the entire incident. The uncomfortable posture of the newsreader and his excessive use of hand gestures as he stutters his way through a pseudo re-enactment of the incident suggest that he is uncomfortably incriminated in a cover-up, thus pointing to the artifice implicated in official reportage.

8 The term 'fourth wall' is most commonly associated with Brecht. It defines the conceptual wall marked along the stage footlights between stage and audience, performer and spectator. Brecht was adamant that this imaginary wall should be broken down so that the spectator could engage (critically) with the spectacle (see Brecht, in Willet 2001: 71).

Echoes of the controversial laws of impunity passed by Presidents Raúl Alfonsín and Carlos Menem resound, echoes which resonate even more powerfully given what we already know about the security guard. We first encounter the security guard in a rather banal family evening at home. Yet by the time he carries out the shooting in the shopping mall, the spectator is already aware of his odious character and his previous role as a repressor in the 'Proceso'. Once again, the justice system is demonstrated to be riddled with corruption. Once again, a repressor is not judged and duly punished for his violent crimes.

In the longest and arguably most wicked scene of the film, the guard lures a blind woman into the *telho*,[9] claiming that he is inviting her into his home. What initially appeared to be an amiable gesture of helping her across a busy road is in fact a sadistic plan to taunt her on account of her disability, which this bigoted character associates with political subversion. Once inside the motel room, the man disappears immediately into the bathroom. He begins to obsessively, compulsively scrub every inch of his hands several times over, an action which typically reflects the torturer's mentality and discourses of repression which portray the subversive enemy as 'dirty' and as a person of whom society must be 'purged'. The woman's suspicions are raised when he does not answer her and, as she begins to be aware of the mirror-clad walls of the motel room, she realises that she is not in anyone's home. The man returns and proceeds to goad the woman mercilessly as he chases her around the room. 'Hija de puta. Zurda de mierda', he cries at her as she desperately flings her stick in all directions in an attempt to defend herself. The close-ups and frenzied camera movement effectively replicate the victim's disorientation in the spectator. The camera struggles to follow the action, having to evade it at times, thus heightening the tension of this seemingly interminable scene. When the camera finally cuts rather abruptly from the motel, it is hardly to the relief of the spectator, who is plunged into a vacuum of deafening silence which accompanies a shot of the guard's despondent looking nephew (the *telho* receptionist), who is suddenly trying to come to terms with the truth about his uncle's past, which he has just overheard on a makeshift radio set up to eavesdrop on clients. With this in mind, the spectator is left in no doubt as to the continuity sketched out in this film from dictatorship to neoliberal Argentina of the 1990s.

The effects of the past weigh heavily on the film's present, as an undeniable link is made between the violence in the neoliberal society of the 1990s and the violence of the dictatorship. Drawing on the work of León Rozitchner, Christian Gunderman repeatedly returns to this point in his comprehensive analysis of the film. He argues:

9 *Telho* is an inversion of the word *hotel* and is the Argentine slang word for motel.

El año del estreno de la película coincide con la fundación de la organiza-
ción HIJOS y con una renovada política de izquierda a partir de las cenizas
del *proceso* y de la continuación de éste por la política económica del dúo
Menem/Cavallo a principios de los noventa, el momento histórico en que
la política se constituye como continuación de la guerra (sucia) por otros
medios. (2004: 86)

'People were tortured so prices could be free', as Uruguayan journalist/
novelist Eduardo Galeano explains so succinctly (cited in Idelber Avelar
1999: 231). This link is further made explicit in the film in the sequence
in which Daniela emerges from the shopping centre and tries to come to
terms with the murder of her little friend. As she walks down the street
in stunned silence, the camera cuts periodically to a parallel sequence in
which another young woman, who we assume to be her now disappeared
mother, is walking down the same street and being pursued by a threat-
ening looking man in a suit and sunglasses. The camera follows Daniela,
adopting the perspective of the pursuer, and then cuts to a shot which now
faces the other woman, the man looming behind her. Both women enter the
same public toilet, Daniela is comforted, rather ironically, by the security
guard's nephew who hears her screaming hysterically, offering a hint of
unity and salvation for the future. The second woman is brutally attacked
as a timely reminder of the past with which Daniela must come to terms,
albeit one she may never escape in this environment of continued violence
and corruption.

The artifice in television reportage should be read as an attempt to ensure
the ideological/political continuity outlined by Gunderman. Slavoj Žižek's
breakdown of ideology aids in explaining the importance of making a scape-
goat of Tigre in order to prevent the police and justice systems —an 'Ideo-
logical', but also in this case, 'Repressive State Apparatus'— from being
questioned (1999: 193–4). It is easier to make a scapegoat of an adult boxer,
whose profession is easily associated with violence, than of a child, who is
more likely to draw sympathy. Hence, the shooting is portrayed as a tragic
accident. Above all, to ensure ideological transparency and continuity, the
system cannot be placed in question.

This illusory nature of realities constructed on television is clearly wrapped
up in a political critique of Argentina in the 1990s, the highly theatrical nature
of President Carlos Menem's regime and its unscrupulous use of the media.
To cite the *TV Guía Negra* once again, '[l]a televisión proyecta con frecuencia
la imagen distractiva de un país imaginario' (in Walger and Ulanovsky 1974:
83). In the case of *Buenos Aires viceversa* this 'país imaginario' is nothing
more than an illusion, fabricated in the rose-tinted reports of strong economic
growth in the news, which cause Cristina to rejoice in a patriotic chant of
'Ar-gen-tina, Ar-gen-tina'. The reports of a buoyant national market are of

course part of television's function as an ISA, maintaining the societal model of consumption in a similar way to the adverts discussed earlier on.

The distinction made in the film between the reality on the street and this 'país imaginario' propagated on the television throws light on the way in which television, as a medium, is re-conceptualising the spatial and temporal boundaries of the nation. As people no longer seem capable of interacting on an interpersonal level, television is accused of functioning as a postmodern equivalent of the age-old strategy of divide and rule. In both *Buenos Aires viceversa* and *Años difíciles* the street is shown as a hostile space. In the case of the Stancovich family in the play, only Olga goes out of the house, in order to take out the rubbish. Alberto reveals how the television has made him fearful of the outside, making him untrusting and suspicious of strangers. He thus criticises Federico for having allowed Mauricio to come into their home.

> ¿Cómo entró este señor a esta casa? ¿Cómo entraste, ladroncito? ¿Te creés que no me di cuenta? Acabo de ver 'Policía en Nueva York'. Se meten en tu casa con cualquier excusa ... Igual que allá. ... Allá son los negros, pero es lo mismo ... Llamen al 101 ... [...] Nos quiere sacar plata. (Cossa 1999: 26)

The value of the nation as a cultural referent is clearly undermined by the fact that Alberto's fear is being cultivated from the streets of New York, rather than those of Buenos Aires. His obsession with monetary value, which goes hand-in-hand with societal models of commodification and consumption, is also demonstrated here. Likewise, a parallel can be drawn once again between violence and fear (of association) in 1990s neoliberal Argentina and that of the 'Proceso'. In the film, there is also an example of this in the old couple who, since the disappearance of their daughter —we assume as a result of the dictatorship— have refused to go out into the street out of fear.

Jesús Martín-Barbero's assertion that television has taken the place of communication on the street reinforces this:

> ese medio se ha convertido en el vínculo vicario pero eficaz de un deter-minado modo de relación con la ciudad. [...] Si la televisión atrae es, en buena medida, porque la calle expulsa. Es la ausencia de espacios —calles y plazas— para la comunicación lo que hace de la televisión algo más que un instrumento de ocio, un lugar de encuentro. De encuentros vicarios con el mundo, con la gente y hasta con la ciudad en que vivimos. (2000: 30–1)

Martín-Barbero clearly perceives television-viewing to be a new form of collective ritual, forging virtual national identities as viewers tune in simul-taneously to the same programme.

This idea of simultaneity is fundamental to Benedict Anderson's definition of the nation as an 'imagined community' (2006: 24). '[N]ationality', 'nation-ness' and 'nationalism' are, he argues, 'cultural artefacts of a particular kind' (4). Anderson conceives of the nation as a modern cultural phenomenon, which has grown out of 'print-capitalism' (18), the novel and the newspaper being the 'mass-produced industrial commodit[ies]' structuring this commu-nity (34). Nowadays, it is clear that television has displaced 'print-capitalism' as the dominant mass cultural form giving shape to this 'imagined commu-nity'. Society has experienced 'the decline of the Age of Typography and the ascendancy of the Age of Television', Postman affirms (2005: 8). Caught between the literary and the televisual, *Buenos Aires viceversa* and *Años difíciles* exemplify theatre and cinema's attempts at carving out a space for themselves as bona fide narrators of the nation. They endeavour to compli-cate Postman's schema by introducing into it a continued role for theatre and cinema, as agents of 'convivio'. If television represents a more widespread temporal simultaneity, film and theatre mourn the loss of spatial simultaneity (presence/'convivio').

Martín-Barbero's play on the terms 'medio' and 'miedo' also reflects a long-standing issue in Argentina —and indeed Latin America in general— regarding the violence of television and its capacity to incite fear (see Martín Barbero 2000). Psychoanalyst Pacho O'Donnell outlines this. He writes: 'volví a reunirme con la idea sobre la violencia de la televisión. Que no son los tiros o los crímenes [...] sino el modo como se descentra a la realidad de su lugar' (in Walger and Ulanovsky 1974: 77). Both *Buenos Aires viceversa* and *Años difíciles* draw a parallel between insti-tutional violence and the way in which television endorses such violence by 'decentr[ing] reality' in order to cover it up. On a more abstract level, both texts highlight 'the many kinds of censorship [which] operate to make television such a formidable instrument for maintaining the symbolic order' (Bourdieu 1998: 16). Endorsing this 'symbolic order' is a 'pernicious form of symbolic violence [...] violence wielded with tacit complicity between its [television's] victims and agents, insofar as both remain unconscious of submitting to or wielding it' (17).

Television and film in *Buenos Aires viceversa* thus represent competing aesthetic forms for narrating the Argentine nation. The aesthetic heteroge-neity of *Buenos Aires viceversa* bears testament to this. The film comprises a hybrid of traditionally cinematic strategies and aesthetic strategies more often associated with television. Hand-held, fly-on-the-wall style camera work, combined with extreme close-up shots, draw on a documentary style of television reportage. Likewise, the technical roughness, poor editing and poor focus of much of the footage conforms to the 'live' format of television. In certain sequences, on the other hand, slowed movement overlaid with an extra-diegetic musical soundtrack demonstrates a classically cinematic style.

There exists a definite sense that whilst film recognises its aesthetic overlap with its audiovisual other, Agresti is also asserting the specificity of film. This is clear in several sequences in which Agresti appropriates conventional aesthetic strategies from television, only to strip them of any obvious editorial manipulation. Sequences in television are usually much shorter, lasting no longer than a few seconds. In contrast to this, there are several (rather paradoxical) instances in the film in which uncut footage means that the camera is left observing the scene without any obvious editorial intervention, as if film is being credited with the rawness and immediacy we would normally expect from television. Gunderman reads this as a citation of 1960s revolutionary filmmaking by the likes of Pino Solanas, Octavio Getino and Fernando Birri, or likewise of Brazilian filmmaker Glauber Rocha's 'aesthetics of hunger' (2004: 95–6 and 102). Whilst I concur with Gunderman's reading of the film's aesthetic, I would also add that in many ways Agresti also preempts Argentine film's predominant shift (or return) towards a reality-uncut documentary style of cinematography, emblematic of films produced in the late 1990s and early 2000s under the critical banner New Argentine Cinema (see chapter 4).

At certain points during the film, Agresti even takes film beyond the visibly manipulated images we see on television, to propose an uncut and at times crude perspective on reality. At several points in the film, he deliberately employs a confusing series of open frames, upsidedown takes and extreme close-ups as the camera trembles in a way that is more reminiscent of an amateurish, although arguably more genuine, style of home video. In other instances, he employs montage editing as a means of drawing attention to the way in which video technologies can manipulate visuality. This is contrasted with the continuity editing most often used in television to create a sense of complete authenticity through the illusion of representational transparency.

There is, however, never a sense that these different aesthetics are in tension with one another. Rather, they represent three levels of reality at work in the film's discourse: firstly, the manipulated images of reality as broadcast on television; secondly the uncut, highly documentary style of footage portraying reality on the streets; thirdly, the reality-that-could-be, romanticised through a classically cinematic portrayal. These three levels of reality all serve to construct a reflexive dimension to the film, which draws attention to the way in which images are capable of manipulating the spectator's vision of the city.

The variety of contrasting techniques employed throughout *Buenos Aires viceversa* certainly informs the film's politics: a politics of visuality. Or indeed, the film's politics of visibility, for ideology can in many ways be construed as a question of visibility. De-naturalising the myths that uphold society's prevailing ideology involves making the non-visible visible once again (Žižek 1999: 59). Television, video and cinema may share the same

technologies, but the message is clear: as media they function in very different ways.[10]

When Daniela is tasked with making a film of the streets of Buenos Aires for the old couple who refuse to go out, this becomes clear. The couple are shocked by her first attempt, which consists of a series of close-up shots of people on the street: street vendors, performance artists, homeless people, children and immigrants; one could say, a very honest and intimate vision of Buenos Aires. Her second attempt at finding beauty on the streets is much more successful as she elevates the camera above street level and films the city's rooftops. Daniela trades the close-up for a series of long shots taken from a far enough distance to avoid any details or discrepancies in the cityscape being apparent. The old couple are delighted with the series of carefully crafted still shots, in which no human presence can be detected whatsoever but the beauty of Buenos Aires' architecture is foregrounded. They agree to pay Daniela this time for her work. Once again this underpins the political message of the film: that since the dictatorship, society has been overwhelmed by a fear of association. The old couple cannot even virtually interact with fellow citizens. Also significant is the fact that it is this vision of the city which Daniela has managed to turn into a viable commodity. The previous attempt may be more representative of life on the streets, but bears no exchange value in a system where market demand governs the content of media production (Gunderman 2004: 99).

Indeed, the juxtaposition of these two videos of the street demonstrates a more complex approach to ideology than in the narrative thread which recounts the story of Cristina. In order to explain this more complex schema of ideology, Žižek places a spin on the Marxian maxim '[t]hey do not know it, but they are doing it', converting it to: '[t]hey know very well what they are doing, yet they are doing it' (1999: 62).[11] The old couple are what Žižek

[10] This is a message that the director returns to in his subsequent film *El viento se llevó lo que* (1998), an allegory of Argentina's peripheral experience of modernity and its location at the very end of the film distribution circuit; Agresti nevertheless celebrates cinema's capacity to bring communities together in a collective and public cultural experience. When television arrives in the secluded Patagonian settlement of Rio Pico at the end of the film, the cinema becomes progressively less populated —the streets deserted— as people retreat into their homes. Main character Soledad remarks in the final voice-over that 'un pueblo con televisión se parece a cualquier pueblo', thus suggesting that whilst film, as a medium, does not place in question local cultural specificities, TV is promoting an increasingly homogeneous, global culture/community.

[11] Žižek problematises the binary formation reality/ideology by introducing a Lacanian structure into his conceptualisation of ideology. In this schema, reality and ideology are co-dependent, as ideology is spawned from the gap between reality (read as the Lacanian Symbolic order, which is structured like a language/fiction) and the 'Real' (which contains what is beyond language and the relatively reductive schema of the Symbolic order) (1999: 79). Ideology glosses over the inevitable excess of the 'Real' in relation to reality. Žižek develops this more complex

would term 'cynical' subjects of ideology (68). Whilst their fear of going out onto the streets is reinforced by the obvious fear of their immigrant, poverty-stricken other portrayed in the video, they remain in denial and will only accept the skilfully edited version Daniela presents in her second attempt at filming the streets of Buenos Aires.

In *Buenos Aires viceversa* and *Años difíciles*, both cinema and theatre are inevitably implicated in defining their specificity through a dialectical engagement with related genres —this often means with each other, which was addressed in chapter 1— but in these cases with television (Robert Stam 2000: 122–3). This question of specificity goes far beyond the commercial and industry-related issues which often place theatre and cinema in competition with television. It is important to look beneath these commercial issues and consider that theatre and cinema also represent competing images, perform-ances, or competing agents of 'convivio' in the construction of 'imagined communities' that conceptually inform the city of Buenos Aires and Argentina as a nation (Anderson 2006: 22). Analysis of *La nube* in chapter 1 intro-duced the idea of television's increasing cultural hegemony as the emblem-atic medium of the culture industry. The works analysed in chapter 2 enable a more detailed analysis of the way in which discourses of advertising and processes of television spectatorship inform social relations and a collective (national) identity in line with the dominant ideology of consumption.

Film may have been the paradigmatic medium of modernity, but it must now recognise television as the signature medium of postmodernity, a phenomenon Stam refers to as 'post-cinema'. He contends: 'Just one, rela-tively narrow band on a wide spectrum of simulation apparatuses, film is now seen as on a continuum with television, rather than as its antithesis, with a good deal of cross-fertilization in terms of personnel, financing, and even aesthetics' (2000: 315). *Buenos Aires viceversa* certainly shows an awareness of this overlap, appropriating the conventional aesthetic strategies of televi-sion, whilst at the same time maintaining film as the antithesis of television, as Agresti implicates the latter in his critique of Buenos Aires in the 1990s. Although theatre does not belong to the same spectrum of 'simulation appara-tuses' as film and television, it can nevertheless be drawn into a parallel area of debate, as both cinema and theatre anxiously work to define their relation-

approach to ideology in order to qualify the argument that we have reached the 'end of ideology' (see Daniel Bell 1965). For postmodernity is often associated with a post-ideological world. Žižek nevertheless argues that we are still living in an ideological world, but that there are no longer two opposing dominant ideologies (capitalism versus communism). He argues that our relationship to ideology is now governed by a certain 'cynicism', which recognises that we are consumed by a single dominant ideology (1999: 62): that of late (consumer) capitalism. At the same time, however, our actions continue to conform to this ideology. 'They know very well what they are doing', claims Žižek, 'yet they are doing it' regardless (62). It is important for him to assert the continued existence of ideology in order to maintain the possibility of an alternative.

ship to television, renovate themselves as genres and in doing so re-establish themselves as an alternative political voice. By drawing out the theatricality in television and in human behaviour, *Años difíciles* places television on a continuum with theatre (an expanded version of the performance continuum introduced in the previous chapter), whereby the two genres coincide through the notion of performance. In both *Años difíciles* and *Buenos Aires viceversa*, this culminates in a rather narcissistic political discourse on the negative impact that television spectatorship is having on the social fabric of Buenos Aires, whereupon the policing of boundaries between theatre, cinema and television and the reassertion of cinema and theatre as mainstream genres is implicated in the construction of a social critique of the darker, fragmented side of *porteño* everyday lives.

In a society now dominated by the logic of consumption, television is clearly no longer a subordinate Ideological State Apparatus. Quite the contrary: what is demonstrated in these films and this play is the threatening scenario that television functions as a hypermedium —a super ISA— located at the interface between the 'Superstructure' and the 'Infrastructure'. Television now informs the dominant ideology that unifies other apparatuses into harmonious ideological control. It is shown to have had an impact on education, the family, social communication, culture, as well as both the political and legal systems, and can perhaps best be defined as a replacement to the Church as the postmodern 'opium of the people'.

'Metáforas del Fracaso' or 'a Family Romance'?
Resuscitating Aesthetic Lineages

La Argentina se tiene que hundir. Se tiene que hundir y desaparecer, no hay que hacer nada para salvarla, si lo merece volverá a reaparecer y si no lo merece es mejor que se pierda.

Ezequiel Martínez Estrada, cited in Ricardo Piglia, *Crítica y ficción*, 53

There exist conflicting opinions as to whether the postmodern is capable of political engagement. This issue largely centres on the representational function of intertextual citation —or 'ironic quotation', 'parody' and 'pastiche' as it is varyingly called (Hutcheon 2002: 89). For Fredric Jameson, intertextual citation —or pastiche— represents nothing more than a superficial mimicry of old styles, which when pulled out of their original contexts initiate the collapse of historical time into a 'pseudo-historical depth' (1991: 20). In this conception of the postmodern —spatially reduced to surface level and temporally reduced to the present— the imagined future (or Utopia) is no longer viable. The term 'postmodernism' itself, alongside a series of other commonly referenced phenomena defined by the prefix 'post', testifies only to what it follows and makes no provision for political change and Utopia, which are inevitably associated with the future. In contrast, Linda Hutcheon argues that intertextuality —this time in the form of parody— is inherently political. 'Complicit' with what it parodies —yes— but nevertheless 'a value-problematizing, de-naturalizing form of acknowledging the history (and through irony, the politics) of representations' (2002: 90). If reality can only ever be approached through different forms of representation, then 'a politics of representation' soon translates into 'a representation of politics' (90).

This chapter examines what I will argue are two *postmodern* and *political* science fictions: Fernando Spiner's film *La sonámbula* (1998), and Ricardo Bartís' play *Postales argentinas* (1988). The plethora of citations which compose each of these texts will be read as a discursive engagement with other texts, aimed at negotiating the artistic identities of theatre and cinema, as well as constructing vital aesthetic genealogies in which such identities

can be grounded: in short a 'politics of representation' (Hutcheon 2002: 90). What will be examined is how the artistic identities and traditions performed in this play and this film compensate for the dystopian portrayals of a nation's failure, a failure characterised by rupture or erasure of both its history and identity. Furthermore, as science fictions, both *Postales argentinas* and *La sonámbula* expose an imagined future: the film portrays Buenos Aires in 2010, the play in 2043. This future may be rather a bleak one, but what is the key definer of political agency if not the capacity to historicise the present and, in doing so, envisage the future?

Buenos Aires 2010: the city has receded behind the thick fortressed walls that shield Capital Federal from a wasteland that lies beyond. Beyond this urban fortress, only the flooded shells of buildings and a bent, rotten old sign indicating 'Lanús' bear any hint that this wasteland once formed part of the densely populated southern suburbs of 'Gran Buenos Aires'. Within the metropolis, a concrete jungle of skyscrapers towers over older-style build-ings, those, such as the Abasto shopping centre, that one would expect to find on the streets of Buenos Aires today. Street level is, however, no longer a navigable space. The ground serves as nothing more than a giant dumpster, inhabited by a blanket of the burnt-out shells of cars —vehicles which were once an iconic symbol of modernity, here the iconic symbol of its decadence. Movement in this Buenos Aires of the future —of postmodernity— has been pushed either underground in tunnels of the 'Subte' or overground on one of the highways that weaves its way across the cityscape amid the tower blocks of a menacing Manhattan-style skyline. In 2010, 'BIG BROTHER' scrutinises everyone. Electronic barcodes grafted onto human skin, tracking devices surgically introduced into the human body and ubiquitous closed-cir-cuit camera surveillance all form part of a sinister governmental panopticon managed by the 'Ministerio de Control Social'.

Buenos Aires 2043: a city post-apocalypse, on the verge of extinction. '[U]na ciudad devastada', as Héctor Girardi, the only surviving witness to the destruction, informs us. Héctor finds himself in 'un Buenos Aires que emite sus últimos estertores. En las esquinas, las fogatas de los sobrevivientes iluminan los esqueletos rancios de mis vecinos de antaño. Hay viento y hay cenizas en el viento' (Bartís 2003b: 43). 'Todos son despojos, desechos de la jactancia humana, hundidos en la fosforescente negrura de la noche [...] entre restos de fábricas, viviendas y automóviles' (54). The strangely ecstatic tone of his final exclamation on the Puente de La Noria, as he confronts the dereliction that lies before him, suggests a man on the brink of delirium: '¡Qué hermosa está Buenos Aires! ¡Negra! ¡Negra y brillante como un pres-agio de la muerte!' (61).

Such are the prophecies of urban decay and impending doom offered respectively in *La sonámbula* and *Postales argentinas*, prophecies which serve as patent allegories of Argentine postmodernity —what Geoffrey Kantaris

Fernando Spiner's vision of Buenos Aires 2010 in *La sonámbula*. By courtesy of Fernando Spiner

Spiner creates a future metropolis in *La sonámbula* to represent Buenos Aires in 2010

in his analysis of *La sonámbula* describes as an 'aggressive postmodernity cut through with the shattered fragments of a stalled modernity' (2008: 52). The linear progression from barbarism to civilisation, so fundamental to the Argentine discourse of modernity, in these texts takes on a regressive dynamic as the passage from nature to culture, supposedly nourished by the fruits of technological advance and cultural civilisation, represents instead, in the extreme, a deterioration towards barbarism, this time an institutionalised urban style of barbarism rather than that spawned at the mercy and anarchy of nature.

Quite the opposite in fact: the 'Pampa', so long revered by nineteenth-century intellectuals as the home of the savage *gaucho* and the cradle of barbarism, constitutes here a Utopian space of exile and freedom.[1] Stripped of any form of culture whatsoever —with the exception of a lone café in both the film and the play— the countryside indeed seems reminiscent of the uninhabited expanse, '[l]a naturaleza campestre, colonial y bárbara',

[1] The most obvious example of the coupling of the countryside with barbarism is Sarmiento's *Facundo*, written in 1845. The first chapter, entitled 'Aspecto físico de la República Argentina y carácteres, hábitos e ideas que engendra', deals with the geography of Argentina, which Sarmiento describes as the major obstacle to his project of civilisation. 'El mal que aqueja a la República Argentina es la extensión' (Sarmiento 2005: 29), he declares, as he contrasts the dangerous, isolated 'Pampa' with the 'envidiable posición' (31) of Buenos Aires.

once so criticised in *Facundo* (Sarmiento 2005: 12). Yet this wasteland is presented as a space of refuge from urban decay in *Postales argentinas*, and the metropolitan enclave of State control via networks of visuality in *La sonámbula*. The anarchy and unpredictability of the countryside is appealing in the face of the crippling urban panopticon. In the film, however, we are never sure whether the countryside actually exists, as it dissipates in between layers of simulation that prevent us from confirming what it really represents. Certainly the most vivid, bucolic depiction of the countryside —rendered even more vibrant in contrast to the bleak black and white images of the city by the fact that it is the only part of the film shot in colour— takes place in the imaginary/virtual space of the main character Eva's dream-memory.

In *La sonámbula*, incarcerated like an island from the countryside lies a postmodern and posthuman Buenos Aires, in which its citizens are forcibly hooked up to audiovisual networks of information and control. The city's form as an island is a clear allusion to dystopia. Buenos Aires of the future is a city, as Kantaris argues, devoured by the transnational and 'deterritorialis[ed]' logic of consumerism and reified in the proliferation of its own image (2008: 53). For David B. Clarke '*the consumer society has remade the [postmodern] city in its own image*' (2003: 3, original emphasis), mediated through screens, reshaping not only the space–time continuum, but also the way in which society interacts (5). This can be read as an extreme version of the fragmented virtual imagined communities created via television spectatorship which were discussed in the previous chapter. Although the cityscape evoked in *Postales argentinas* bears little evidence of any such systems of control, one can imagine it having passed through this state in order to reach the post-apocalyptic ruins alluded to in the play.

Given such blatant visions of death and destruction, it would seem easy and obvious to hurriedly wedge *La sonámbula* and *Postales argentinas* into the well established critical discourse of failure. This discourse, as will be developed below, outlines a tradition of artistic production in Argentina that allegorises the nation's failed project of modernity. In her analysis of *Postales argentinas*, Mariana Pensa (n.d.) certainly foregrounds the discourse of failure, defining the play quite simply as 'la historia de la destrucción y desaparición histórica de la ciudad de Buenos Aires' (n.p.). Whilst Pensa makes many valid points in her analysis as to the nature of this failure, she overlooks a deeper level of meaning in the text. Her fleeting reference to the play being written 'a la manera del teatro dentro del teatro' (n.p) and to writing as a form of Utopia are never fully developed in conjunction with other mechanisms of self-referentiality at work in the text: principally the role of intertextuality, fundamental to the politics of both the play and the film and to which I will return in due course.

The concept of failure dates back to the nation's inception, some even argue to the conquest of America (Graciela Scheines 1993: 9). To Nicolas Shumway, the persisting Argentine notion of 'fracaso' has its origins in the

> peculiarly divisive mindset created by the country's nineteenth century intellectuals who first framed the idea of Argentina. This ideological legacy is in some sense a mythology of exclusion rather than a unifying national ideal, a recipe for divisiveness rather than a consential pluralism. This failure to create an ideological framework for union helped produce what Ernesto Sábato has called 'a society of opposers' as interested in humiliating each other as in developing a viable nation united through consensus and compromise. (1993: x/xi)

In contrast to Sábato's idea of 'a society of opposers', the acquiescence of Martínez Estrada's words in the epigraph to this chapter exemplifies another major characteristic in the discourse of failure: that the (literary) expression of the political aspirations of nation-building is consistently stifled by the author's resignation to fatality. His essay on the nation, *Radiografía de la pampa* (1933), as the title suggests, treats Argentina as an infirm patient (see Martínez Estrada 2001). Present-day expressions of failure have focused on the fact that until recently Argentina was considered part of the First World. For Argentina, the twentieth century marked a rapid decline 'from first-world to third-world status in only a few short decades' (Shumway 1993: x), fodder for a discourse of lost opportunities, as Fernando Ainsa underlines: ' "Ayer fue el porvenir y no nos dimos cuenta", verdadera metáfora de un país cuyo proyecto inicial de poblamiento y desarrollo parece hoy tan lejano en el tiempo como desmedido en su ambición' (2000: n.p.).

This idea that the Argentine project of modernity repeatedly becomes derailed is the source of this discourse of failure. Graciela Scheines' work *Las metáforas del fracaso* (1993) is arguably the most comprehensive examination of the expressions of failure in Argentine culture, written from a cultural perspective. Scheines charts the descent of Argentina from before its inception, from the fall of the paradisiacal and Utopian empty land conquered by the Spaniards (9). She is, however, never defeated by her own compilation of national failure and maintains optimism at the possibility of breaking out of this cyclical pattern of failure and moving towards a brighter future:

> El país somos nosotros, todo nuestro pasado —la historia nacional—, nuestro presente y también los proyectos del futuro. Mientras no nos liberemos de las imágenes espaciales o geográficas de América (paraíso, espacio vacío o barbarie) de origen europeo, de las que derivan las nefastas teorías del Fatum, lo informe, lo facúndico, lo telúrico, que nos fijan e inmovilizan como el afiler a la mariposa, y que hacen de América una dimensión inhab-

itable ajena a toda medida humana, no superaremos el movimiento circular, las marchas y contramarchas, las infinitas vueltas al punto de partida para volver a arrancar y otra vez quedarnos a mitad de camino. (95–6)

Ultimately, Scheines examines the politically subversive value of the multitude of 'metáforas del fracaso' littered throughout the history of Argentine cultural production, in which she includes the lyrics of tangos, theatre, literature and film. She argues that art, whilst representing these metaphors of failure, can remain aloof from them at a critical and reactionary distance (120). The capacity of *Postales argentinas* and *La sonámbula* to 'de-naturalise' (Hutcheon 2002: 2) these 'metaphors of failure' will be central to defining their politics.

Taking its lead from Jameson's idea of the 'political unconscious' (2002), the subsequent analysis will draw on a psychoanalytic hermeneutic aimed at surfacing repressed anxieties about the cultural past, which are surreptitiously woven into a subtext of these allegories of failure. Jameson employs Freudian terms to describe how a text works on two different levels: the surface or 'manifest' level (which he equates to the 'superstructure'), and the 'latent' or deep level (which he equates to the 'base'[2]) (2002: 17) Whilst it cannot be denied that the 'manifest' content of *La sonámbula* and *Postales argentinas* charts a nation's failure, once this surface meaning is scratched, a 'latent' anxiety about the cultural identity and socio-political agency of theatre and cinema can be revealed. What I am referring to here is angst about the characteristically postmodern disintegration of art as an autonomous entity. Jean Baudrillard describes this phenomenon when he argues that '[t]he state of arts has generalized itself to the extreme [...] When everything is aesthetic, nothing is either beautiful or ugly any longer and art itself disappears' (1992: 10). Intertextual citation thus functions as an attempt (albeit rather makeshift) to breathe life into national (cultural and artistic) identities and open up a space in which the visions of failure can be challenged. The activeness of this agency can of course be debated —the capacity of art to act as a substitute for politics questioned— but what is clear at the very least is that even though *Postales argentinas* and *La sonámbula* may proffer seemingly clear-cut visions of failure, they ultimately narrate their success, *as art forms* and *as a genre* (science fiction), at representing failure.

Jameson might well, given the chance, brand *Postales argentinas* and *La sonámbula* as nothing more than valueless postmodern pastiches, de-histor-

[2] In *The Political Unconscious*, Jameson sketches out the classic Marxist schema of 'base or infrastructure' and 'superstructures'. The 'base' he defines as 'THE ECONOMIC, OR MODE OF PRODUCTION' and the 'superstructures' as 'CULTURE', 'IDEOLOGY (philosophy, religion, etc.)', 'THE LEGAL SYSTEM' and 'POLITICAL SUPERSTRUCTURES AND THE STATE' (2002: 17).

icised and de-politicised products of what he terms the 'new spatial logic of
the simulacrum' (1991: 18). I would, however, argue that neither *Postales
argentinas* nor *La sonámbula* are consumed by this logic. They remain aware
of their 'complicity' with the postmodern (Hutcheon 2002: 10) —with the
melting of the 'superstructure' into the 'base'— and attempt to compensate
for their collusion. This they achieve through citation. It is my view, therefore,
that analysis of these texts benefits from the use of a depth model, such as that
proposed in Jameson's earlier work in *The Political Unconscious* (2002). The
citational relationships established in both *Postales argentinas* and *La sonám-
bula* reveal an anxiety to rectify the boundaries of genres muddied within the
postmodern melting pot of art, politics and society, although this could also
be argued to be symptomatic of the nostalgic version of postmodernism that
harks back to a time when artistic boundaries and identities were easily iden-
tifiable and which takes such anxieties into account (Jameson 1991: 19). The
fact that *La sonámbula* is shot in black and white indeed points to a certain
nostalgia, although not in such a blatant way as Esteban Sapir's recent film
La Antena (2007), which, although it supposedly represents Buenos Aires (or
another Latin American city) of the future under the menacing dictatorship of
Mr TV, is much more reminiscent of gangster-ridden 1930s Chicago.

 The collapse of the aesthetic is one thing Graciela Scheines does not take
into account when defining art as an 'otra dimensión' (1993: 120), at a critical
distance from both history and politics. Before these texts can function in the
'otra dimensión' that she defines, they must first restore this 'otra dimensión',
restore art as an autonomous field. The potential for change, she argues, lies
in art, which has set itself up as the 'otra dimensión' in order to challenge
these discourses of failure. She teases out the paradoxical position of art
in relation to her discourse of failure: '[l]os argentinos sabemos que en la
práctica la historia y la vida hasta ahora han sido un fracaso. Pero logramos
sobrepasarlo saltando a otra dimensión: la del arte' (120). A work of art that
builds itself on failure can, she argues, by doing this subvert this failure. The
self-reflexive contemplation afforded by intertextuality, in *Postales argen-
tinas* and *La sonámbula*, of the boundaries of theatre and cinema as specific
art forms enables this 'other dimension' to be restored.

> Todo ellos [los artistas] están a salvo, refugiados en esa otra dimensión
> que llamaré provisoriamente el pasaje. Desde esa zona de seguridad
> construyen sus ficciones que reflejan con inteligencia y como un espejo la
> realidad del país. La tarea es encontrar una expresión (literaria/filosófica)
> que en vez de servirle al escritor para salvarse de la situación inmutable
> del fracaso, tenga el poder de revertir tal situación. Una expresión que
> influya decisivamente en los argentinos hasta lograr que la historia,
> nuestra historia, comience a moverse hacia adelante e interrumpa su itin-
> erario circular. (Scheines 1993: 120)

Psychoanalytical frameworks are not only important in this chapter as a means of uncovering the unconscious layer of these texts, they are also instrumental in constructing the 'manifest' discourses of failure. The fact that the failure of modernity and the advent of postmodernity are couched in these texts in classic Freudian models means that these texts can explore the effects of modernity, postmodernity, cybernetic cultures and the posthuman on human consciousness —that is, the way in which individuals engage with their surrounding milieu. Interpersonal relationships shaped in *Postales argentinas* by the Oedipus complex serve to highlight the problematic nature of both individual and national identities, which have traditionally been based on the family narrative. Likewise, this chapter will draw on a number of perceptual psychoanalytical structures which have been central to the study of cinematic spectatorship, namely the scopophilic gaze of the cinematic spectator-cum-voyeur (see Laura Mulvey 1992). As everything and everyone in *La sonám-bula* has become subject to the camera's gaze, such structures now govern the way in which society interacts.

Freudian theory is cited in order to bring the repressed unconscious of modernity to the surface, challenging the repressions of sexuality and aggression made in the name of (modern) purity, progress and order (Bauman 1997: 1–4). The resurgence of these repressed impulses marks the cracks in modernity and the centred, unified modern subject. Lying beneath these discourses of failure is another Freudian theory: that of the 'family romance' (Freud 2001b: 236–41). This family romance, played out in the intertextual citations made in each text, counterbalances the portrayal of failure by attempting to re-centre these texts in established theatrical and cinematic traditions, although —as will emerge throughout the analysis— the coupling of these two opposing structures is a constant source of friction; not least in the fact that this play and this film employ (rather incongruously) intertextuality as a means of stabilising —centring, that is— their sense of identity. The mechanism of citation itself involves an inevitable de-centring of identity as it is constantly displaced onto an Other. It is nevertheless this friction that opens up a liminal space in which the discourse of failure can be challenged.

Psychoanalysis and science fiction can also be said to fit hand in glove, as both are attempts to ground fantasy in reality by means of a rationalised, scientific discourse. Both can be seen as an exploration of the dark side of modernity, in the case of science fiction, anxieties surrounding the human effects of technological advancement; in psychoanalytical terms, the resurgence of repressed instincts that threaten the centred sense of self. Science fiction also has the capacity to project into the future, however bleak its vision may be, although often its portrayal of the future has more to do with extrapolated anxieties of the present designed to serve as a warning. In many ways *La sonámbula* prefabricates a memory of events in the present. Several aspects of the film would have reminded those watching it at the

time of its release of key moments in the Menem regime: his politics of forgetting is signified in the obvious allegory of a government conspiracy to induce widespread amnesia; frequent tracking shots that follow the path of an abandoned railway line allude to Menem's closure of those railway lines not working at a profit, whilst also allegorising a more general lack of investment and decaying infrastructure as a consequence; finally, the explosion in the chemical factory could be interpreted as a reference to the controversial explosion in an arsenal in Córdoba, the origin of which is debated to this day, many believing that it was a deliberate explosion to cover up illegal arms-dealing with Croatia and Ecuador (Ventura 1997, n.p.; and García 1998, n.p.). Science fiction is also intimately linked with the fantastic and with the idea of Utopia, thus underlining its potential for political engagement. In a climate said to be consumed by a proliferation of the present, the importance of this ability should not be undervalued, however removed from reality it may seem to be. *La sonámbula* also conforms to the modified sci-fi genre of cyberpunk, a dystopian genre which deals with those left on the margins of, or who rebel against, cybernetic cultures.

Before progressing any further and to avoid subsequent confusion, the plots of this play and this film need outlining in a little more detail in such a way that their reflexive complexity may begin to be glimpsed. *Postales argentinas* presents one of a series of putative conferences aimed at reconstructing the life of postal worker and failed writer, Héctor Girardi. The reconstruction takes the form of a theatrical production and is based on fragments of manuscripts found in the dried-up bed of the River Plate. The conference/ performance is introduced by one of the actresses as follows:

> [e]n el año 2043 fueron encontrados en el lecho seco del Río de la Plata los manuscritos que nos permiten reconstruir hoy la vida de Héctor Girardi y su pasión por escribir. Pasión trunca por cierto. Al igual que el país al que perteneció Girardi, estos textos son sólo una colección de fragmentos y residuos defectuosos, pese a lo cual sean una importancia inmensa en la medida en que permiten recuperar para nuestros estudios las costumbres de este país borrado ya de la faz de la tierra. (Bartís 2003b: 43)

The 'postal' takes the form of a biography, aimed at recuperating the memory of Argentina through the relationships Héctor has with his mother, his girl-friend Pamela, and his desire to write. What is made very clear from the beginning of the 'postal' is that theatre is the vehicle by which a series of fragmented literary texts are brought to life. *Postales argentinas* is composed of a plethora of theatrical, literary, poetic and political citations, some acknowledged, some buried anonymously in the body of the text: the words of Juan Domingo Perón, General José de San Martín, Rubén Darío, Pablo Neruda, Gustavo Adolfo Bécquer and William Shakespeare are cited, to name but a

few. An important negotiation is thus set up not only between theatre and its own tradition, but between theatre and political discourse and finally between theatre and literature (more specifically poetry) as vehicles of memory and identity, and narrators of the nation.

Also charting the fate of Buenos Aires in the future, as described above, *La sonámbula* represents the oneiric voyage of Eva Rey as she sleepwalks through time from an unspecified date in the past to the city in 2010, bicentenary of the 'Revolución de Mayo'.[3] She is delivered to a city ravaged by the effects of a major explosion in a chemical factory, which has left 300,000 inhabitants in the city with total amnesia. Bearing a scar on her chest, similar to that on the bodies of all those affected by the explosion, Eva is captured and taken into the 'Centro de Investigaciones Psicobiológicas' whereupon her programme of rehabilitation begins under the baleful watch of Dr Gazzar. Yet, unlike the other patients who are monitored, Eva claims to remember. Her dreams reproduce vivid images of the past, as well as references to the mythical revolutionary leader Gauna, references considered to be highly dangerous by the establishment as they are believed to prove his existence. Government informant and fellow amnesiac Ariel is at this point contracted to follow Eva as she escapes out of the city, in order for the Centre to monitor her path, then locate and eliminate Gauna. The film traces their journey out of the city and into the unknown, in a world in which every move, even the depths of the unconscious, are accessed and controlled by video camera surveillance. Explicit reference to the technological overlaps between film and video surveillance sets up an important interrogation of the role of film in informing social relations, as well as its technological and ethical relationship to other audiovisual media (notably, once again, its rival television).

The nuclear family, alongside the nation and the city, is arguably the most important social paradigm of modernity in relation to which individual and collective subjectivities are negotiated. In both *La sonámbula* and *Postales argentinas* family relations are central to the representation of modernity's decadence and it is irregularities in these relations that reveal those aspects of human nature that have been quelled in order to cement conventional family ties in the name of civilisation and progress. What is made clear is that the family, and by association the nation, no longer serve as structures through which identities can be mediated. The linear, genealogical structures on which individual, collective and national identities were once centred here fragment, as individuals are severed from their past and as a result are left languishing in a present with no fixed point of origin or *telos*. Yet the paradigm of the family provides the interface between two divergent levels

3 The Revolución de Mayo or the 'Semana de Mayo' took place in 1810 and resulted in the establishment of 'la Primera Junta', Buenos Aires' first independent government.

to these texts. Woven into the failed family relationships in both *Postales argentinas* and *La sonámbula* is an underlying 'family romance', played out in the citational relationships that constitute each text. It is then through these citations that theatre and cinema —both artistic families of a kind— negotiate their own exalted origins in defiance of a diminishing sense of history and national identity.

The repression of human instinct in the name of civilisation and progress is the central argument of Freud's most socially orientated work, 'Civilization and its Discontents'. Published in 1930, on the eve of a wave of fascist authoritarianism and with memories of the First World War still fresh in mind, Freud's appraisal of the dark side of civilisation seems highly applicable to Argentina, given its own experiences of dictatorship and political violence in the name of social advance —advance in this context articulated as a discourse of purification. He argues:

> The fateful question for the human species seems to me to be whether and to what extent their cultural development will succeed in mastering the disturbance of their communal life by the human instinct of aggression and self-destruction. Men have gained control over the forces of nature to such an extent that with their help they would have no difficulty in exterminating one another to the last man. (2001a: 145)

For human beings, he argues, 'the purpose of life is simply the programme of the pleasure principle. [...] There can be no doubt about its efficacy, and yet its programme is at loggerheads with the whole world, with the macrocosm as much as with the microcosm' (76). The main discontentment of civilisation is that 'happiness', in the form of pleasure, can never be achieved as the passage of civilisation, from nature to culture, has involved repression of the most essential human instinctive drives, repression which is inevitably re-channelled, which resurfaces as perversions and/or aggression.

One of the fundamental libidinal drives to be repressed by civilised society is incest. Incestuous instincts play at the heart of the reciprocated Oedipal relationship between Héctor Girardi and his mother in *Postales argentinas*. The collapse of the mother–son relationship, which ends in matricide, echoes the decay of (urban) civilisation into violence. We also see how these Oedipal relations fragment Héctor's sense of self, in his conflated role as both son and writer. His continued dependence upon his mother —'the first *love*-object' (Freud 1967: 339)— for inspiration for his writing is equated with the sensation that he has never overcome his separation from the maternal breast, 'the first oral component of the sexual instinct', according to Freudian theory (338). Not only does he liken his writer's block to a milk-less breast, but he describes the inspiration that his mother gives him as milk from her breasts:

Estoy seco como los pechos de las madres porteñas … (*Revelación*) ¿Madre?
¿He dicho 'madre'? (*Baja la escalera y va a proscenio.*) ¡Qué necio soy!
¿Cómo no advertí antes que en ella está mi salvación? (*Chupetea en el aire,*
como mamando.) Debo beber las postreras gotas de su leche inspiradora.
(Bartís 2003b: 43–4)

Whilst Héctor seems to struggle to overcome his separation from the maternal
breast, his mother perpetuates this with a reciprocated 'erotic attachment'
(Freud 1967: 342) to her son. As she tries to fondle his genitals and kiss him
on his lips, it is she who 'attempts at seduction' (342) rather than her son, as
is the case in the classic Oedipal scenario. It should, however, be remembered
that although this technically corresponds to a reversed Oedipal situation,
Freud remains consistently flexible as to the potential for 'variations [upon]
and masked forms' (346) of his theories. That is not to say that the classic
Oedipus complex does not exist in this relationship. Héctor clearly feels a
certain desire towards his mother and although he rejects her advances, he
escapes to masturbate behind the wardrobe as a means of sublimating his
repressed desire.

As Ana Amado (Amado and Domínguez 2004) is careful to point out, the
family has historically been defined as much by its divisions and prohibi-
tions, as it has by its affiliations. She argues:

> al subrayar lo familiar desde los *lazos* intentamos poner en evidencia el
> doble mecanismo de enlace y separación, de atadura y corte, de identidad
> y diferencia que funda lo familiar en tanto proceso y a partir del cual
> se puede leer el orden político, social y cultural de la Argentina contem-
> poránea. (14)

As Ricardo Piglia, co-scriptwriter of *La sonámbula*, writes in his novel
Respiración artificial: 'Los lazos de sangre son lazos de sangre. Sobre todo
lazos. De sangre. La familia es una institución sanguinolenta; una amputación
siempre abyecta del espíritu' (2001b: 44). At its base, the family is defined
by prohibition: the incest taboo. Amado makes an important structural link
between the family and society when she argues, with reference to anthro-
pologist Claude Lévi-Strauss's work, that the incest taboo is 'la ley universal
básica a través de la cual se establece el pasaje de la naturaleza a la cultura,
es decir, de la biología a la norma' (Amado and Domínguez 2004: 26). In
this post-apocalyptic scenario, in which the progression from barbarism to
civilisation has run full circle and in which an institutional super-ego no
longer manages such prohibitions, previously suppressed instinctive drives
inevitably resurge. The role of this governmental super-ego —all-powerful
in *La sonámbula*, utterly absent in *Postales argentinas*— is a major point of
contrast between the film and the play.

The Oedipal relations in play here between mother and son are used to exemplify the breakdown of conventional genealogical succession, by which identities have traditionally made sense. When portraying Argentina's experience of neoliberalism in the 1990s, Amado draws attention to the process of social 'desubjetivación' which she argues is caused by

> la ruptura de las cadenas genealógicas, ruptura que impide la construcción de la propia historia en términos de la estructura familiar tradicional [...] la interrupción genealógica o el quiebre de códigos tanto de las relaciones familiares del triángulo padre-madre-hijo, como de las del triángulo Estado-familia-individuo. (2004: 19–20)

The process of 'desubjetivación' in *Postales argentinas* takes place, however, through a distortion, rather than rupture, of the genealogical line. When Héctor's mother declares that she wants a grandchild by her son, she instigates instead a folding-in of family relationships through incest. '¡Sí, Héctor! ¡Intentálo! ¡Tu puedes! ¡Papá! ¡Cabalgáme! ¡Hazme nietos!' (Bartís 2003b: 50). Héctor's mother clearly confuses him with his absent father. We are told that his father died when he was born, a fact that increases the pressure on Héctor to replace his father. Héctor is bestowed with a certain duty to emulate his father and keep his memory alive. 'Tú solamente debes escribir. Recuerda (*Lo acaricia hasta que la caricia se convierte en un pellizco.*) el anhelo de tu padre. Todo se derrumbará y tú serás el único testigo sobreviviente ...' (45), his mother reminds him. But Héctor is constantly made to feel inferior as his father's memory is lauded. With a romantic and nostalgic tone his mother describes his father: '¡Tu padre! ¡Oh, tu padre! ¡Cómo te quería! Fue el hombre más bueno que jamás se haya conocido [...] ¡Ah, tu padre! Era rubio y sus ojos celestes alumbraban una pasión argentina' (47). Writing is clearly the key to his whole sense of identity —as a man, a son and an Argentine— and his inability to write an obvious expression of the 'castration complex' (Freud 1967: 326), captured so succinctly in Héctor's question, '¿qué será ahora de mi pluma?' (53).

Héctor becomes acutely aware of his failure in a moment reminiscent of the Lacanian mirror-phase. The moment of coming face-to-face with his image, which would normally be the moment in which the subject's ego is formed, is for Héctor the moment when a failed ego is born. 'Me miré en el espejo del bar y éste me devolvía la más genuina imagen de mí mismo, la imagen del fracaso' (54). As a small token of relief, however, it is also in this mirror that Héctor first sees Pamela, his 'Other' and replacement mother figure thus restoring some sense of belonging.

Héctor seems sure of his identity —'¡Soy Héctor Girardi! ¡Soy un argentino! (Bartís 2003b: 57)— but he is unclear as to what this identity signifies. Amado makes an important link between the family and the nation, with specific reference to the Argentine context:

> Imaginar una nación siempre implicó imaginar un tipo de familia: ésta
> ofrecería, según aquellos que forjaban su diseño, la versión idealizada de
> una ficción de por sí utópica. En la etapa fundacional del Estado argen-
> tino moderno (1880), la cuestión familiar ocupaba el centro de los debates
> y de las preocupaciones sociales y políticas. La familia era entonces,
> 'un objeto', a la vez cuestionado como existente y proyectado como 'a
> construir'. (Amado and Dominguez 2004: 20)

Perhaps the most famous example in Argentine theatre is Roberto Cossa's
La nona (1977), written during the dictatorship as an allegory of the military
regime. The play tells the story of a family of Italian immigrants whose
funds are bled dry by the fact that the 'nonna' is permanently hungry. As
she is head of the family, the rest of the family bow to her every need and
work night and day to keep her insatiable appetite satisfied until they eventu-
ally tire and one by one begin to hatch a plot to do away with the 'nonna'.
Performed at the height of the dictatorship, the 'nonna' provided a suffi-
ciently oblique reference to crippling military power to avoid censorship. The
allegory, however, was crystal clear. The parallel drawn between the state
and the family (notwithstanding its rather dysfunctional character) makes an
important statement regarding the fact that society should be constructed like
an extended family. Numerous instances of political allegories set up using
the family paradigm also exist in Argentine cinema. Recent examples include
Albertina Carri's film on the incestuous relationship between a brother and
sister in *Geminis* (2005); Pablo Trapero's film *La familia rodante* (2005),
in which family loyalties are put to the test as the entire family is crammed
into a campervan during a road trip to the northern Argentine province of
Misiones; Lucrecia Martel's film *La ciénaga* (2001), which portrays, as the
title suggests, the stagnation of family relationships and a broader allegorical
representation of the stagnation/decadence within middle-class society in the
nation's interior (exemplified in Martel's home province of Salta).

The incest and trickery at the centre of this parent–child relationship seem
to echo the corrupt and overbearing relationship between government and
citizens. Héctor's mother is portrayed as corrupt and continually tries to
deceive him, not least when the two sit down to play a round of 'truco', a
typical Argentine card game which depends on subterfuge in order to trick
the opponent as to the value of the cards in hand. The most hurtful decep-
tion comes, however, when Héctor realises that all the literary inspiration
his mother has offered him over the years has been cited from other works
of literature and theatre. The realisation that his literature is the work of
another drains his sense of self, although quite how this differs from stealing
words from the letters he sorts at the post office and quoting from his mother
remains unclear.

> ¡Comprendí que mi madre citaba! Nada hubiera podido hacerme tanto daño
> ... ¿Qué era lo cierto y qué era lo falso en el discurso de mi madre? ¿Soy
> yo, en realidad, el que me habito o soy el resultado de las lecturas trasno-
> chadas de mi madre? (*Mira su propio mano, imitando a Hamlet.*) ¿Quién
> soy? ¿Adónde voy? ¿Dónde estoy? ¡Estoy huérfano de historia! (Bartís
> 2003b: 48)

In this case, citation functions as a continual displacement of identity onto
an Other whereby Héctor is left with no sense of past, parentage or origins.
He is the embodiment of the barren postmodern 'depthless' pastiche. 'Estoy
árido', he laments, 'como estos barrios que se mueren, no soy un hombre'
(50). The displacement of his unified sense of identity through citation acts as
a metaphor for the peripheral Argentine identity, capturing the complexities
not only of postcolonial, but also post-national identities constantly negoti-
ated in relation to an (historically European) ex-centric point.

The fact that Héctor's identity is embodied in his office as a writer means
that the parent–child relationship is mirrored in the citational relationships,
which in turn serve to map this play's relationship to its literary and theat-
rical forefathers. Use of citation in the play can be read in two contrasting
ways. On the one hand, his mother's citation, which doubles as sexual and
literary promiscuity, represents the corruption of the Girardi family lineage.
On the other hand, this citational web marks the play's engagement with its
own forefathers and insertion of its self into a variety of theatrical, political,
literary, national and transnational lineages. Far from constituting a 'meta-
phor of failure', the latter constitutes more of what Freud would have termed
'a family romance'.

Theatre and cinema, as concepts, are families of an artistic and generic
kind. In his discussion of the 'family romance', Freud argues that it is essen-
tial for an individual to free himself from parental 'authority', in order for
him or her to mature into what he describes as a 'normal state' —that is to
say, free from neuroses (Freud 2001b: 237). During early childhood, the only
authority the child knows is that of his parents, until at some point he or she
becomes hostile to this authority.

> The child's imagination becomes engaged in the task of getting free from
> the parents of whom he [or she] now has a low opinion and of replacing
> them by others, who, as a rule, are of higher social standing ... mak[ing]
> use in this connection of any opportune coincidences from his actual expe-
> rience. (238–9)

'[H]igher social standing' can be interpreted here as a more desirable
cultural lineage, a lineage exalting the autonomy of theatre and cinema as
artistic forms as played out in both the autochthonous national theatrical

and cinematic traditions and broader Western traditions cited in the film and the play.

Harold Bloom (1973) appropriates the Freudian model of the 'family romance' in his study *The Anxiety of Influence*, in which he likens the relationship between poets to a 'family romance' (8). Bloom describes the poet's battle to liberate himself from the 'father' poet, despite in many cases having absorbed these influences unconsciously (11). He charts the poet's resistance to paternal 'influence'. Succumbing to influence, he argues, signifies giving away a part of the self (6). The two main stages of Freud's 'family romance' are played out on two different levels in *Postales argentinas*. On one level, Héctor strives to sever his ties with his family, by killing his mother. His inability to write could also be read as a subliminal attempt to cut himself off from his father. On another level, the text is constructing a fiction about its own exalted origins within both specifically national and Western literary and theatrical traditions. The web of citations constituting both *Postales argentinas* and *La sonámbula* corresponds to the second stage of the 'family romance', during which the child constructs a 'work of fiction' (Freud 2001b: 240) in his or her imagination that 'exalts' his or her origins. How this differs from Bloom's appropriation of 'the family romance' to literary analysis is that *Postales argentinas* and *La sonámbula* make a very conscious appropriation of their artistic forefathers. Bloom, in contrast, argues for the unconscious and unwanted absorption of poetic influence.

Once again, a clear parallel can be drawn between questions of artistic and national identity. In many ways the nation itself was born out of 'a family romance'. Nicolas Shumway underlines the importance of 'guiding fictions' in establishing a 'sense of nation' (1993: xi): '[t]he guiding fictions of nations cannot be proven, and indeed are often fabrications as artificial as literary fictions. Yet they are necessary to give individuals a sense of nation, peoplehood, collective identity, and national purpose' (xi). Such 'guiding fictions' constitute what Benedict Anderson (2006) describes as a discourse of 'continuity', crucial to modern nation-building and in overthrowing pre-modern religious 'fatality' (11). Although Anderson defines the nation as 'new' and 'historical' (11), he underlines the fact that nations, as they are imagined and expressed politically, 'always loom out of an immemorial past, and, still more important, glide into a limitless future' (11–12). The nation, even though it may be based on no more than a fiction, must always construct a sense of lineage: its origins in the distant past and 'continuity' into the foreseeable future.

Whilst *Postales argentinas* carves (albeit rather tenuously) a space for itself among the founding fathers of the nation and within a lineage of Argentine literature, it also works to build a lineage for theatre, placing itself within a Western theatrical tradition. The presence of Oedipal relations in itself reminds us that Freud found inspiration for his theory from

Sophocles' play *Oedipus Rex*, and the fact that Héctor's mother wants to have a grandchild with her son is reminiscent of Sophocles' other play, about the myth of *Antigone*. The list of citations made by Héctor's mother over the years includes works by playwrights Armando Discépolo, William Shakespeare and Samuel Beckett. The play's affiliation with other theatrical texts serves to negotiate a space within a genealogy of Western theatre as well as more specifically within a nation's tradition of theatre. These citations are, however, not without tension. If the function of citation is to deconstruct the rhetoric of failure, by constructing an alternative (artistic) lineage, then citation of Rubén Darío's poem 'Lo fatal' (1905) contradicts this by bringing us back to the play's surface thematic of a nation's fatal path towards extinction, echoing Darío's pessimistic line: 'no hay dolor más grande que el dolor de ser vivo' (1996: 168).

I would suggest that it is certainly the theatrical lineage that takes precedence. Embedded in Bartís' philosophy of theatre and his politics of representation is a tussle with literature. Héctor's girlfriend, Pamela, may encourage him to write in order for his art (and to a certain extent for him) to be reborn —'volverás a escribir para que tu arte renazca' (2003b: 60)— but ultimately it is the rebirth of theatre that Bartís is interested in. This is supported by his more theoretical writings on theatre, in which Bartís makes every attempt to distance theatre from literature, which he describes as 'un vampiro de la actuación' (13). Instead, he highlights the primacy of theatre's performative element.

> Lo más importante que pasa [...] es la fuerza y la energía con que se actúa ese texto, pero la actuación no está ni podría estar nunca dentro del texto, nunca podrá estar esa energía, esa decisión, esa voluntad de existencia que yo busco cuando dirijo un espectáculo. (12)

Carving out a space for theatre amidst the founding narrations of the nation involves usurping literature's predominant role in nation-building, although to what extent Bartís also engages in a form of vampirism by intertextually feeding off old dramatic texts (dead forms of theatre) in order to reassert theatre's role in nation-building is open to contention.

In *La sonámbula* the family proves to be equally problematic in the development of identity, on account of the widespread amnesia. Those who have suffered amnesia after the explosion in the chemical plant are 'huérfano[s] de historia' just like Héctor Girardi (Bartís 2003b: 48). Families may have been shattered, but the family unit nevertheless remains an important normalising structure in the social and political imaginary, perceived as an almost unquestioned, timeless paradigm in relation to which individual and social identities are negotiated. Whilst discussing the different ways in which the family can now alternatively be configured, Amado highlights the fact that

las prácticas sociales y culturales siguen impregnadas de un vocabulario genealógico que remeda las consignas de filiación, y que se adjudican en el orden de la realidad o en el de la representación el poder de fabricar líneas de descendencias, filiaciones y parentescos. (Amado and Domínguez 2004: 32)

The development of identity relies on a sense of personal history and memory, one thing absent in every amnesiac, save Eva Rey, who seems to remember elements of her past in her dreams, although she is unable to confirm the veracity of these visions. The Centre for Psychobiological Research therefore carries out memory re-programming whereby patients are lodged in prefabricated families, never knowing if this family is their real family. The victims' pasts are completely re-programmed as if they were computers rather than human beings, to include even their likes and dislikes. At one moment, Ariel's son reminds Ariel that he likes fishing, or at least that he was told that he likes fishing in one of his rehabilitation sessions. For the 'Ministerio de Control Social' the family continues to represent a 'poderoso paradigma de normalización' (Amado and Domínguez 2004: 32), much as it did during the dictatorship. This is confirmed by Gabriela Nouzeilles's description of the role of the family within the military discourse, when she argues that it constituted

el espacio en el que convergieron el interés político, la vigilancia higienista y el saber eugenésico. Motor de la reproducción biológica y moral, la institución familiar conectaba el cuerpo individual y el organismo social al mismo tiempo que regulaba las fronteras entre lo privado y lo público. (Nouzeilles, in Amado and Domínguez 2004: 18)

As in *Postales argentinas*, the family in *La sonámbula*, on a manifest level at least, serves as little more than a metaphor of failure: the institution by which a truly fragmented social fabric is haphazardly patched back together, which simultaneously serves as an obvious allegory of social fragmentation in Argentina following the dictatorship. Widespread amnesia and the deliberate re-programming of identities in accordance with governmentally controlled subjectivities is an obvious reference to both the dictatorship and the politics of 'olvido' that ensued in the Menem years. Once again, however, this is a film composed of a series of citations and beneath the thematic surface of the text, yet another 'family romance' is being performed. This time the family romance inserts *La sonámbula* into an established tradition of sci-fi film and literature on both a national and an international level.

Kantaris describes *La sonámbula* as a '*noir* sci-fi homage to [Fritz Lang's] *Metropolis* [1927] and [Ridley Scott's] *Blade Runner* [1982]' (62), highlighting the film's attempt to insert itself into a North American tradition of

cinematic science fiction. Digitally re-mastered shots of the cityscape certainly remind us of the cityscape in both these films (2008: 62). Also, as Kantaris points out, the fact that the film is largely shot in black and white provides a citation of the 'old future', particularly in the case of *Metropolis* (62–3). In contrast, Andrea Cuaretolo (2007), in her attempt to trace a national tradition of science fiction in Argentina, overlooks these two citations. Instead, she focuses on the influence of a more modest home-grown sci-fi tradition and draws links with what is considered to be the first Argentine science fiction film, Hugo Santiago's *Invasión* (1969), as well as Gustavo Mosquera's more recent *Moebius* (1995), and a reputable Argentine tradition of fantastical literature. Cuaretolo clearly sees *La sonámbula* as a sequel to *Invasión*:

> Mientras en *Invasión* la resistencia se defendía de una amenaza que se encontraba fuera de los límites de la ciudad, en el espacio incierto de la barbarie, en *La sonámbula*, por el contrario, el peligro se sitúa en el seno mismo de la civilización. La Buenos Aires de Spiner podría ser Aquilea medio siglo después de la invasión. La ciudad representa aquí la suma de todos los males. (2007: 90)

Whilst Cuaretolo's placement of *La sonámbula* in a local/national tradition performs the important role of examining Argentine culture from the centre outwards, rather than from a displaced European or North American centre, the dialogues she establishes between *La sonámbula* and other science fiction films perpetuate a sense of decadence and the lineage of failure, as evoked in the above quotation. Cuaretolo privileges an autochthonous lineage of cinematic and literary science fictions, albeit via their representations of Argentina's failed project of modernity, in preference to a transnational lineage. The lineage Kantaris proposes tends not only to exalt the film's artistic origins and place it within broader Western cinematic history, but to exalt the country's experience of modernity and technological development by citing First World metaphors of the experience of modernity. Jameson argues that 'in the postmodern, autoreferentiality [set up in these texts via intertextuality] can be initially detected in the way in which culture acts out its own commodification' (1992a: 5). Cuaretolo's avoidance of what are quite obvious citations of *Metropolis* and *Blade Runner* may be a deliberate tactic to avoid suggesting that *La sonámbula* 'acts out its own commodification' in relation to the Hollywood film industry, which would surely undermine her reading of the film's politics. I would maintain, however, that this peculiarly Argentine rendition of the Hollywoodesque sci-fi movie is undertaken tongue-in-cheek in a way that parodies, with a postcolonial irony, *La sonámbula*'s affiliation/dependence on the imported Hollywood sci-fi models.

The varying lineages proposed by Kantaris and Cuaretolo represent two extremes of analysis: the global tradition versus the national tradition. Yet,

clearly caught in the middle, the film seems to play the one off against the other. Clearly artificial sequences resembling the cityscapes of *Blade Runner* and *Metropolis* are interspersed with shots documenting the reality of contemporary Buenos Aires. The rusting hulk of ships docked in the harbour in Buenos Aires, as well as the flooded towns of Carhué and Epecuén,[4] one would expect to find in Argentina today.

The autochthonous lineage is nevertheless very valid. *La sonámbula* is not the only Argentine science fiction film to seek out its origins in the history of cinema. In Eliseo Subiela's 1995 film *No te mueras sin decirme adónde vas*, the protagonist Leopoldo invents a 'recolector de sueños'. As he records dreams he gradually digs up the previous lives of those he monitors. When he monitors his own dreams he finds that he was in fact Thomas Edison, inventor of the phonograph and the electric light bulb and considered to be one of cinema's founding fathers (Bordwell and Thompson 2004: 460). *La sonámbula* coincides with Subiela's film on the mechanical recording of dreams in order to recuperate a memory of the past. Subiela's earlier, more disturbing film, *Hombre mirando al sudeste* (1985), also deals with cinema's ability to construct a memory of the past (Kantaris 2008: 61–2). It takes place in a mental hospital. The unexplained arrival of mental patient Rantes leads to a series of theories that try to explain Rantes' presence. He might have read Adolfo Bioy Casares' sci-fi novella *La invención de Morel* (1953), and thus think he is a hologram in keeping with the fate of the novel's protagonist as he records and projects his own eternal image prior to his organic death. What is also alluded to is the fact that Rantes might also represent a cinematic resuscitation of one of the dictatorship's disappeared (61). This capacity for cinema to make absence present and to resuscitate the past is fundamental to the politics of *La sonámbula* (61–2).

The idea of resuscitating the past and reviving aesthetic lineages is intimately linked with the question of memory: theatre and cinema as vehicles of memory; memory as a tool of resistance. The postmodern has much to do with problematising our relationship to the past, as it represents the collapse of traditionally stable linear categories of time, whereupon both the past and the future collapse into a perpetual sense of present (Huyssen 2003: 2). Jameson affirms that the 'weakening of the sense of history and of the imagination of historical difference which characterizes postmodernity is, paradoxically, intertwined with the loss of that place beyond all history (or after its end) which we call utopia' (2004: 1). Both *Postales argentinas* and *La sonámbula* set themselves up as what Kantaris (2008) describes as 'memory machines', capable of breathing life into the past and in doing so opening up a Utopian

4 Part of *La sonámbula* is filmed in Carhué and Epecuén, two neighbouring towns in the Province of Buenos Aires which were left submerged (Epecuén permanently so) following a flood in 1985.

space for change in the future. The idea of breathing life into the past is taken from Piglia's novel *Respiración artificial* (2001a [1981]). This novel is about reconstructing the past from fragments and citations. It is about a (his)story that can never be written, only approached through citation of fragmented evidence from the past.

In *Postales argentinas*, theatre is set up as a vehicle of memory at the very beginning of the play when the audience is told that this 'postal' is a theatrical reconstruction of the fragments of Héctor's texts found in the dried-up river bed. Theatre provides the medium through which these texts are unified. Theatre works to (re)present the absent Argentine nation, even though it is nothing more than an ephemeral and incomplete reconstruction —a snapshot, as the title suggests— that tries to bring Héctor and the nation alive once again. Cinema's ability to render an absent past present is also alluded to in *La sonámbula*. When Ariel is watching a recording of Eva's dreams, given to him by the Centre for Psychobiological Research, his son asks him if he is watching a film. Ariel replies that he is watching a sort of film and the colourful, bucolic images of Eva's former life in the country-side are immediately associated with cinema's ability to reconstruct the past, albeit in a highly romanticised fashion, in contrast to the black-and-white images which in the rest of the film are associated with the bleak world of video surveillance (although the fact that they are black-and-white also para-doxically makes some reference to the past, or the future as it was imagined in the past). The doubling of Eva's dream and cinematic representation also hints at the Hollywood ideal of cinema as a dream machine.

Cinema's role as a 'memory machine' provides one of the main arguments of Kantaris' analysis of *La sonámbula*. He argues that, although cinema never achieves anything more than a '(dis)simulation' of presence (2008: 60), it compensates for 'the erasure of the nation state as a space of collective agency and memory' (52). This 'erasure', he links not only to the specifi-cally local phenomenon of the recent Argentine dictatorship, but to more macro processes of 'transnationalisation [and] deterritorialisation' taking place in the transition 'from nation-state to global market' (52–3). Cinema, he argues, alongside television and other cybernetic media constitute an 'illu-sory audiovisual community' (53), an extreme version of the virtual commu-nity constructed through television spectatorship which was examined in the previous chapter.

Memory should not, however, be confused with history and in many ways, as Andreas Huyssen argues, the memory culture we now live in is respon-sible for de-stabilising the linear schema of time on which the 'discourse of history' and Utopia were once based (2003: 1). Mechanical reproductions of memory, such as photography and film, he argues, 'impinge upon the present' because of the way in which they collapse both space and time (1). Huyssen argues further: '[a]t stake in the current history/memory debate is

not only a disturbance of our notions of the past, but a fundamental crisis in our imagination of alternative futures' (2). Despite drawing attention to the problematic nature of memory culture for older modern concepts such as the nation, which, Huyssen argues, relied on a solid 'discourse of history' and linearity of time, he nevertheless argues for the need to assert the politics of memory in

> an age in which globalization produces new forms of locality that still have to find a vision of another future than that offered by neoliberalism, market ideology, and media triumphalism. Memory of past hopes, after all, remains part of any imagination of another future. (105)

As these texts attempt to breathe life into the artistic genealogies outlined above —so perfectly captured in Piglia's idea of 'respiración artificial', which evoke the artificiality and rather contrived nature of these genealogies— they are confronted with another obstacle in reaffirming their legitimacy and identity: restoring the notion of art and the function of the aesthetic itself. As mentioned briefly earlier on, one of the defining characteristics of the postmodern and key differentiator between the postmodern and the modern is the disintegration of the previously hermetic categories of art, politics and social life into one. The struggle of *Postales argentinas* and *La sonámbula* to reassert their generic identities and specificities through the lineages that they construct should be read as an attempt to challenge this typically postmodern collapse of art, politics and the social order into a single paradigm of commodification, a phenomenon which is brought to the fore when Jameson highlights

> the immense distance between the situation of modernism and that of the postmoderns (or ourselves), and between tendential and incomplete commodification and that on a global scale, in which the last remaining enclaves – the Unconscious and Nature, or cultural and aesthetic production and agriculture – have now been assimilated into commodity production. In a previous era, art was a realm beyond commodification, in which a certain freedom was still available; in late modernism, in Adorno and Horkheimer's Culture Industry essay, there were still zones of art exempt from the commodifications of commercial culture (for them, essentially Hollywood). Surely what characterizes postmodernity in the cultural area is the supersession of everything outside of commercial culture, its absorption itself. (1998: 134)

The assimilation of Nature into culture has already been discussed in relation to both *La sonámbula* and *Postales argentinas*. *La sonámbula* also demonstrates the assimilation of the Unconscious as the Centre for Psychobiological Research drugs Eva in order to tranquilise her and put her to sleep so that

her Unconscious can be accessed and her dreams recorded and analysed for information about the past. What these texts refuse, however, is the wholesale assimilation of culture and the aesthetic into this postmodern order. Yet in restoring the notion of the aesthetic and the status of art as a separate category, both theatre and cinema must confront and subvert their own complicity in the processes of commodification which have caused the boundaries separating art from politics and art from the social order to weaken. Intertextual citation in both *Postales argentinas* and *La sonámbula* therefore takes on an important self-reflexive function for interrogating the spillage of theatrical codes of performativity and cinematic codes of spectatorship into society: what the co-writer of the film's screenplay, Piglia, might refer to as 'bovarismo social' (2001a: 25).

The term 'bovarismo' is of course derived from Gustave Flaubert's character Emma Bovary, who chooses refuge in a fictional dream world over her dull reality. I borrow the term here from Piglia's analysis of the literature of Roberto Arlt. He describes the phenomenon in relation to Arlt as follows:

> para Arlt la sociedad está trabajada de ficción, se asienta en la ficción. En este sentido se podría hablar de un bovarismo social. Hay una crítica muy frontal de Arlt a lo que podríamos llamar la producción imaginaria de masas: el cine, el folletín y sobre todo el periodismo son máquinas de crear ilusiones sociales, de definir modelos de realidad. (25)

What Piglia is suggesting here is that literature, cinema, and I would add to this theatre and television, are media/art forms that feed the fantasies of the collective imaginary and through which society has created an imaginary identity within the dominant ideological processes of commodification. In Piglia's reading of Arlt, money and fiction are inextricably linked: society is built upon a fiction, because the making and exchange of money, something which Piglia associates with fabrication, is one of its major organising principles (Avelar 1999: 93–4). In the light of this statement, Piglia makes the following proposal: '[h]abría que hacer una historia del lugar de la ficción en la sociedad argentina. El discurso del poder ha adquirido a menudo la forma de una ficción criminal' (2001a: 25). Piglia clearly believes that the discourses of power are mediated and sustained through fiction, an idea which takes us back to the models of social and political theatricality set up in chapter 1 in relation to dictatorship and further explored in chapter 2 in relation to the use of fiction in political cover-ups. Piglia also argues that reality and fiction have intertwined: 'En la historia argentina la política y la ficción se entreveran y se desvalijan mutuamente, son dos universos a la vez irreconciliables y simétricos' (73). He continues:

hay una red de ficciones que constituyen el fundamento mismo de la sociedad, la novela trabaja esos relatos sociales, los reconstruye, les da forma. La pregunta en realidad sería: ¿de qué modo la novela reproduce y transforma las ficciones que se traman y circulan en una sociedad? (93)

In *La sonámbula*, the cinema contemplates its own complicity in the regimes of visuality controlling society. Dr Gazzar is the embodiment of the archetypal cinematic spectator/voyeur, on account of the fact that one of his organic eyes has been replaced by a prosthetic camera-eye. As the camera cuts to assume the perspective of Gazzar's camera-eye, what is suggested is that Gazzar —and by association those viewing the film— sees the world mediated by his experiences of cinema and other audiovisual technologies. The closing in of the camera's shutters in the shot, representing the shutters of Gazzar's camera-eye, leaves nothing more than a peep hole, suggesting that both Gazzar and the cinema spectator are voyeurs, with a limited outlook on reality. Gazzar pries into the mind of Eva Rey, eventually turning her into a fetish as she becomes his object of fantasy and obsession, so much so, that he eventually sees the image of himself in her dreams. As Christian Metz argues, '[t]he practice of cinema is only possible through the perceptual passions: the desire to see' (1992: 741). In his comparison of cinematic spectatorship with the Lacanian mirror-phase, Metz argues that 'the spectator can do no other than identify with the camera'. The fact that this camera has become an integral part of Gazzar's organism suggests that all perception is now governed by the modes of perception developed in relation with audiovisual media. The camera never adopts the perspective of his organic eye, suggesting that its inferior perceptual capacities are now obsolete. If film is to distance itself from the audiovisual networks controlling Buenos Aires in 2010, *La sonámbula* needs to upset the spectator's identification with the camera.

I argued earlier that the intertextual relationships played out in *La sonámbula* served to carve out a space for the film in the history of cinema. When thinking about *La sonámbula* in relation to the history of cinema, other parallels can be drawn in relation to Gazzar's camera-eye. This leads me to an alternative interpretation of the cine-eye, which makes reference to Russian Formalist and Montagist Dziga Vertov's theory of 'Kino-Eye'. We are once again invited to consider the history of cinema and its involvement in the bringing together of man and machine, the ultimate creation of the cyborg. Dziga Vertov's 'Kino-Eye' was, as Annette Michelson argues, 'an ideological concern with the role of art as an agent of human perfectibility, a belief in social transformation as the means for producing a transformation of consciousness and a certainty of accession to a "world of naked truth"' (Michelson 1984: xxv). 'Kino-Eye' envisaged cinema as publicist for industrialisation, for contented workers and for bringing these workers and their-factory machines closer together.

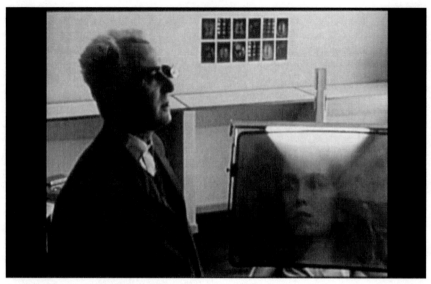

Amnesiac Eva in *La sonámbula*. By courtesy of Fernando Spiner

Spiner plays with the idea that all perception is mediated, as patient Eva's face appears under a gigantic magnifying glass and Dr Gazzar uses his prosthetic camera-eye to examine her.

'Kino-Eye' is a theory that interfaces the mechanical cine-camera with the organic human eye as a means of technologically enhancing the scope of human vision. *Man with a Movie Camera* covers a full working day in the cities of Moscow, Odessa and Kiev. More importantly, the film provides a symphony of the scopic potential of the cine-camera. During this day, the cameraman is portrayed as an integral part of society and with the aid of his camera he can film from the sky, in between trams, beneath trains passing overhead and on rooftops. The camera is omnipresent, even if it is in a rather surreal fashion as it emerges from a glass of beer towards the end of the working day, later moving on its tripod, seemingly of its own accord, thanks to the illusions constructed through montage, themselves demonstrated in the film. As much as a documentary on a day in the life of the Soviet polis, this film showcases the cine-camera and the montagist's amazing ability to provide the audience with hereunto unseen perspectives of the city: a deeper, more microscopic reality. Two montage shots are of particular significance to this analysis: first, the opening shot in which a human eye is projected into the lens of the cine-camera, suggesting that the two are one and the same; second, the shot in which the face of a contented worker is merged with a shot of a fast moving machine. The wheel of industry spins over the smiling face signalling the fusion of man and machine as fundamental to the modern projects of industrialisation and technological advance.

The Utopian fervour that punctuates Vertov's manifestos for the 'Kino-Eye' was embedded in the rhetoric of Soviet Communism and this must not be forgotten when transposing the idea of the 'Kino-Eye' to other contexts. Nevertheless the idea of camera-enhanced vision extends beyond such rhetoric, as Joseph Christopher Schaub (1998) has argued in his work on 'Kino-Eye' as a 'cybertext'. Schaub traces the cyborg back to the Futurist movements of the early twentieth century, focusing in particular on Dziga Vertov's 'Kino-Eye' as 'the first revolutionary cyborg' and his 1928 film, *Man with a Movie Camera*, as potentially 'the first revolutionary cybertext' (1–2).

Whilst the all-seeing cine-camera of Vertov is never associated with the negative aspects of an audiovisual panopticon, as it is in *La sonámbula*, the dialogue that I have established between the film and Vertov's theory of the 'Kino-Eye' serves to highlight the way in which a Utopian project of cinema as a force for change has led to a scenario in which cinema must now consider the negative side of the video technologies cinema shares with CCTV surveillance and television. Several shots throughout the film mark points of self-reflection in which cinema engages in a struggle with its own apparatus. Close-up shots of the surveillance camera monitoring Eva in the 'Centro de Investigaciones' bring the cine-camera face-to-face with these technologies of control and surveillance. The way in which the cine-camera zooms in on the surveillance camera subtly suggests that cinema can adopt the most revealing vantage point from which to scrutinise the processes of audiovisual control at work in Buenos Aires in 2010. But the oppositional stance of the cine-camera and the surveillance camera in this shot is undermined when, in another shot, the camera aligns itself seamlessly with the perspective from Gazzar's camera-eye, as if testing the limits of its collusion.

As has been argued thus far in this investigation, film, like theatre, can be defined as a performance art. It is hardly surprising, therefore, that *La sonámbula* demonstrates not only the manner in which cinema and video technology has shaped social relations, but also the way in which performativity mediates social exchanges. Theatre is shown to be a crucial medium in the reconstruction of social relations. This is best demonstrated in the rehabilitation sessions for amnesiacs in the Centre for Psychobiological Research. The sinister group session, administered by one of the centre's psychologists, consists of placing a couple on a platform (to all intents and purposes a stage) on which they must perform an embrace in front of the other patients (now also spectators). Acting as director, the psychologist tells patient Boris to approach fellow patient Carolina and embrace her from behind. The wooden gestures of both patients suggest that they are performing an unnatural action with which they are uncomfortable. The complete artifice of the situation comes to a climax when, despite assertion from the psychologist that she should remain calm, Carolina becomes agitated at Boris's advances and runs off the stage shouting

'¡no puedo ... no puedo!' The sessions, as rebellious patient Gorrión reminds us in his challenge to the psychologist, are obligatory. He also suggests to the other patients that the dreams they are recounting to the group are dreams they have been told about by the psychologists, rather than dreams actually dreamt. Performance is used to construct the fiction of a political cover-up, glossing over absent memories and cementing together new artificial communities. In *Postales argentinas*, Héctor is constantly paranoid that both his mother and Pamela are performing lies. Human behaviour is intimately tied up with the idea that social relations are nothing more than artifice.

There is a striking resemblance between Piglia's view of society as a web of fictions and what Bartís repeatedly describes as a society based on theatricality. It is, at this point, worth taking a brief excursion into some of Bartís' other plays in order to explore the way in which social theatricality represents a constant threat to theatre in his work. Looking back at the production of his play *Hamlet o la guerra de los teatros* (1990), Bartís explains that he had (and indeed continues to have) certain

> preocupaciones sobre el espacio de la actuación y el lugar del actor en la sociedad, frente a la creación y la actuación brutalmente artificiales. [...] Percibíamos la política como un artificio actoral muy elevado. Frente a los políticos, el trabajo del actor y el espacio de la actuación quedaban muy reducidos y nos cargaban de dudas. La pregunta era si tenía sentido, o no, actuar en una realidad tan 'dramatizada', tan 'actuada'. (2003a: 88)

Both Piglia and Bartís demonstrate an obvious anxiety over the role of fiction in constructing artificial social and political realities, which, certainly in Bartís' case, is a direct reference to the Menem regime and the 'bovarismo social' that spread throughout a society that lived fictitiously beyond its means, in a simulacrum of First World affluence. Piglia also points to a longer tradition of this concern in literature. This is a recurring issue in Bartís' theatre and it is thus important to place *Postales argentinas* in dialogue with Bartís' other plays and a significant body of work disclosing the teatrista's own philosophy on theatre. Both exercises serve to clarify the manner in which Bartís regards the status of contemporary theatre as threatened. It is this process of adaptation or the translation of foreign plays to an Argentine context that reveals the influences informing Bartís' style of theatre and the theatrical and literary lineages with which he chooses to engage.

Bartís' 'versión libre' (loose adaptation) of Shakespeare's *Hamlet* (1601) problematises what Bartís describes as two distinct forms of theatricality at play in society: artistic and political. It is not surprising then that the original title of the play was modified to incorporate this idea of two conflicting theatres: *Hamlet o la guerra de los teatros*. The play depicts the way in which artistic theatre is employed to deconstruct the theatricality (read 'artifice') in

social and political processes. Rather than distancing itself from the latter, however, aesthetic theatre opposes social and political theatricality from its own privileged proximity. Bartís uses his theatre to draw out the theatrical side of politics, which is made clear in his suggestion that Claudio is Menem —'[u]n rey de farsa' (Bartís 2003c: 111)— and Hamlet's murdered father represents Perón (94). Claudio's assassination of his brother is immediately equated with Menem's metaphorical assassination of classic Peronism. Living with the knowledge of his uncle's fratricide, Bartís' Hamlet describes the artifice and appearance surrounding him: 'Todo aquello es apariencia, pues son acciones que el hombre puede actuar. La actuación no es más que engaño y disfraz' (97). Yet, the play seems to suggest that the best way to strip a performance of its artifice and seek justice for crimes done is to stage another performance, as Hamlet organises a play to re-enact his father's poisoning in front of Claudio and his mother. Hamlet also makes clear to the actor he hires that he should take special care not to 'sobreactuar', alluding to theatre's capacity to reveal artifice and present a discourse of truth. Reality, suggests Bartís, is stranger —or at least more theatrical— than fiction. To this effect, Hamlet declares: '[l]a naturaleza les dió una cara y ustedes se fabrican otra distinta. Caminan dando saltitos, hablan sensualmente y hacen pasar su tontería por candidez' (106).

Bartís' *Hamlet o la guerra de los teatros* contains only nine characters and its duration is no more than a third of Shakespeare's original. The act of adapting this turn-of-seventeenth-century play to contemporary Argentina is clearly an act of affiliation with a Western tradition of theatre, another element in the 'family romance' outlined previously. It can also be read as recognition of Shakespeare's frequent reference to the way in which theatre infiltrates society and human behaviour, be it in Jaques' famous speech declaring that '[a]ll the world's a stage', Hamlet's use of theatre as a means of revealing the truth about his father's murder, Richard III's self-recognition as a masterful thespian as he performs his way to the throne, or countless other examples.

As in *Postales argentinas*, disrupted family relations are also at the heart of *Hamlet o la guerra de los teatros*. Hamlet laments at the very beginning of the play: 'me pesa mi condición de hijo' (2003c: 97). Once more, Oedipal relationships are in play. Hamlet's father asks him to avenge his death. '¡Si me tuviste alguna vez amor, véngame de este infame y monstruoso asesinato!' (97). His father's suggestion that he may indeed not have felt any love for his father hints at an Oedipal scenario. Hamlet is perhaps more upset about being usurped by his uncle for his mother's attention, than by the actual death of his father.

Two of Bartís' other most recent *versiones libres* include his 1994 version of Armando Discépolo's 1924 play *Muñeca* (see Bartís 2003d), and his 1998 play *El pecado que no se puede nombrar* (see Bartís 2003e), which draws on Roberto Arlt's novel *Los siete locos* and its sequel, *Los lanzallamas*. Discé-

polo is largely considered the father of the *grotesco criollo* genre of theatre, cultivated in relation to the experiences of the Italian immigrant community at the beginning of the last century. It represented a contrast to the earlier and more festive 'sainete' (one-act play), charting the progressive disillusionment among the Italian immigrant community. Roberto Cossa's style of theatre, examined in *Años difíciles* in the previous chapter, represents a continuation of the *grotesco criollo* style. The *grotesco criollo* is a genre of theatre that epitomises a loss of hope and feeling of failure. This disillusionment is translated to Bartís' adaptation of *Muñeca* in another vision of failure. It parodies the Unitarian Utopia of urban civilisation and immigration. Enrique complains that '[l]as viejas fuerzas del país aliadas en el desastre no nos dejan cumplir con nuestro programa de renovación. Si nos dejaran, reedificaríamos la capital en dos años y poblaríamos la República en cinco' (2003d: 131). His words are a clear parody of Juan Bautista Alberdi's famous formula for progress: 'gobernar es poblar' (1943: 242).

El pecado que no se puede nombrar recounts the plot made by a group of dissidents who plan to cause gas explosions in several key military posts. Their hope to overturn a military regime results in a plan for another coup and temporary dictatorship in order to stabilise their new regime. Jorge Dubatti describes *El pecado que no se puede nombrar* as

> [una] verdadera moraleja a la manera del 'viejo' teatro político: el 'pecado que no se puede nombrar' es el de haber perdido los sueños, el de haber perdido la capacidad de generar utopías. Esta actitud política de resistencia ya estaba presente en las frases de Juan Domingo Perón y José de San Martín intertextualizadas en *Postales argentinas*, así como en la asimilación del padre de Hamlet con Perón y de Claudio con Menem en *Hamlet o la guerra de los teatros*. (in Bartís 2003a: 189)

In a plot which echoes the theory of the 'dos demonios',[5] violence provides the solution to violence, dictatorship the solution to dictatorship, in a formula only too familiar over the course of Argentine history. What is more, the role of fiction in consolidating their coup and feeding the discourses of power is made clear. In order to consolidate their coup, they intend to show films in the poor neighbourhoods, effectively to brainwash the population: '[f]ilmaremos películas y las exhibiremos en los barrios pobres' (2003e: 195). Here Bartís draws an interesting line between theatre and cinema, clearly implicating cinema in the construction of the discourses of power. Once again, the Arltian/

[5] 'La teoría de los dos demonios' is a famous and controversial theory put forward by some to explain the 1976 military coup d'état. It focuses on the existence of two sides to the conflict, which led to a brutal escalation of violence: left-wing activism on the one hand and military repression on the other (see Pigna n.d.).

Piglian idea concerning the imbrication of politics, fiction and money stands out (Piglia 2001a: 21–8).

Theatre can be interpreted as Bartís' answer to 'mechanical reproduction' (see Benjamin 1970: 219–46), his affirmation of the 'aura' of the work of theatre, its authenticity, uniqueness and origins, which are fixed in a specific context and then lost in the annals of time. 'Para Ricardo Bartís', suggests Dubatti, 'el teatro es una experiencia efímera. Inmediatez e intensidad vital, que acontece en los cuerpos de los actores, en el convivio y el encuentro de presencias' (in Bartís 2003a: 7). Any kind of theatre that is recorded in a dramatic text, Bartís defines as 'teatro perdido' (7) as the essence of the performance, the moment of the encounter between performer and spectator, is lost. Bartís also describes theatre as a Utopian process.

> Al no trabajar con Textos, no aceptar su dominio, el ensayo se te va abriendo y abriendo y abriendo y abriendo y hay momentos en que estás muy perdido. Arena entre las manos. Y como son relaciones humanas basadas en compromisos humanos, esos procesos son enormemente desgastantes. Uno debe 'creer' en el ensayo. Producir un 'nosotros', aislado del mundo, muy singular, como si fuera un grupo de expedicionarios perdido en el desierto en búsqueda de una especie de talismán que sería la obra o el espectáculo que durante mucho tiempo no existe y se ve como una quimera, como algo utópico que uno necesita encontrar para darle legalidad a ese deseo y a esa voluntad de juntarse y ensayar. (10)

Bartís employs the idea of Utopia in a rather unusual way. Utopian narratives are conventionally teleological. Bartís, in contrast, is clearly more interested in process rather than any end product; his likening of theatre to a chimera rather goes against the modernist idea of Utopia as a teleological programme for political change. His style of theatre seems much more in line with post-modernism —to be more precise with the poststructuralist conceptualisation of performance— which is often associated with the loss of Utopia. Jameson examines the status of Utopia within the context of postmodernism:

> if this last [the postmodern] is as dehistoricized and dehistoricizing as I sometimes claim here, the synaptic chain that might lead the Utopian impulse to expression becomes harder to localize. Utopian representations knew an extraordinary revival in the 1960s; if postmodernism is the substitute for the sixties and the compensation for their political failure, the question of Utopia would seem to be a crucial text of what is left of our capacity to imagine change at all. (1991: xvi)

I would suggest that Jameson's ideas of 'compensation' and 'substitut[ion]' are crucial here in understanding Bartís' curious definition of Utopia. The politics of Bartís' theatre are located both in the fact that it is a collective process

which constructs a 'nosotros' as well as in its capacity as a performance art form to reiterate with variation. The idea that no two performances are the same is what generates a dynamic for change in his theatre and attempts to compensate for the loss of Utopian narratives. This dynamic does not move in any particular direction, or towards a specific alternative, and is thus anti-teleological in form. A space for transformation is, however, set up. Bartís specifically aims to combat the stagnation of society as it dramaturgically repeats and becomes trapped in the same ideological script.

The task of resisting the visions of failure and resuscitating art's capacity to envisage Utopia is delicately negotiated in *La sonámbula* and *Postales argentinas* through a politics of generic identity and specificity. 'El teatro [...] necesita fundar algún territorio de "verdad" para poder afirmarse y no enloquecer', Bartís maintains (9). As in Eduardo Pavlovsky's *Paso de dos* and *Rojos globos rojos*, or Solanas' portrayal of the 'Tanguedia' in *El exilio de Gardel* (analysed in chapter 1), this 'territorio de "verdad"' lies in the here-and-now of pure performance. As the final line of Jameson's most recent work on Utopia reaffirms, 'utopia as a form is not the representation of radical alternatives; it is rather simply the imperative to imagine them' (2007: 416). The way in which they breathe life into these lineages may be somewhat makeshift and the act of citation may collapse any linear accel- eration of time upon which such genealogies (and Utopia) would normally be structured, but the 'imperative to imagine' an alternative future remains. Cinema and theatre carefully set themselves up as spaces in which the imag- ined future can be expressed. Bartís may accuse literature of vampirism, 'como un vampiro de la actuación', as the dramatic text sucks the blood/life out of theatrical performance (2003a: 13), yet his texts also engage in a type of vampirism —necrophilia even— as they feed promiscuously/incestuously off their ancestors in order to survive, revitalising theatre and cinema as established and autonomous art forms invested with the power and influence of their forefathers.

To conclude, *Postales argentinas* and *La sonámbula* attempt to demon- strate that the collapse of boundaries has not signified a harmonious coming together of art and life, and art and politics, but a need to re-establish the boundaries and the differences, without renouncing the privileged position cinema and theatre now hold in understanding the contemporary condition of social and political relations. There is, however, a sense that the artificially resuscitated genealogies built in *Postales argentinas* and *La sonámbula* are achieving nothing more than a prolongation of the rather illusory existence of theatre and cinema as autonomous and specific art forms. Whilst these texts try to compensate for the loss of autonomy from within the confines of the postmodern, there remains a sense that this results in a simple postponement of the inevitable collapse of the aesthetic into the social and the political; and with it, a rather fated collapse of Utopia.

Biodramas/Biography/Biopolitics: Projects of 'Convivencia' in New Argentine Cinema and Theatre

En un mundo descartable, ¿qué valor tienen nuestras vidas, nuestras experiencias, nuestro tiempo? Biodrama se propone reflexionar sobre esta cuestión. Se trata de investigar cómo los hechos de la vida de cada persona —hechos individuales, privados— constituyen la Historia.

Vivi Tellas, cited in Mariana Obersztern, *El aire alrededor*, 46

For millennia, man remained what he was for Aristotle: a living animal, with the additional capacity for a political existence; modern man is an animal whose politics places his existence as a living being in question.

Michel Foucault, *The History of Sexuality*, 143

One of the most interesting points of comparison to be made between recent cinema and theatre is in the appropriations that certain films and plays make from the documentary genre. New Argentine Cinema is a well established critical label for what in fact represents a somewhat heterogeneous group of films produced since 1995. The lack of any unifying ideology or programme, however, means that it falls short of qualifying per se as a movement (Wolf 2002: 30). New Argentine Cinema is generally characterised by its minimalist aesthetic (blurring documentary with fiction), its emphasis on micro-political, everyday existences, also typical of documentary, and the fact that it shuns macro-political allegories that attempt to give any picture of the social totality (Wolf 2002: 29–43). Its almost exclusive focus on contemporary scenarios, often on those living on society's peripheries (Wolf 2002: 33), 'push[es] the boundaries of Argentine national identity through low-budget cinema' (Falicov 2007: 152). Often likened to post-war Italian neorealism,

what characterises many of the films made in difficult economic conditions is, as Joanna Page suggests, 'their ability to make aesthetic virtue out of economic necessity' (2009: 2).

New Argentine Theatre is much harder to pin down on account of its greater diversity of aesthetic approaches. Citing both Eduardo Pavlovsky's aesthetics of multiplicity in *Rojos globos rojos* (see chapter 1) and Ricardo Bartís' focus on performance in *Postales argentinas* (see chapter 3) as antecedents of this movement, Jorge Dubatti defines New Argentine Theatre by its attempts to revise the parameters of dramaturgy. He points to an opening up of theatrical processes to less conventional means of script-writing and performance, as well as a newfound appreciation of 'la imbricación de tres acontecimientos: el convivial, el lingüístico-poético y el expectatorial' (Dubatti 2003: 6). The concept of New Argentine Theatre does, however, also seem to be cemented, albeit loosely, on ideological grounds, by what critics interpret to be contemporary theatre's common rejection of neoliberalism. Theatre practitioners contest neoliberal trends with a discourse which underlines theatre's status as a local, organic art form able to challenge the disembedding forces of globalisation (see Dubatti 2007: 63–4).

Despite the multiplicity of aesthetic approaches in New Argentine Theatre, Vivi Tellas' Proyecto Biodrama (2001 to 2008) nevertheless stands out in its appropriation of documentary, as well as the associated genres of biography and testimony. Tellas' project established itself over six years as one of the longest running fixtures on the annual programme of theatre production, reaching its fourteenth edition. The series ended when Alejandro Tantanian took over as director of the Teatro Sarmiento; its final edition was Tellas' own biodrama entitled *Archivos*. In this ongoing project she uses documentary theatre as a means of searching for intimacy and a performance outside the bounds of conventional theatre.[1] No exact definition exists for the term 'biodrama', but it approximately equates to a biography staged in the form of a play. The term also encapsulates the idea of a significant slippage between documentary (bio) and fiction (drama).

As in previous chapters, the main focus of this chapter will be to examine the strategies of re-politicisation and re-socialisation inscribed into borrowings from documentary in more recent theatre and cinema. Such borrowings can be brought together in their efforts to deconstruct the discourses of neoliberalism and its local variant *menemismo*. The politics of the films and biodramas examined in this chapter register the experience of political and economic upheaval on a private, micro-political level. They do this by focusing on three strategies: recovery of the Real, recovery of the social, and

[1] For more information on this biodrama see Tellas' website: www.archivotellas.com.ar, last viewed 14 July 2010.

the setting up of theatre and cinema as test beds for renewed projects of societal 'convivencia' thrown into disarray in the wake of the economic, social and political Crisis that afflicted Argentina in December 2001.

The dissipation of the real amidst a proliferation of performances, images and representations should at this stage in the investigation be all too familiar. In chapter 1, *La nube* demonstrated the transformation of Buenos Aires into Guy Debord's 'Society of the Spectacle' (2004), representing a simulacrum of modernity. *Buenos Aires viceversa* in chapter 2 highlighted the artifice and spectacle in television reportage. And the previous chapter looked at the way in which *La sonámbula* projected similar concerns into the future, anticipating the disappearance of the real amidst the proliferation of images, representations and simulacra, leaving Buenos Aires of the future, as Geoffrey Kantaris concludes, as nothing more than the Baudrillardian 'desert of the Real' (2008: 67). In *Welcome to the Desert of the Real* (2002), Slavoj Žižek reminds us that the 'postmodern doxa' conceptualises 'reality' as 'a discursive product, a symbolic fiction which we misperceive as a substantial autonomous entity' (19). 'On today's market', he argues,

> we find a whole series of products deprived of their malignant properties: coffee without caffeine, cream without fat, beer without alcohol ... And the list goes on: what about virtual sex without sex [...], the contemporary redefinition of politics as the art of expert administration, that is, as politics without politics, up to today's tolerant liberal multiculturalism as an experience of the Other deprived of its Otherness. [...] Virtual Reality simply generalizes this procedure of offering a product deprived of its substance: it provides reality itself deprived of its substance, of the hard resistant kernel of the Real. (10–11)

The Menem years in Argentina can certainly be likened to a virtual reality: a simulacrum of First World affluence under the banner of modernisation and neoliberalism which was 'misperceive[d]' by many as a 'substantial' phenomenon. What is significant for my analysis here is the manner in which Žižek interprets society's reaction to this loss of the Real, arguing that 'the "postmodern" passion for the semblance ends up in a violent return to the passion for the Real' (10). Although not as violent as the search for the Real described by Žižek (who uses cutters and terrorism as examples), recent theatre and cinema's borrowing from documentary represents nevertheless a timely reality check: 'an attempt to regain hold on reality, or (another aspect of the same phenomenon) to ground the ego firmly in bodily reality, against the unbearable anxiety of perceiving oneself as nonexistent' (Žižek 2002: 10).

In his article on the biodrama series Óscar Cornago confirms this trend towards a resuscitation of the Real. He maintains:

[e]n una sociedad desbordada de representaciones e imágenes, de simu-
lacros y ficciones, la recuperación de lo real ha funcionado como una
especie de consigna en campos muy diversos. [...] Tanto en el arte como
en la escena mediática se ha tratado de crear un efecto de realidad que
estuviera más allá de lo ficticio, de lo que no es verdadero, del engaño y
lo teatral. (2005: 5)

It is the 'sed de realidad' (5) that emerges in reaction to this proliferation of
representations, images, fictions and simulacra that Cornago suggests has
motivated both cinema and theatre to appropriate ground from documentary
in recent times.

The history of documentary is as old as the history of cinema. The first
films ever to be made were in fact called *documentaires* and were made for the
purposes of information, education and propaganda (Susan Hayward 2000:
90). To all intents and purposes therefore film was born as documentary, born
as a transparent window on reality designed to recuperate/observe the images
and sounds of ordinary everyday existence, and only subsequently deviated
into fiction (although the boundary between documentary and fiction is by
no means clear-cut). As film spectators, in many ways, we are conditioned
by certain reflexes that make us want to read the film as a window on reality.
Hayward also highlights periodic returns to documentary or neo-documentary
genres: *cinéma-vérité* in France and direct cinema in North America in the
1960s; documentary as a means for ethnic minorities to challenge the estab-
lishment and create a representative space for themselves in Western societies
in the 1970s (2000: 92). In each of these cases, the revival of documentary
can be associated with times of social, political or economic upheaval and the
imperative among filmmakers to use cinema to address the problems arising
from the turmoil. After World War II, filmmakers turned to documentary
for financial reasons, as there were not enough financial resources to budget
feature filmmaking. New Argentine Cinema is described by some to be
heavily influenced, as was much politically engaged Latin American cinema
of the 1950s and 1960s, by post-war Italian neorealism (Aguilar 2006: 34;
and Page 2009: 33). Emerging at a time when Italy had lost its sense of iden-
tity as a nation, neorealism attempted to reconstruct national identity through
cinema, drawing on a documentary style of cinematography in order not only
to collapse the distance between cinema and life, but also in a democratic
impulse to represent marginal sectors of society and give meaning to the most
trivial events. New Argentine Cinema engages in a similar project of social
mapping. As Robert Stam affirms: 'the cinema made it possible for ordinary
people to know about each other's lives, not in the name of voyeurism but
in the name of solidarity' (2000: 73). Stam's argument that 'realism' became
'the cornerstone of a democratic and egalitarian aesthetic' can certainly be
applied to many examples of New Argentine Cinema which set themselves

up as spaces in which socially, politically and economically peripheral characters can be represented. Numerous examples of this are found in New Argentine Cinema: Adrián Caetano's *Bolivia* (2002) portrays the exploitation of a clandestine Bolivian immigrant; Edgardo Cozarinsky's *Ronda nocturna* (2005) depicts a night in the life of a young male prostitute; Pablo Trapero's *Leonera* (2008) examines a group of female prisoners who have given birth to and raise their offspring inside their jail. There exist numerous other examples —too many to cite here— but those mentioned already give an idea of the different ways in which recent films attempt to throw new light on society by portraying it from its margins.

Most important for this study, however, as Michael Chanan argues, is the fact that documentary is a crucial ingredient in the tradition of political filmmaking in Latin America (1997: 202). This is echoed in Joanna Page's observation that New Argentine Cinema shows an 'affinity with the new cinemas of other emerging nations, such as Iran and Brazil', namely in their common appropriation of documentary and neorealist cinematography in similar projects mapping out the nation (2009: 198). Chanan also makes the important observation that television inherited the aesthetic of documentary (1997: 203). The citation of neorealist aesthetics can also be interpreted reflexively as recognition of the threat posed by the neighbouring medium of television (suggested in relation to *Buenos Aires viceversa* in chapter 2), alongside other performative art forms and documentary movements that arose in the wake of the crisis as a means of resistance. Cinema is able to hark back to neorealist ideas, back to ideas of cinematic transparency. Theatre, in contrast, appeals back to documentary via the notion of presence/immediacy and its status as an organic art form. In both cases, the focus here will be on the way in which documentary is styled as a tool of political resistance.

One of the most interesting points made by Bordwell and Thompson in their definition of documentary is the way in which they differentiate it from fiction. They argue that documentary and fiction differ in the way they are 'tied to actuality' (2004: 132). Whereas documentary aims at a more literal representation of reality, fiction often relates to it through allegory. This chapter, in contrast to the examination of films and plays dealt with previously, marks a shift from allegory to documentary (Page 2007: 157). Much of the effort to empty out the Menemist discourse is still negotiated along the boundary between aesthetic performance and social performance, but theatre and cinema now assume the role of stripping political theatre of the excessive levels of theatricality reached under President Menem rather than matching them. The appropriation of documentary and the recovery of the real thus serve as a challenge to political theatricality which is associated with artifice. As politics becomes further removed from reality and conceived increasingly in terms of a fiction, theatre and cinema reinvent themselves along neorealist lines in order to step into the void left by politics.

Without a doubt the most poignant example of the collapse of mainstream politics and proliferation of alternative forms of activism in Argentina in recent years was the acute social, political and economic crisis unleashed on 19 and 20 December 2001 when the country defaulted on its foreign debt payment. The simulacrum of Argentine modernity, as fabricated over two decades of neo-liberal policies, with its apex in the *fiesta menemista* of the 1990s, was revealed to be nothing more than a fictional *castillo en el aire*. Argentina's illusory boom tumbled and the cry of anger that was to become emblematic of the spontaneous street protests —the celebrated *cacerolazos* that burgeoned in the aftermath— demanded 'que se vayan todos'. '[T]odos' meant of course the entire political class. Bank accounts were frozen, savings in dollars were converted one-for-one into the heavily devalued peso, unemployment surged and a little over half the population found itself abruptly below the official poverty line (Grimson 2004: 92). If the dictatorship had not done enough to discredit the political class, then society no longer had any reason or inclination to trust conventional political processes, turning instead to alternative forms of participation.

The words of Eduardo Duhalde, cited in Mauricio Rojas' *Historia de la crisis argentina* (2004), sum up the effect of the 2001 crisis on the social fabric of a country 'quebrado y al filo de la anarquía':

> El pueblo no confía en los políticos ni en sus representantes. El pueblo no se siente interpretado por sus dirigencias sindicales o empresariales y desconfía también de la Justicia. Y tan grave como esto es que se ha perdido la confianza en el seno mismo de la comunidad [...]. El profundo deterioro moral que ha minado la confianza entre los ciudadanos, ha roto la credibilidad en las instituciones públicas y ha alterado los pactos básicos de la 'convivencia' [...]. Hoy tenemos el inmenso desafío de reconstruir nuestro capital social, cuyos componentes esenciales son: la capacidad asociativa de un pueblo para construir un proyecto común; la confianza entre los miembros de una misma comunidad y entre sus instituciones y representantes; la ética de comportamiento del conjunto de la sociedad y la conciencia cívica de la población, es decir, su valoración de vivir en democracia y de aspirar a mejorar las condiciones de su existencia. (119)

For many, it will seem at the very least ironic that Duhalde should speak in such a way —not only had he been Vice-President to Carlos Menem in the early 1990s, but, in May 2003, he was forced to cut short his term as President following the controversial shooting of *piqueteros*[2] blocking the Puente Pueyrredón[3] (Grimson 2004: 192)— but his words nevertheless sum up the

[2] The term *piqueteros* refers to a movement/mobilisation of the unemployed.

[3] The Puente Pueyrredón is an important bridge traversing the Barracas neighbourhood of Buenos Aires and crossing the river Riachuelo. It is the most important link between the

fragmentation felt at the heart of Argentina's social fabric: moral deteriora-
tion and a loss of trust resulting in a loss of any coherent sense of commu-
nity; public institutions left with little or no remaining credibility; loss of a
'proyecto común'; and perhaps most pertinent to this study, a transforma-
tion in what Duhalde refers to as 'los pactos básicos de la 'convivencia'.
Loss of the founding pacts of societal 'convivencia' is a major theme of
the crisis and many of the alternative forms of participation that emerged
at the time of the crisis focus on reconstructing a sense of 'convivencia'. In
many instances art and culture provided a form of social participation. The
concept of 'convivencia', as will be demonstrated further on, is central not
only to debates surrounding the reconstruction of Argentina as a nation, but
to defining the socio-political interventions of theatre and cinema and how
cultural capital can compensate for what Duhalde sees as the loss of Argen-
tina's social capital.

Biodrama/Biopolitics: Recuperating the Social in Mariana Obersztern's play *El aire alrededor* (2003) and Luciano Suardi and Alejandro Tantanian's *Temperley* (2002)

Vivi Tellas' Proyecto Biodrama began in 2001 and enjoyed a successful run
at the Teatro Sarmiento until 2008 when Alejandro Tantanian took over as
Director of the theatre. Like many recent films, the Proyecto Biodrama draws
on documentary and merges it with fiction in a project that takes as its source
of drama the experiences of real living people. Each biodrama is conceived
by a different director/*teatrista*, who is asked to dramatise the life of a real
person currently living in Argentina. There is no constraint on the aesthetic
format the biodrama should take, only that the director should collaborate
with the person in question as part of the creative process. Tellas outlines the
project as follows:

> El **Proyecto Biodrama** se inscribe en lo que se podría llamar el 'retorno
> de lo real' en el campo de la representación. Después de casi dos décadas
> de simulaciones y simulacros, lo que vuelve —en parte como oposición,
> en parte como reverso— es la idea de que todavía hay experiencia, y de
> que el arte debe inventar alguna forma nueva de entrar en relación con ella.
> La tendencia, que es mundial, comprende desde fenómenos de la cultura
> de masas hasta las expresiones más avanzadas del arte contemporáneo,
> pasando por la resurrección de géneros hasta ahora 'menores' como el
> documental, el testimonio o la autobiografía. El retorno de la experiencia
> —lo que en el Proyecto Biodrama se llama 'vida'— es también el retorno

Capital Federal and the conurbano zona sur and was the regular site of road blocks set up by
piqueteros at the time of the Crisis.

de Lo Personal. Vuelve el Yo, sí, pero es un Yo inmediatamente cultural, social, incluso político. (2007: n.p.)

The most important elements to underline here are first the Proyecto Biodrama's imperative to capture the intimacy of real lives, recoiling into the private space of the individual, and second, the emphasis that Tellas places on giving this self a meaning in relation to cultural, social and political matrices. This ensures an exploration of the role that different structures play in the construction of subjectivity.

The fact that each biodrama is staged by a different director makes the aesthetic range of the project varied, a testament to the aesthetics of multiplicity. Despite the diversity of the project, each play takes as its basis the same rubric outlining how it should stage the relationship between theatre and life, and each director must find his or her own way of staging this 'retorno de lo real': Stefan Kaegi's ¡Sentáte! (2003),[4] which dramatises the relationship between owners and their pets, uses animals on stage —a pair of tortoises, a colony of fourteen rabbits, a dog and an iguana to be precise— to ensure the constant unpredictability of the real in the performance; the actor in Edgardo Cozarinsky's Squash (2005), Rafael Ferro, represents his own life, the sensitive nature of which means that at one point in the play Ferro tells the audience that he forbade his parents from watching the performance for fear they would be offended by some of the revelations; Javier Daulte's Nunca estuviste tan adorable (2004) may be constructed very much as a fiction, with overtly theatrical scenes and a romanticised orchestral soundtrack that is quite cinematic at times, but Daulte himself appears in this dramatisation of the life of his grandmother. Each biodrama grounds its representation in reality in some way, although this is not necessarily through the explicit appropriation of theatrical documentarism.

Two biodramas do, however, stand out in their use of a naturalist aesthetic: Suardi and Tantanian's Temperley[5] (2002) and Obersztern's El aire alrededor (2003). El aire alrededor: sobre la vida de Mónica Martínez (2003), as the title suggests, dramatises the life of Mónica Martínez based on four interviews carried out by Obersztern with Mónica at her home, five evening telephone conversations and finally a trip with the whole cast of the biodrama to her village, Carlos María Naón (Obersztern 2004: 46). The play follows the humble, rural existence of Mónica Martínez chronologically from birth to old age, as represented through her personal life, family relations and friendships. Temperley is also based on a series of interviews, this time carried out with

[4] A recording of each of the biodramas is available for viewing in the Centro de Documentación in the Centro Cultural General San Martín on Avenida Corrientes in Buenos Aires. It is thanks to these recordings that I have been able to analyse the biodrama series.

[5] Tantanian wrote the text and Suardi directed the play.

a Spanish woman who emigrated to Argentina in 1935 and currently resides in the southern neighbourhood of Gran Buenos Aires called Temperley. The woman chooses to remain anonymous, going only by the initials T.C. and by the false name of Amparo in the play. An atmosphere of melancholy pervades throughout as we learn of the humble experiences of this woman and her sister, who travelled by boat from Galicia to Buenos Aires at around the time of the Spanish Civil War to seek a better life in Argentina. Both these plays invite consideration regarding the kind of engagement that can be read into texts that retreat into private space and, whilst the lives portrayed are obviously affected by larger-scale events taking place around them, seem to shun any relationship to macro-political concerns. The line of investigation followed here examines how the private can be read as political.

Both *Temperley* and *El aire alrededor* refuse patent allegories of their macro-political context, and whilst the political and economic context of these plays is not completely absent, it is well and truly subordinated to the day-to-day experiences of their protagonists: life in adolescence, marriage, parenthood and old age, all experiences with which most spectators can easily identify. The following analysis will examine what kind of engage-ment can be read in these plays that retreat into the very private spaces of the family and the home, examining ultimately what they reveal about a wider shift in the focus of politics from the public to the private in recent theatre (and cinema).

The sincerity and intimacy of the encounter between spectator and actor, alongside the consentient way in which we are taken into the private, everyday lives of Amparo and Mónica, strives for a veritable ambiance of theatrical 'convivio' in which instances of 'convivencia' are portrayed. The recuperation of the real in both *Temperley* and *El aire alrededor* is intimately tied to what I will argue is a biopolitical strategy that attempts to recuperate the social into the political, granting the humble experiences of these two women a meaning beyond the confines of their private world, as well as to set theatre up as a space of expression in which new pacts of 'convivencia' can be played out. Although no mention of the Crisis is made in *Temperley*, Tantanian remarks that

> [a] partir del 19 de diciembre de 2001, de lo que pasó y pasa, hay algo de la especificidad del teatro que a mí me puso en crisis. No solamente me pregunto qué hacer sino para qué. Hay en mí una idea mucho más quebrada respecto del motivo por el cual uno debería seguir haciendo lo que hace. (Cited in Cabrera 2002: n.p.)

I would suggest that through these ideas of 'convivio' and the recupera-tion of the social, Tantanian finds theatre's specific response to the Crisis. If the Crisis took away people's control over their own destiny and left them

feeling wholly unserved by the political class running the State, then theatre's response is to give back that agency by giving a meaning to the trials and tribulations of the forgotten individual.

In relation to this, Ana Amado and Nora Domínguez consider the collapse of the social during the Menem years which led up to the Crisis. They contend:

> Durante la década de los noventa, la aplicación estatal de inflexibles políticas económicas neoliberales fue acompañada localmente por la fuga simultánea de sus responsabilidades, que afectó integralmente el orden de lo humano desde punto de vista social al dejar a las familias de sectores medios y bajos en el más absoluto desamparo y desprotección. Un dato contrario, sin duda, al propuesto por las estructuras imperantes en el primer mundo. [...] En consecuencia, los reclamos, que adoptaron múltiples formas de petición contra tal política desertora, apuntaban a la falta de producción, regulación y presencia estatal en educación, salud, trabajo, vivienda, justicia, seguridad, es decir, áreas de impacto decisivo en el orden familiar. (2004: 18)

The family, as suggested in the analysis of *Postales argentinas* and *La sonámbula* in the previous chapter, lies at the interface between the social and the political and the private and the public as a vital paradigm of individual and collective identity. *El aire alrededor* and *Temperley* take the form of family narratives as the lives of their protagonists are told through the encounters they have, or letters they exchange, with family members.

What the biographies presented in *Temperley* and *El aire alrededor* engage in is what I would describe as a sort of biopolitics. The term 'biopolitical' will more readily conjure up Michel Foucault's negative definition of the term in his portrayal of 'bio-power', whereby State power is cultivated at the level of everyday life (1979: 140–1). In *The History of Sexuality* (1979), Foucault states that the increased politicisation and control of social life, through institutions such as public health, the family, education and the police, is a fundamental trait of modernity, aimed at subjecting the population by means of its 'docility' to capitalist processes of production (139–40). This is certainly true of dictatorial regimes such as the 'Proceso de Reorganización Nacional'. In contrast, however, what will be of major interest here is the positive meaning that can be associated with the term 'biopolitics'. These texts demonstrate a desire for politics to be located more at the level of 'bare life' (Agamben 1998: 4), which rather contradicts the European idea that the focus of politics on the micro-politics of the social is symptomatic of a broader collapse of ideas and an attempt to compensate for a general trend of de-politicisation (Furedi 2005: 18). What they point to is a positive conceptualisation of biopolitics more in line with that of theorists such

as Michael Hardt and Antonio Negri's biopolitical ideal of the 'multitude' (2006). Hardt and Negri's *Multitude* provides a blueprint for societal 'convivencia' that reaches beyond the confines of the nation-state and is based on a multiplicity of different subject positions which find cohesion in their diversity. The 'multitude', they define as follows:

> The multitude is an internally different, multiple social subject whose constitution and action are based not on identity or unity (or, much less, indifference) but on what it has in common. [...] The concept of the multitude challenges this accepted truth of sovereignty. The multitude, although it remains multiple and internally different, is able to act in common and thus rule itself. Rather than a political body with one that commands and others that obey, the multitude is *living flesh* that rules itself. (2006: 100)

Obersztern focuses on the family in all her plays and although they highlight fractures in the family unit, it is still portrayed as a key micro-political space in which identities are cultivated and grounded. Family affiliations, as Judith Filc argues, continue to represent the initial step in processes of integration:

> Lo que garantiza este proceso [de integración], entonces, es la existencia de un espacio (familiar y social) en el cual se construyen vínculos que entretejen filiaciones biológicas, sociales y políticas. Nacer en el mundo occidental es, todavía, nacer en un hogar y en un Estado-nación que, supuestamente, garantiza nuestra identidad como 'hijos' y 'ciudadanos'. (2004: 215)

In *El aire alrededor*, the family becomes a political tool in the sense that it is used to recuperate the private sphere (as part of a broader attempt to recuperate the social) and make it public. The play does, however, refuse to use the family as a microcosm of the nation, as is so often the case in the Argentine theatrical tradition, as was demonstrated in my analysis of *Postales argentinas* in the previous chapter. Roberto Cossa's *La nona* and Eduardo Pavlovsky's *Telerañas* (1977) are just two examples of plays that have represented a series of violent and dysfunctional family relationships in order to allegorise state violence during the dictatorship. Ricardo Bartís' *De mal en peor* (2004) uses the family paradigm to allegorise the decadence of the upper middle classes in Argentina. Instead, Obersztern rejects this familiar allegory of the nation in favour of a more intimate biographical representation of a single person and her surroundings. The family, like theatre itself, serves as an intermediary between the private and the public. It is through this that she explores the subtle relationship between theatre and life, drawing out the theatricality intrinsic to family life, yet in a way that naturalises the theatre of life, rather than denaturalising social processes as was explored in the relationships between aesthetic theatre and social theatre in chapter 1. The

best example of this is in the amusing second scene of the play when Mónica and Nancy, as little girls, are play-acting the birth of Mónica's first child. The scene portrays the seamless association between theatricality and the process of growing up, imagining what adult life will be like:

> NANCY: Abrí ¡Abrí más …! Vos sufrí. ¡Abrí!
> MÓNICA: Vos haceme con el pañuelito así, en la frente.
> NANCY: No puedo. Estoy ocupada.
> MÓNICA: Bueno, me hago yo como si fueras vos.
> [...]
> NANCY: Voy a consultar con los otros doctores. *(Hace un aparte y luego vuelve.)* Vamos a hacer todo lo que está en nuestras manos. [...] Le hacemos un tajo en la panza, le damos a su bebé y se lo lleva a casa. Va a ver que cuando tenga al bebé en los brazos se va a olvidar del mal momento. (Obersztern 2004: 49–51)

These final lines by Nancy may reproduce the kind of clichés one would expect to hear in a hospital drama, but as Nancy and Mónica are both children at this point in the play, the theatricality in their behaviour seems entirely natural. Play-acting is a normal part of childhood and through this Obersztern is able to subtly remind the audience of theatre's relevance in documenting experience, the Proyecto Biodrama's *raison d'être*. The negotiation of theatre's recuperation of the social here is much more subtly played out than in the more overt negotiations across the boundary between aesthetic performance and social performance explored elsewhere in this investigation. The boundary nevertheless remains a crucial organising principle governing the way in which theatre can engage with real life, whilst remaining a separate entity.

The only reference to any historical or political context in *El aire alrededor*, save the rather allusive reference made in the title, is in a series of radio bulletins announcing the death of General Perón. The historical significance of this event is, however, soon diffused by the fact that the immediate impact of the event for Mónica is that school classes are cancelled. A rather infantile discussion between Mónica and Nancy then ensues as they disagree over the radio's claim that thousands of people are crying at Perón's demise. Nancy claims not to have noticed anyone crying, whilst Mónica claims that their classmate 'la señorita Marta Bachelo' was crying. 'Se ve que lo quería,' comments Mónica, as Pope Paul VI's blessing is transmitted over the radio. 'Hay que ver. A veces dicen que te quieren y no te quieren,' Nancy responds cynically. 'Que mal pensada, Nancy [...]. Vamos a tener que llorar, nomás. [...] ¡Pobre hombre!' (53–4). The announcement of Perón's death delicately roots the play in a highly restless period of Argentina's recent history, yet events such as the Dirty War and the dictatorship are forced backstage,

nothing more than 'el aire alrededor'. The importance of politics in the daily life of Mónica and her family is deflated as the icon of modern Argentine politics is reduced to nothing more than a '¡[p]obre hombre!' In this sense, Obersztern upsets conventional biography in her deliberate undermining of context. Biography is usually structured as a narrative of a person's life in relation to a series of major political or economic events. In *El aire alrededor* such events are either notable in their absence or, in the case of Perón's death when an event from the macro-political sphere touches the private sphere of everyday life, are shown to be irrelevant.

Major political events are also notable in their absence in *Temperley*, although the play gives, albeit understated, a greater sense of context. 'Los sucesos de la época atraviesan su historia', comments Tantanian, 'pero nosotros no los nombramos' (in Cabrera 2002: n.p.): the play opens in 1980, mid-dictatorship, even if mention is never made of the oppressive regime; it then jumps back to 1933, a time when Argentina called itself 'el granero del mundo', although also the 'Década infame' characterised by the first in a series of military coups that were to corrupt this vision of wealth and stability; Ana's letters are dated 1976 and although they refer to unbridled consumerism and raging inflation, the recent military coup sparking Argentina's most brutal dictatorship is never brought up; a final flashback to 1943 before returning to 2002 might encourage a parallel between two moments in Argentine history that stand out for political instability resulting from a close succession of ill-fated attempts at the presidency.[6] It is as if the play silently and subconsciously traces the nation's decline with the mere mention of such dates. That having been said, yet another token mention of Peronism seems to indicate that, whilst contemporary theatre is ready to shun macro-political contexts, Perón must not be forgotten. Amparo makes reference to 'el tiempo de Perón, cuando se puso la jubilación' (195). The reference to Peronism is coupled with reference to his social policy and a time when the government intervened in social life.

The macro-political is explicitly eschewed in several mentions made by the characters to the information media. One example is Amparo's first letter to Carmen in 1935. Carmen at this stage has already arrived in Buenos Aires, whilst Amparo is still harvesting potato crops in Galicia. Amparo writes: '[e]mpiezo por contarte las novedades de estas tierras. Sé que estás al tanto por los medios informativos que se escuchan a diario. Pero en ellos no sale lo que pasó con nuestro hermano Jesús' (191). Implicit in Amparo's statement is the fact that the news may have informed her about what is going

6 Following another *coup d'état* in 1943 Argentina had three different military presidents in the space of a year, and between December 2001 and May 2002 it had five different presidents in the space of just five months before the last of these, Néstor Kirchner, finally consolidated his position.

on in Spain at that time, but it in no way gives her any information about
how macro-political events are experienced on a more social/personal level.
Jesús has been recruited into the army. The play here subtly reinforces the
importance of representing micro-political scenarios to recuperate the social
into the experience of broader political events. In fact, one of the ways in
which *Temperley* creates its sense of intimacy is through its epistolary struc-
ture, which privileges personal testimony. This is reinforced in Jesús' letter
in 1989 as he seeks to supplement the information he has gained from the
media with more personal details. He writes:

> Pues ya dejemos este camino y vamos a darnos una vuelta por ese amar-
> gado Buenos Aires, ya tus informes juntos con los de Hipólito también me
> acercaron algo más a lo desecho que está ese país, y de la tele y todos los
> medios informativos que trato de escuchar lo único que saco en limpio es
> desastre y miseria, como se ha visto en esos atracos a casas de comestibles.
> Esto es penoso y nos duele a los que en ésa tenemos familias, y si este
> hambre llegase a estos hermanos, yo Jesús sin alabarme, os digo: 'estas
> puertas están abiertas' y no con lujos, pero comeremos juntos y fuera de
> eso que llamaremos TRISTE. (Suardi and Tantanian 2003: 213)

Temperley may steer clear of explicit engagement with the political, but what
it does record is a more explicit link between the social and the economic.
The letters written in April 1976 by Amparo's daughter-in-law Ana, a mere
month after the military coup, make no mention whatsoever of the political
turmoil of the period. This of course could be interpreted as an effect of
censorship. But more than a simple reference to the silencing of society,
Ana's letters foreground the primacy of economic conditions, in particular
Argentina's adoption of a neoliberal economic model, which spark an explo-
sion of consumerism. Ana's letters are punctuated by the verb 'comprar',
which she mentions no less than twenty-one times as she recounts her daily
life in terms of the goods she has purchased and the prices that each of these
products has cost (2003: 199–201). The narratives of Ana's everyday life tell
a story of nothing more than what she has bought:

> 20–5–76
> Le diré que no le compré al nene calzoncillo, ni nada que había hablado,
> ya que se lo compro acá ...
> También le voy a comprar las medias a José, iguales a las que vimos
> [...].
> El sábado posiblemente vamos a comprar la mesa y sillas para el comedor,
> ya fuimos a ver y aumentaron el doble, pero como uno tiene guita hace lo
> que quiere [...]; hoy me fui a comprar un par de zapatos. (199)

Recounting the prices of some of her purchases, Ana explains:

[l]o que bajaron es algunas cosas para comer: las papas 2.5000, los huevos a 7.000, el azúcar también; en fin, algunas, porque el café aumentó 5.000 pesos el ¼ kilo, las bananas 10.000 [...], ya no sé si comprar ropa o darles de comer. (199)

The fact that the prices of the goods run into their thousands places in relief Argentina's experience of hyperinflation and lays the scent of impending crisis for the spectator. Amparo's humble approach to life is placed in stark contrast to the rather superficial suggestion in Ana's letters that you are what you purchase.

Alejandro Grimson argues that two 'fantasmas' lie at the heart of the Argentine experience:

Genocidio y hiperinflación son dos núcleos duros de las memorias colectivas de los argentinos. Difícilmente puedan comprenderse los últimos diez años sin comprender el peso que esos fantasmas tuvieron sobre la imaginación y sobre las prácticas políticas [...] son las fantasmas de la experiencia argentina. [...] Los argentinos no podrán reconstruir un proyecto común, que eso es al fin y al cabo una nación, sin encontrar las sincronías entre ambos. [...] [Es] en el verdadero espanto por la nueva cotidianeidad, así como en la esperanza de un cambio colectivo, donde reaparecen los modos de reimaginar la nación. (2004: 191–2)

One could add to this the poverty experienced by more than half the nation following the 2001 crisis. Although reference to the dictatorship is absent from *Temperley*, the impact of the economy on personal experience is ever present, as the biographies of Amparo and her family are told in relation to the economic rather than the political. This reinforces the idea that the play gradually traces Argentina's economic decline from the 1930s, when Amparo's sister Carmen arrives in Buenos Aires (some years before Amparo) and sends letters telling of affluence. 'No lo vas a creer Amparo mía, cuando andes por acá, de lo que son capaces las señoras como la de Lamarca: usan los zapatos una vez y después los amontan en cajas dentro de los roperos [...] De cabretilla, de gamuza, de piel de lagarto ...' (191–2). A similar sort of excess recurs as a metaphor of the *fiesta menemista*. One of the best examples of this is in *El fulgor argentino*, staged by the neighbourhood theatre group Catalinas Sur, which represents episodes from Argentina's history. In the section of the play dedicated to the Menem years, the caricature of a middle-class 'cheta' (or yuppie) struts across the stage with two mobile phones in her hand, telling the people with whom she is talking about her recent holiday in Miami and the fact that she owns two mobile phones, as well as two of certain other household appliances. The woman, dressed in stilettos and a heavily shoulder-padded jacket, replicates the very worst stereotype of pseudo-affluence during the Menem years. In contrast to this, a

family of *cartoneros* enters the stage on the opposite side showing the two extremes of neoliberalism.

Temperley distances itself from such obvious clichés. Instead, a melancholic tone pervades throughout and there is a constant sense of a struggle to survive, evoked repeatedly in a succession of letters from both Spain and Argentina that begin: 'Nosotros como siempre: con un tira y afloje, pero vamos tirando' (190). The play begins in 1980 and already in the opening line Amparo is feeling the physical strain of the years gone by: 'Ay ... Me duelen todos los huesos ...' (Suardi and Tantanian 2003: 183). She recalls her childhood in rural Galicia at one stage: 'el campo es difícil. Así que como íbamos viniendo ... algunos se iban yendo. Y mi padre haciendo pozos [...] para tenerlos cerca' (197). Over the years she has lost brothers, sisters and her husband. She has also lost her son and his family in an accident. The sense of loss is made even more poignant by the fact that each scene, although set in a different year, takes place in December, traditionally a family time. This is marked by the constant presence of a Christmas tree on stage.

Unlike *El aire alrededor*, *Temperley* does not take an entirely chronological form. The play begins in 1980, but immediately jumps back to 1933 before then taking a predominantly chronological passage through time (save for a brief interlude near the end when the storyline moves back to 1943) to the year 2002 when the play is being staged. These flashbacks serve to evoke the weight of the past on the present. In the final scene the passage of time can be seen layered into the set, as the decadence becomes visible. The stage directions outline that '*por debajo del papel*', there are '*diversas texturas, colores, papeles, pinturas: capas geológicas de la casa, testimonio de los innumerables resurrecciones y muertes que aquellas paredes tuvieron*' (2003: 216, original emphasis). Amparo, now losing her sight, is surrounded by dust and dirt which she no longer has the energy to clean, and rising damp is damaging the letters she has kept. She begins to confuse her surroundings, imagining that Christmas should be in winter time like it was in Galicia. Despite the immense sadness in Amparo's tone, especially in the final stages of the play, her words are punctuated with the rhetoric of survival, surely engineered to inspire hope in an audience which at the time the play was staged would still have been feeling the devastating effects of the Crisis.

Alternative Strategies for 'convivencia' or the Emptying Out of Modern Structures of Identity?

One of the most interesting comparisons to be made between the Proyecto Biodrama and recent cinema, in relation to the issues of 'convivio' and 'convivencia', is between Beatriz Catani and Mariano Pensotti's play *Los 8 de julio* (2002) and Martín Rejtman's film *Silvia Prieto* (1999). Both texts probe the structures by which individual identities and social relations are constructed. Likewise, they employ video documentaries in conjunction with their main

text as laboratories in which projects of 'convivencia' are put to the test. A telling dialogue can be set up between this film and this play in relation to issues of 'convivio' and 'convivencia', upsetting the established assumption among theatre critics that theatrical presence (or 'convivio') automatically sets theatre up as the most effective art form for forging social relations ('convivencia') (Dubatti 2007; and Cornago 2005).

Los 8 de julio documents (via video and theatrical testimonies) a period of six months in the lives of three people —actor Alfredo Martín, pregnant María Rosa Pfeiffer and pilot/painter Silvio Jorge Franchini— who all share one thing in common: they were born on 8 July 1958 and have answered the advertisement posted in the newspaper for people born on this day to partici-pate in the biodrama. Alfredo is instructed to film María Rosa over a period of six months without ever actually meeting her in person; María Rosa is asked to carry a camera around with her and to get passers-by to take photos of her at any moment or in any place she chooses; Silvio is asked to produce six paintings of the same tree. Each of these tasks contributes to the objective outlined in the play's subtitle: *experiencia sobre registros de paso del tiempo*. *Los 8 de julio* explores the more humble elements of their everyday exist-ence, demonstrating how theatre is able to encourage interaction and forge inter-subjective affiliations, notably within a context of social disintegration little more than six months after the December 2001 crisis. It certainly places a similar emphasis on social experience to that of the biodramas examined previously. The play establishes an important engagement with audiovisual documentary when it opens and closes with the screening of a series of mini-interviews filmed on 8 July 2002 in the Plaza de Mayo. This sequence aims to bring together a group of people who all find themselves in the same square at the same time. The montage of recorded interviews not only establishes a relationship between these individuals, but demonstrates the diversity of people simultaneously located in the same urban space and who, on account of their different backgrounds and experience, would otherwise have had little contact with one another. In contrast to the primacy of theatrical pres-ence in the documentarism of the two biodramas analysed previously, it is the audiovisual elements in *Los 8 de julio* rather than the mutual presence of actors and spectators in the Teatro Sarmiento that makes this biodrama 'abiertamente documental' (Cornago 2005: 18).

Rejtman's 1999 film *Silvia Prieto* embarks on a similar excursion into the structures governing identity and community as the protagonist Silvia Prieto learns of, or rather must come to terms with, the existence of another woman called Silvia Prieto. In a style reminiscent of the theatre of the absurd, as critic Pablo O. Scholtz briefly points out, *Silvia Prieto* follows the incon-gruous series of events that characterises a short period in the daily life of its protagonist (1999: n.p.). Scholz's conclusion that *Silvia Prieto* can be reduced thematically to the fact that 'de tanto comer pollo, uno termina casándose'

seems equally absurd, although it captures the rather random logic governing the way its protagonist performs her daily routine. Like the theatre of the absurd, *Silvia Prieto* delves into the existential anxieties of late modernity, bringing questions of displaced identity and a loss of agency to the fore. In a similar fashion to *Los 8 de julio*, the film makes a significant demarcation of the boundary between cinema and documentary as it incorporates a documentary sequence of a meeting between a group of women all named Silvia Prieto in real life.

Name, date of birth, nationality, profession: these are all founding characteristics on which our modern identities are constructed. Yet the individual does not choose any of these (save some varying degree of choice regarding his or her profession); in another challenge to the Cartesian formula for self-hood, these signifiers are imposed from the outside, based on the uncontrollable circumstances of where, when and to whom one is born. Both *Los 8 de julio* and *Silvia Prieto* invite consideration about the essentially meaningless structures on which subjectivities are based and upon which communities are built. Whilst the participants of *Los 8 de julio* seem to embrace their shared date of birth, *Silvia Prieto* is more cynical about the way in which social relations are formed. Silvia is at the same time fascinated and horrified to discover the existence of another Silvia Prieto living in Capital Federal, not to mention the other Silvia Prietos who almost certainly reside in the provinces, or who have married, as the other Silvia is quick to remind her. Having taken the conscious decision to discard her married name Echegoyen and recover her independence by taking back her maiden name, Silvia finds her sense of individuality is thrown into crisis, shaken at its very foundation. The precariousness of our sense of self, which is grounded in non-exclusive signifiers that are transferable to others, is hence exposed.

At 27, Silvia decides to transform her life, a change that involves finding a new job as a waitress, quitting marihuana and buying a canary that she intends to train not to sing. The tone of the voice-over in which Silvia narrates her thoughts and intentions certainly suggests that her actions are positively premeditated: 'estaba completamente decidida', she avers with absolute conviction. Yet nothing ultimately seems to change for Silvia save a slight modification in her otherwise unremarkable daily routine. The spectator nevertheless subsequently learns that these life-changing decisions were in fact caused by the fact that one day Silvia took her washing to the launderette and was accidently given back the wrong bag of clothes. As the film progresses, she is overtaken by events and her power to take decisions even on the most banal of levels is gradually displaced onto others to the point where her final comment in the film is '[y]a no me importaba nada'. Silvia's increasing apathy can be read as symptomatic of a more general trend of disillusionment. Maristella Svampa argues that it is the primacy given to the neoliberal economic model since the dictatorship that is responsible for

diminishing the function of politics: 'la subordinación de la política a la economía condujo a una naturalización de la globalización, en su versión neoliberal' (2005: 54). She goes on to reason that not only has this naturalisation of the neoliberal model left politics inert —'if there is no alternative, politics can have little meaning', to borrow Furedi's words (2005: 14)— but it has also had a serious impact on the integrity of the nation-state and any collective sense of identity cultivated therein. This film reveals similar trends to those identified previously in my analysis in relation to advertising and television spectatorship.

The rather incidental structures governing social interaction are also a central theme in Rejtman's film *Los guantes mágicos* (2003). In this film a group of thirty-somethings begin to get together socially after Piraña is driven home by *remisero* Alejandro. Piraña recognises Alejandro as being a primary schoolmate of his brother Luís, although neither Luís nor Alejandro, when they finally meet, recognise one another or recall that they might have been in the same class. The only (rather unconvincing) empirical evidence that Piraña gives us is that the two men are the same age. When Valeria and Alejandro start seeing one another, Valeria makes repeated reference to their compatibility as a couple by stating: 'me encanta que los dos estemos en el transporte de pasajeros'. When Alejandro sells his car later on in the film in order to go into business with Luís and Piraña, he becomes a coach driver. Valeria reasserts the fact that they are still working 'en la misma rama' as if Alejandro changing job might mean that they were no longer romantically compatible. Valeria's comments make an important link between profession and identity. The absurdity of our forms of association is further represented in a group of Sagittarians who, having met on a trip to a spa in Brazil and having discovered that they are all of the same star-sign, decide to continue their affiliation to one another by meeting three times a week to walk in the *Bosques de Palermo*. Only Sagittarians are allowed to attend. When we see the scene of the group walking in the woods, no one is seen conversing with anyone else, they are just walking.

In her examination of how the subjectivity of Rejtman's characters becomes bound up in the 'circulation of commodities', and patterns of 'labor' and 'consumption', Page comes to the conclusion that Rejtman's 'films represent [...] a study in miniature of the relationships between the economic and the social under capitalism and the particular variants of these to be observed in Argentina at the turn of the twenty-first century' (2009: 70). As subjectivity becomes 'bound up' in economic circuits and the social is subsumed into the economic, agency progressively diminishes and with it any active sense of community.

Globalisation and neoliberalism are concurrent trends. Globalisation is omnipresent in the film and can be seen to influence even the smallest details of the characters' everyday lives. The characters regularly eat in Chinese

tenedor libre restaurants. Silvia expresses the stereotypical Argentine fasci-
nation with travelling to Europe. When the taxi driver takes her to the
Aeroparque, she tells him that she is flying to Europe, despite the fact that she
is travelling to Mar del Plata and that international flights leave from Buenos
Aires' other airport Ezeiza. She also tells the other Silvia Prieto that she has
been on a trip to Italy and gives her a present: a bottle of imported shampoo.
All the characters believe in the superior quality of imported goods. Brite
takes her name from the washing powder she promotes. The film's humour
makes fun of Argentina's fascination with globalisation despite its location
on the peripheries. Brite is an obvious misspelling of Bright (the effect we
assume the powder has on clothes), and one of the Chinese restaurants in
which they dine is called 'Tokyo'. The one common identity the characters
all share is that they are Argentine, but mention is never made of this, or of
national culture. National identity is consistently emptied out, displaced onto
and decentred by global cultural paradigms.

Alfredo, María Rosa and Silvio of *Los 8 de julio* also possess a common
identity as Argentines. Although this is never stated explicitly, their concur-
rent existences are subtly framed in national terms in a way that avoids
allegorising Argentine national identity, as in the film. The play, however,
makes no reference to globalisation and is rooted firmly within the localised
framework of the nation, something one could argue is deliberate. This seems
to confirm Dubatti's definition of theatre as a local, territorialised art form
(Dubatti 2007: n.p.). The play is performed, in the first instance at least, on 17
October ('Día de la Lealtad Peronista'). Alfredo Martín films the first scene
of his documentary of María Rosa's life on 25 May (the day in which Buenos
Aires' first independent government —'la Primera Junta'— was established
in 1810) and it is no coincidence that the subjects of this play were all born on
8 July, just one day before Argentina's Independence Day. Although the testi-
monies of these three characters make no mention of the Crisis, the directors
are clear about their intention to 'presentar, sin ningún proceso de simbol-
ización, la realidad inmediata de este año. Por eso la obra empieza y termina
con entrevistas realizadas el 8 de julio del 2002 en Plaza de Mayo' (Catani
and Pensotti 2002: n.p.). Catani and Pensotti continue to explain the need to
rethink models of representation and fiction in the wake of the experience
of 2001: 'el extremo quiebre social y la crisis política, obligan también a
replantearse los modelos de representación y de construcción ficcional, y esta
propuesta de biodrama es un espacio propicio para esta reformulación experi-
mental' (n.p.). In a similar manner to that of *Temperley* and *El aire alrededor*,
the play avoids any macro-political allegories about the Crisis. Instead, the
projects of 'convivencia' are not articulated in national terms in the play, as
if the myths of progress that underpinned the nation during the 1990s need to
be emptied out and a national identity grounded on a more intimate, biopo-
litical level in which the humdrum aspects of each person's daily life are

granted the most importance: María Rosa's hand movements, her trips to the zoo, the fact that she is pregnant; Silvio's boat trips. More personal concerns are staged instead of these people's pertinence to broader identity structures. Hence, they are not portrayed as puppets of circumstance like the characters of *Silvia Prieto*, and a certain sense of agency is restored.

The pretext for the alliances in *Los 8 de julio* may be based on the rather incidental fact that the participants were born on the same day, but the encounters are congenial. In contrast, *Silvia Prieto* is structured on a series of failed attempts at cohabitation. 'En la película no hay personajes que formen comunidad,' comments Rejtman, '[l]os únicos son las Silvias Prieto al final, aparentemente', affirms the director (1999, n.p.). Both Silvia and Brite are separated from their husbands, Marcelo and Gabriel. But it is not long before Brite has engineered a swap. When Gabriel spends the night at Silvia's house for the first time she explains in the voice-over that she wants to avoid the intimacy of the morning after, and swiftly ushers him out to the *parrilla* on the corner of her street. Mario and Marta meet on the television dating programme 'Corazones solitarios'. It is only with the aid of the television that they are able to meet and become engaged. 'La televisión me cambió la vida,' Marcelo exclaims. Before his appearance on TV, he was an ordinary man, working to make barely enough to live. The incentive for couples who meet on 'Corazones Solitarios' to marry is created by the promise of a series of high-profile televised appearances in public and an all-expenses-paid wedding party. The budding relationship between Mario and Marta is nothing but fractious and the spectator is repeatedly left wondering exactly what on earth these two characters have in common, save the taste for fame, of course. Marta urges Mario at one point: 'tenés que aprender lo que es la convivencia'. Both are obviously motivated not only by the material incentive of a lavish wedding party sponsored by the television, but also by the sense of existence and belonging that their various appearances on television have given them. This is somewhat reminiscent (although rather more innocuous) of Mauricio's televised attempt at murdering his family in *Años difíciles*, described in chapter 2. The sentimentality of Mario and Marta's nuptials is notably absent. The reality of cohabitation will inevitably follow the wedding spectacle and their fleeting brush with fame. It is a reality that we predict is most likely to be fraught with conflict.

Rejtman, however, uses documentary as a counterpoint to the absurd 'convivencia' portrayed in the film. The documentary bolted onto the end of the film records a meeting between a real group of women all sharing the name Silvia Prieto. Echoing the amiable tone of *Los 8 de julio*, this meeting is positive and although the women have only met on a very superficial level, they seem already to have created some sense of community, although to what extent this is lubricated by the fact that they are being filmed is open to speculation. Rejtman comments:

> En el caso de las Silvias Prieto no hay nada que las una. Sólo el nombre,
> que es como un artificio estúpido. Es la nada. Porque el nombre es lo que
> te pusieron. Lo que te vino encima. Es todo y nada. Si te preguntan quién
> sos, lo primero que sos es el nombre que tenés, pero al mismo tiempo el
> nombre es lo menos personal que tenés, porque podés compartirlo con
> tanta gente ... (1999: n.p.)

Rejtman is perhaps forgetting the identity they share as Argentines or as
women, neither of which are explored in his films. Neither rich nor poor, 'ni
alta ni baja' (as Silvia describes herself), switching from one job to another,
from one partner to another, Rejtman's characters float in society, unable to
ground their identities in any fixed or meaningful paradigms.

Martin Esslin describes the Theatre of the Absurd as a genre that is united
by '[a] similar sense of the senselessness of life, of the inevitable devalu-
ation of ideals, purity and purpose' (2001: 24). A similar argument can be
made about the way in which *Silvia Prieto* demonstrates the absurdity of the
postmodern (human) condition. Silvia is infatuated with order. She obses-
sively chops chickens into twelve pieces each and counts the exact number
of coffees she serves at the bar. Silvia tells us: '[d]esde el día que empecé a
trabajar había servido más de 3.800 cafés con leche y casi 12.000 cafés. Me
resultaba demasiado difícil seguir la cuenta.' When she can no longer keep
count, she leaves her job. The spectator must struggle to make sense of this
excess of order, which seems to have no point whatsoever. This is not the
only manner in which Rejtman works to confuse the spectator, as he or she
is left even more perplexed by the use of close-ups in the film. A spectator's
conditioning by a learned set of cinematic codes will usually tell him or her to
interpret a close-up shot in cinema —even more so a shot that zooms in— as
a means of foregrounding an object or action that is of prime importance to
the film's plot. Rejtman deliberately upsets this rule (*Silvia Prieto* has very
little plot). The close-up shots of Silvia aggressively chopping chicken and
of the other Silvia stirring a cake seem to hold little meaning.

Yet the Theatre of the Absurd is often associated with Existentialism, a
movement that promotes 'pure potentiality and the freedom to choose itself
anew at any time' (24). It is this 'potentiality' that Rejtman's characters
lack. Furedi argues that a diminished sense of human subjectivity is mainly
to blame for the exhaustion of all political consciousness. People are now
viewed as the 'object', rather than the 'agent', of change. '[I]n the era of
the "death of the subject", "death of the author", "centred subject", "end of
history" or "end of politics"', argues Furedi, the idea that external conditions
have an overwhelming impact on human integrity has aggravated the culture
of defencelessness and fear in which humanity now lives (2005: 78). As
suggested in the science fictions considered in the previous chapter, society
now lies in the grasp of Fate, as if there were no alternative for the future.

Fate in the film is largely governed by economics. It is society's 'defer-
ence to Fate' or deference to neoliberalism that Furedi believes to be most
profoundly 'anti-politic[al]' (29).

This explains why the characters in the film seem emotionally numb.
Neither Silvia nor Marcelo appear at all affected by regret, nostalgia or even
relief during the screening of their marriage. When Brite's colleague, Cris-
tina, is run over by a bus, Brite and her other colleagues stage a very half-
hearted protest for justice. The protest is silent, the demonstrators sit on the
ground and banners trail on the floor. The protesters do nothing more than
passively go through the motions of staging a demonstration. The slogans on
the banners, such as '¡Justicia YA!' and 'No a la impunidad', may imitate the
messages given out in the aftermath of the dictatorship but the passion with
which such political opposition was undertaken is no longer evident. Cristina
is soon forgotten, another 'vida descartable' quickly replaced as if she were a
commodity. This is further supported by the fact that Silvia is given Cristina's
uniform when she starts work promoting washing powder: '[e]l uniforme
que me dio la empresa era uno que usaba Cristina, la chica que atropelló el
colectivo. Pero hubo que hacer algunos arreglos porque Cristina era un poco
más gordita que yo.' We are also told that when the bus ran Cristina over,
the passengers did not notice the body and took all the free samples that she
had been handing out, desperate to take their share of the promotion. This
emotional numbness can be read as symptomatic of the fact that these char-
acters are 'objects' rather than 'agents' of the system in which they live.

In a similar way to *Silvia Prieto*, a series of interviews opens and closes
Los 8 de julio, bringing together a group of people who happen to find them-
selves in the same square at the same time on the same day (also the 8 July).
In the opening recording, each describes what they are doing on that day, and
in the closing recording they imagine where they might be in five years' time.
The air of crisis is, however, present as one man explains: '[h]oy el 8 de julio
tenía pensado ir a buscar trabajo. Estoy con la mayoría de acá.' Another man
claiming to occupy the same park bench morning, noon and night speaks of
similar misfortunes: 'se perdió la calidez que uno tenía antes', he says, 'estoy
sin laburo hace un año y medio y la verdad no sé dónde voy a terminar. [...]
No saben cuál es el futuro. [...] Un lugar donde te secuestran si te vestís bien,
donde tu vida no vale nada. Y si no tenés guita, también te van a matar.' A
young man exclaims that he feels 'mucha bronca con las cosas que están
pasando'. These pessimistic testimonies sit alongside more trivial responses,
like the tourists who have enjoyed visiting the Plaza de Mayo, the woman
with her grandchild, who plans to develop a film and feed the pigeons, or the
man who is quite simply 'tranquilo'.

The projects for the future are just as mixed. One man hopes no longer
to be in Buenos Aires, but in the south 'compartiendo asado, mate'. 'Todo
igual' replies another man in a somewhat disillusioned tone; 'en las mismas

condiciones que ahora', says another woman seemingly contented, 'visitando a mi nieto, trabajando'; 'en Salta haciendo unas buenas vacaciones', explains another. This is followed by a rather more negative statement: '[v]oy a estar en la misma plaza, con el mismo puesto, cobrando la misma plata. Me gustaría en realidad que todo esté un poco mejor.' What is interesting is that no mention is made of macro-politics. Despite the air of crisis, echoed in the sirens that can be heard in the background, the interviewees make reference only to their own modest aspirations for the future. There is little expectation, or even hope, of change beyond that.

Los 8 de julio may set theatre up as the perfect space for 'convivio', yet the engagements formed rely on a mixture of different media. The use of audio-visual support in *Los 8 de julio* rather complicates the distinction between theatre and cinema in relation to presence and the idea that theatre, as an organic art form is naturally better suited to 'convivio' through the idea of presence. Presence and theatrical aura are consistently lauded by both Dubatti and Cornago as theatre's most important political tool. Cornago makes repeated reference to the Proyecto Biodrama series as a rejection of techno-logical mediation in social relations. He seems conveniently to overlook the reliance of Catani and Pensotti's project of 'convivencia' on technological mediation: Alfredo's use of video to observe María Rosa (which would be rather voyeuristic if it were not for her consent); María Rosa's use of photog-raphy to represent herself; the video documentary of Silvio and projection of his paintings onto a large screen at the rear of the stage. Cornago argues that the key to the project is the way in which it constructs

> una mirada sobre el teatro hecha a partir de lo que no es teatro, la propia vida; pero al mismo tiempo una reflexión teatral sobre la vida de las personas con el fin de rescatar ese lado que parece perderse desde acercamientos más técnicos, mediatizados o intelectuales, para rescatar su sentir, su *estar-ahí*, su modo (teatral) de ser presencia, física y sensorial, efímera e inmediata. (2005: 10, original emphasis)

Theatre may appear to be asserting its capacity to document reality via the notion of presence, but what we see, certainly in *Los 8 de julio*, is that theatre is relying heavily on audiovisual technology to give those who are absent from the stage a virtual presence. The initial contact was achieved through advertisements placed in the newspaper and sent out by e-mail. Neither María Rosa nor Silvio are present at the performance; instead their presence is achieved virtually in video recordings made prior to the performance. María Rosa makes contact via the telephone when she calls Alfredo and offers to answer any questions the audience may have, and apologises for not being able to travel every weekend from Córdoba in order to appear in person. Alfredo underlines the spontaneity of this part of the performance by stating

that he is always nervous at this stage of the play because he never knows whether María Rosa will call at the correct time. The audience of course has no proof that it is María Rosa calling, which rather seems to comment upon the nature of theatre spectatorship. The spectator always enters the theatre with the expectation of encountering artifice and actors playing the role of someone else. In documentary, as spectators, we expect to see real people representing themselves. In *Los 8 de julio*, those interviewed do indeed represent themselves, but the fact that these interviews/testimonies are framed as theatre means that the documentary imperative of the project is somewhat undermined. The doubt that is left in the spectator's mind as to the veracity of these encounters underlines the fact that theatre cannot hide its apparatus and render it transparent like cinema (employing neorealist techniques) can.

Jorge Dubatti might highlight the issue of theatrical presence as the one characteristic that continues to set theatre apart from other media/art forms and enable it to resist the incursions of the mass media, but the three main characters of *Los 8 de julio* never appear in the presence of each other. Another example of displaced presence can be found in the other woman occupying the stage, as she is Jorge's wife, who has come as his representative. Again, the audience must trust that this is Jorge's wife as there is no way of proving her identity. Theatrical presence essentially means that you cannot get away from the fact that the person is acting and that their natural space is not the theatre. Theatre cannot deny its own apparatus, and transparency is achieved less through the appropriation of documentary techniques than it is through reflexivity. The only way that Alfredo can try to be in the same place as María Rosa is by standing in front of the screen that is projecting the video he has made of her and inserting himself virtually/translucently into the image. He literally confronts, and therefore highlights, the barrier existing between the subjects of the play. Cornago certainly echoes Dubatti in his intention to assert the aural presence of theatrical encounters, arguing of the biodramas in general:

> En una respuesta a una realidad mediatizada por las tecnologías de la imagen, se asiste a una reivindicación de una realidad humana *en bruto*, que recupere al individuo libre de tecnologías mediáticas y discursos teóricos; se trata de la defensa de una subjetividad más allá de intelectualismos, que vuelve a presentarse, antes que nada, como una suerte de enigma, el enigma que esconde toda vida humana en su expresión más irreducible como presencia. (2005: 5, original emphasis)

The almost complete dependence on audiovisual media and displaced presence in forging 'convivencia' in *Los 8 de julio* provides a clear-cut challenge to both Dubatti's and Cornago's arguments for the primacy of theatrical presence, which relies on outmoded formulae. Defining New Argentine Theatre

in terms of 'convivio' is clearly inadequate, overly generalistic and rather antiquated. I would argue quite the inverse: *Los 8 de julio* seems willing to —indeed needs to— renounce theatrical presence/'convivio' in order to achieve a broader and more convincing network of 'convivencia'. The inclusion of video recordings enables theatre to profit from certain reflexes in the film spectator that make the spectator want to read the film projection as a window on reality. This window on reality —on the streets outside— is materialised in the screen covering the back of the set. The fact that a large screen covers the rear wall of the stage means that for a moment, the Teatro Sarmiento doubles as a cinema. It is also worth noting here that *El aire alrededor* also uses a screen at the back of the stage onto which images of the countryside are projected. Grass is laid out on the stage and a hen is allowed to wander about in a bid to enhance the authenticity of the performance.

What must be remembered is that my analysis here focuses specifically on the Proyecto Biodrama and I do not wish to feed any misconceptions or generalisations about the use of audiovisual support in contemporary theatre. Many plays continue to avoid any cross-fertilisation with audiovisual media. I would nevertheless argue that, despite Dubatti's affirmation that he is defining theatre within the current cultural conditions 'sin nostalgia del pasado, ni anhelo de ortodoxia o de absurdos modelos de pureza de "género"' (22), buried in the politics of 'convivio' is an obvious drive to define theatre as an autonomous cultural form and highlight those generic traits that separate it from cinema and television in particular. This is clear in his emotive call for 'revenge': 'la "revancha" del teatro sobre las posibilidades del cine y la televisión'. '*Insistimos*', he continues emphatically, 'el teatro encuentra sus virtudes en sus limitaciones' (Dubatti 2007: 63, my emphasis). Yet the need for theatre to modernise and deal with competition from both television and street-based performance is clear. It is worth noting briefly that this perceived crisis in theatrical modes of representation is not an explicitly Argentine concern.[7] The way that theatre can achieve this modernisation is by incorporating audiovisual support. For one of cinema's strengths over theatre is the fact that it can record what is going on in the streets and can portray people within their own contexts.

Documenting Cinematic Spectatorship and Projects of 'convivencia' in Lisandro Alonso's *Fantasma* (2006)

Fantasma is the final twist in Alonso's trilogy, which also includes *La libertad* (2001) and *Los muertos* (2004). *La libertad* follows a typical day in the life of

7 See María M. Delgado and Caridad Svich (2002) for a collection of 'Performance manifestos' written by theatre practitioners who aim to address the position of contemporary theatre in society and in particular its relationship to the economic, the political and neighbouring art forms/media.

Misael Saavedra, a logger in rural Corrientes. Its sequel, *Los muertos*, which is also set in remote Corrientes, tracks Argentino Vargas as he is released from prison and journeys along a secluded river to visit family. Documentary and fiction blur as these two chronicles, acted out by non-professionals, unfold. The tempo of both films is languorous, sound is purely diegetic (although dialogue is scarce) and a curiously disengaged camera observes the seemingly insignificant movements of these two unusual protagonists.

In *Fantasma*, both Argentino Vargas and Misael Saavedra are brought to the Centro Cultural General San Martín on Avenida Corrientes to attend the première of *Los muertos*. During a little less than an hour, the camera observes (in what seems to be largely unmediated real-time) these two rural characters as they roam the dressing rooms, bathrooms, corridors and stairways of a building that epitomises urban middle-class cultural space. In stylistic continuity with its predecessors, *Fantasma* draws on explicit documentarism. Yet, unlike *La libertad* and *Los muertos*, in which film endeavours to cover up its own apparatus, appealing to the transparency of documentary, *Fantasma* appropriates the documentary format performatively. In this film, cinema (quite literally in certain shots) confronts its own apparatus. It provides, as Page suggests, a reflexive finale to the trilogy which comments not only on the previous two films, but also in more general terms on cinema as an institution, processes of distribution/exhibition, cinema's capacity to document the real and, of particular interest here, film spectatorship as a medium for 'convivencia' (2009: 63).

Like many examples from New Argentine Cinema, *Fantasma* borrows from documentary as a means of surveying and representing society's peripheries. More than a straightforward citation of documentary techniques, *Fantasma* in many ways tests the limits of documentary. As discussed previously, a spectator watches a documentary with certain expectations. However, the extreme naturalism of Alonso's aesthetic upsets the expectations of even the most seasoned documentary spectator, leaving him or her with a thirst for greater mediation (in the form of editing). There is a sense in all of Alonso's films that he is trying to strip film and documentary of as much mediation as possible. This is mainly achieved by the fact that the subjects of Alonso's film appear to be filmed in real time: Saavedra following his daily routine as a woodcutter (*La libertad*) or Vargas steadily paddling up the river in his canoe (*Los muertos*). Alonso also plays with our expectations in other ways. In the second shot of the opening sequence, *Fantasma* cuts to a blank screen and all we hear are the haunting, discordant tones of an electric guitar. This blank shot lasts for what in cinematic time seems an eternal three minutes. The spectator in the cinema might at some point during this seemingly endless sequence assume that there is a technical problem with the image; the spectator watching the film on DVD would be more than tempted to seize upon the fast forward button on the remote control.

The lack of dialogue in *Fantasma* has led the critic Horacio Bernades to describe the film as an exercise in 'el mero, simple, intenso acto de mirar. Mirar a esos dos extraños recorrer un lugar extraño' (2006: n.p.). It cannot be denied that most of the interaction established between the characters in the film and between the characters and their surroundings is visual. 'All the characters in the film pass their time looking: at others, at the building, at the film', argues Page (2009: 67). When confronted with these two strange rural beings, the employees of the San Martín replicate the 'gaze of the outsider, the anthropologist' that Page argues is set up not only in Alonso's work but in the work of a number of other contemporary Argentine directors (2009: 69). This may be so, but I would argue that far from '[un] mero, simple, intenso acto de mirar', as Bernades suggests, *Fantasma* also proposes *un intenso acto de escuchar*. Alonso's use of sound in the film is as important in positioning the spectator in relation to these rural Others as the film's visuality. Alonso experiments with the cinematic apparatus and the different ways in which even the most naturalist and seemingly transparent documentarism can manipulate identification or estrangement in the spectator. This technique enables the spectator to glimpse how Alonso is testing the limits of cinema in relation to ideas of 'convivio'. Whereas diegetic sound in both *Los muertos* and *La libertad* (aside from the credit sequences) fits harmoniously with the films' rural settings, the persistent repetition of irritating, piercing electronic sounds throughout *Fantasma* unsettles the spectator, awakening him or her to the alienation of these two rural figures in the middle of the city. The first words we hear in the film are the electronic words of the lift: 'Bienvenido. Planta baja'. The telephone, an unexplained sort of dial-up tone that recurs throughout the film, and the acute beeping sound made by the service lift each time the doors are left open are irritating to the spectator in a way that de-naturalises these otherwise normal diegetic sounds and replicates the strangeness of the surroundings for Saavedra and Vargas. The surge of electronically generated sounds, in place of human voices, makes the San Martín impersonal and daunting. We might be mistaken in thinking that Alonso is trying to put us in his subject's shoes.

Besides sight and sound, the film also attempts to evoke the haptic (see Laura Marks 2000),[8] as both Vargas and Saavedra touch objects in order to work out what they are. Whilst the spectator is used to the bi-sensory

8 Marks makes an important contribution to film theory by exploring the multi-sensory potential of cinema, in particular what she defines as 'haptic visuality'. She suggests that '[h]aptic visuality implies a familiarity with the world that the viewer knows through more senses than vision alone. Changes of focus and distance, switches between haptic and optical visual styles, describe the movement between a tactile relationship and a visual one' (2000: 187). 'Haptic visuality', she argues, 'requires the viewer to work to constitute the image, to bring it forth from latency' (183). *Fantasma* dabbles with the multi-sensory potential of cinema.

experience of watching a film, these men are used to a rural environment in which they are constantly using all their senses. Both men are drawn to water sources in the building. The moments in which they splash water over their faces and hair provide a refreshing source of relief from their outlandish experience of the city, even for the spectator, who may remember Vargas' canoe journey along the rivers and streams of Corrientes. We hear Saavedra turn on a shower and leave the water running as if trying to fill this strange environment with a trickling noise that is familiar to him.

Whilst on one level Alonso flirts with the possibility of documentary achieving virtual 'convivio' through spectator/actor identification, the film's reflexivity also questions this possibility. By staging the process of spectatorship, *Fantasma* tests the capacity of film to bring people from different classes into the same space. Alonso sets film up as a test bed for social integration —or 'convivencia'— across the class divide. He asks us what happens when we encounter, both on screen and in person, someone of a different class. The term 'convivio' has thus far only been used in reference to theatre spectatorship, but *Fantasma* stages a rare moment of cinematic 'convivio' when we witness Vargas, who has been invited to attend a screening of the film, coming face-to-face with his own image as recorded in *Los muertos*. He also encounters the two other people attending the screening in person.

The cinema is, however, sparsely populated, which points to another issue raised by the film's reflexivity: the marginality of the film in terms of both its subject matter and its relation to distribution circuits. This is an issue that Page addresses in her analysis of *Fantasma*:

> By means of reflexivity Alonso raises ethnographic questions concerning the relationship of these protagonists with their director and their audiences. What are the ethics of transplanting Misael and Vargas from their rural environment to place them under observation in a temple to high urban art? How can we maintain a vision of their hermitlike existence, close to nature and untouched by consumer society, when we know that these protagonists have been contracted to act on film, offered wages as an incentive to leave their usual jobs aside for the duration of shooting? By turning his documentary subjects into actors, Alonso acknowledges as impossibilities two paradigms that seemed to underpin his filmmaking: first, that the camera simply observes without constructing (the documentary illusion) and, second, that the film can fully step out of the market (the autarkic reading). (Page 2009: 67–8)

She underlines that *Fantasma* makes us aware of our different class status as a spectator. The very first scene in the film presents perhaps the most clear-cut metaphor of the cinema screen as one in a series of imaginary, cultural, economic and/or social shields that separate the spectator of Alonso's films from their characters; these partitions are never really broken down. In this

shot we see Vargas in a workshop with shelves stacked row-upon-row with shoes. Clasping a red shoe in one hand he presses himself hard up against the window. A stark opposition is established between the camera and spectator on one side of this window and Vargas on the other. The force with which he pushes himself against the glass suggests a sense of entrapment, that he is in a place that is strange to him and from which he may want to escape, if only to explore the equally peculiar surroundings of Capital Federal which we assume he is observing through the window.

The fact that the screening of *Los muertos* takes place in the Centro Cultural San Martín, a place more often associated with theatre than with film, leads me to a parallel comparison between theatre and cinema spectatorship. I will now take the idea of 'convivio' as an analytical tool to explore the differences between theatre and cinema spectatorship. Theatrical 'convivio' is juxtaposed with a type of virtual 'convivio' that cinema enables in the transactions between film and spectator; a type of 'convivio' that lacks the presence of theatrical 'convivio', but arguably achieves a broader and more inclusive 'convivencia' as a result. The film makes the perfect challenge to theatre's claims that presence automatically achieves 'convivio', and 'convivio', 'convivencia'. Whilst both men are present in the San Martín, this presence is nothing more than ephemeral and for a short time their intrusion into this staunchly middle-class space, as the film's title suggests, is haunting. One scene seems to repeat itself in a way that alludes to the invisibility of these two men, their phantasmagorical presence in the San Martín. In the first rendition of the scene early on in the film, Vargas stands in the entrance hall to the San Martín facing the doors that lead out onto Avenida Corrientes. Two workmen enter the building. A third workman then enters after the other two and follows them diagonally across the entrance hall and towards the lift. Vargas then comes face to face with the poster advertising the première of *Los muertos*. The scene at this point seems fairly inconsequential. Yet later on in the film, the same scene seems to repeat itself. This time, a woman working in the Complejo San Martín is standing in the entrance hall in roughly the same place as we have seen Vargas standing previously. Once again, two workmen enter the building and walk diagonally across the entrance hall and towards the lift. They are then followed by the third workman just as he had appeared to follow them before. The woman then replicates Vargas' movements, moving up to the poster advertising *Los muertos*. The apparent repetition of the same scene leads us to question, not necessarily the physical presence of Vargas in the San Martín, but his (social) visibility in this environment that is so alien to him and in which he is rather alien to the film spectator and those who frequent the Teatro San Martín. Despite almost brushing past Vargas, these men do not seem to register his presence, whereas they exchange greetings with the woman. Vargas' presence is made to seem completely out of place.

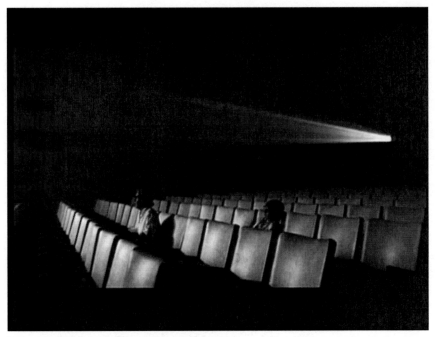

Rare example of cinematic 'convivio' in *Fantasma*.
In a rare instance of cinematic 'convivio', Vargas is seen watching his own film alongside another spectator, probing cinema's potential to bring different subjects from completely different walks of life into each other's presence. The emptiness of the screening room also comments on the marginal status of director Lisandro Alonso's filmmaking

The rather uncomfortable situation of 'convivio' set up in the screening of *Los muertos*, I would suggest, winks at theatre and points to the rather naïve assumption that theatrical presence ('convivio') automatically achieves 'convivencia'. The accentuation of the class divide in the encounter between Vargas and the other spectators reinforces the fact that theatrical 'convivio' is really restricted to the middle classes. The film's message is clear: it is quite simply not enough to achieve spatial continuity. Despite Vivi Tellas' desire to represent the ordinary everyday lives of *porteños*, the biodramas only confirm the restricted nature of theatre spectatorship (save perhaps the very working-class existence of Amparo in *Temperley*, though she is not a marginal figure like many of the characters in recent cinema), more so if we consider that many of the directors working in the biodrama series choose their subjects from the artistic world: Analía Couceyro's *Barrocos retratos de una papa* (2001 and the first in the biodrama series) dramatises the life of sculptor Mildred Burton; Mariana Chaud's *Budín inglés* (2006) dramatises the lives of 'cuatro lectores porteños'; as mentioned previously, Cozarinsky's

Squash dramatises the life of actor Rafael Ferro (played by Ferro himself); Alfredo in *Los 8 de julio* is also an actor, and Silvio, a painter. The emerging pattern is self-evident. More than a democratic staging of normal everyday lives, the biodramas mentioned above represent, rather, an attempt at shoring up the field of artistic production, as theatre re-creates itself as a space of expression for other art forms.

It is worth commenting briefly upon a similar trend of failed 'convivencia' in other examples of contemporary Argentine theatre. *La escala humana* (2001) by Javier Daulte, Rafael Spregelburd and Alejandro Tantanian is an excellent example of a play which brings humanity's ability to live harmoniously side by side into utter derision; a recurring theme in the work of three of the most prominent *teatristas* currently working in Buenos Aires and equally successful on the international circuit. The play underlines the banality of violence. In one instance, character Mini explains to the rest of her family that she cannot serve the *milanesa* with lemon juice. As she explains why this is impossible, she very casually drops into the conversation that she happened to murder someone at the supermarket and therefore cannot go there to pick up the lemons as the police are probably looking for her:

> MINI: A lo que iba es que no pude comprar limones. Las milanesas las vamos a tener que comer con mayonesa o mostaza. Si no querés, Silvi, no las comés. Pero al mercado no puedo volver. Por lo menos hoy. Maté a alguien y tendría que estar buscándome la policía. (Daulte, Spregelburd and Tantanian 2002: 11)

The violence escalates as Mini calls upon her children for help dismembering the corpse, whereupon they engage in an equally banal discussion concerning how many pieces the body should be divided into, as if they were referring to a slab of meat. As the three *teatristas* mix portrayals of violence with, for example, Norberto's plan to orchestrate a ban on Coca-Cola —*the* icon of the global market— an underlying (and by now familiar) correlation between globalisation, gratuitous violence and failing 'convivencia' emerges. One clear conclusion can be drawn from this brief excursion into another contemporary play: that theatre may achieve 'convivio' in the perfunctory sense that performers and spectators find themselves in the same place at the same time, but recent plays, such as *La escala humana*, deliver the rather cynical thematic of society's incapacity to placidly cohabit.

Film may not achieve 'convivio' in the sense that spectator and actor are in each other's presence —although this scenario is indeed staged in *Fantasma*— but it is arguably a more appropriate medium through which to explore the possibilities of 'convivencia'. *Fantasma* demonstrates how film, as a medium, has the capacity to bring people together whose paths would otherwise never cross. However, once these paths have crossed, the

resulting encounter between Vargas and the people working in the San Martín is devoid of any sense of mutual understanding or communication, showing the ultimate incommensurability of these classes. The politics of spectatorship that Alonso engages in brings to the fore just how *other* the subjects of his films are. The spectator in turn is made acutely aware of his or her middle-class status and rather restricted outlook on society.

This contradiction which is played out in the film likewise seems to comment back on some of the other canonical texts of New Argentine Cinema. More than simply providing a reflexive viewpoint on Alonso's previous two films, *Fantasma* establishes a critical perspective on a project common to a number of other recent Argentine films that use natural actors and attempt to set themselves up as spaces of expression in which those on society's peripheries can be represented. The most prominent examples of this would be Adrián Caetano and Bruno Stagnaro's *Pizza, birra, faso* (1998), Pablo Trapero's *Mundo grúa* (1999) and Caetano's later film *Bolivia* (2002), alongside other less well-known examples such as Ana Poliak's *La fé del volcán* (2001), Diego Lerman's *Tan de repente* (2002), or Federico León and Marcos Martínez's recent documentary *Estrellas* (2005). The politics of visibility that is so fundamental to the above films, on account of their attempts to represent the plight of those living on society's fringe, must be measured against the ethics of the gaze that they project onto these peripheral characters and the kind of dialectic that is established between actor and spectator. These films do not explicitly address the divide between their subjects and their spectators. Certainly *Pizza, birra, faso* encourages empathy between spectator and actor in a way that tries to bridge the class divide between them. *Fantasma*, on the other hand, is very clear about the fact that these films are not made to be watched by those they represent. *Mundo grúa* arguably gestures towards this otherness through the camera work, but does not express overtly the issue of spectatorship as a mechanism for 'convivencia'.

Fantasma also confronts its position in relation to the market in a much more explicit manner. The films of Trapero and Caetano, for example, are much more transparent about their relationship to the film industry. Moreover, the sheer number of recent films that deal with marginality has contributed to a phenomenon that has made marginality fashionable and turned marginal existences into commodities, commodities that represent, via the international film festival circuit, Argentina's specific contribution to the global culture industry. Cozarinsky's film *Ronda nocturna* (2005) is also more cynical about the capacity of film to achieve a sense of community across the class divide. *Ronda nocturna* (2005) follows a night in the life of main character Víctor, who works as a prostitute on the streets of Buenos Aires. Social inclusion is clearly shown to depend on commodification. The only way in which Víctor can enter into the circuits of capital is by turning himself into a commodity. As a human commodity he is afforded transient access to elite space such as

the penthouse male gym and the ambassador's hotel suite. Since the 2001 crisis, marginality has become progressively more fashionable, commodified through the marketing of the popular music genre *cumbia villera* and tours to the *villas miseria* organised for foreigners.[9] Poverty is the commodity on sale to the international tourist and one of the reasons why Buenos Aires, with its curious mix of the First and Third Worlds, has become an exotic destination in the globalised world. The fact that marginality has taken on a market value and has been part of branding New Argentine Cinema on an international level (on the film festival circuit) poses the question as to how far New Argentine Cinema's apparently more inclusive 'convivencia' achieves nothing more than to replicate the socio-economic structures that marginalise such characters in the first place. Cinema does present, although rather paradoxically, formal possibilities for a more widespread, inclusive 'convivencia' that exceed those presented by theatrical 'convivio'. However, what these films' attempts at greater 'convivencia' ultimately achieve is to place in relief the fundamentally fragmented nature of the society that they depict and attempt to bring together.

9 For example, see http://php.terra.com/travel/templates/destino_features.php?&desti-nation=38& feature=30010 for information on the kind of *cumbia villera* or *villa miseria* tours currently on offer.

Conclusion

In the introduction to this study I suggested, with reference to the work of Jacques Derrida (1980) and Hayden White (2003), that genre was by no means a redundant concept within the context of postmodernism, rather that it should be reconceived as a contingent or performative construct which is symptomatic of the prevailing context. Certainly the reflexivity of many of the plays and films discussed in this book is evidence enough of their preoccupation with both generic boundaries and the boundaries of the aesthetic in more general terms, which maintain art as a separate category in relation to the political, the social and the economic. This sense of relativity accorded to the concept of genre means that the edges of genre blur and it takes on a newfound fluidity in relation to neighbouring genres (or media/art forms). The fact that I systematically place theatre and cinema's borrowings from other genres/media/art forms in dialogue with their political and social engagement, underpins the idea that aesthetic categories are historically contingent constructs relative to their socio-political context. What I would now like to consider, as a way of bringing together the various threads running through this investigation, is how discussion of reflexivity and the performativity/contingency of genre illuminates certain other processes of identity construction at large: namely social, cultural and national identities in relation to Argentina's experience of (post)modernity.

In chapter 1, I cited Eduardo Pavlovsky's idea that '[n]o es sólo cultura la producción de una obra de arte, sino también la producción de subjetividad (2001: 157). Each chapter has established a dialogue between the hybridisation of aesthetic forms and questions of identity (both individual and collective), subjectivity and agency in relation to Argentina's specific experience since the return to democracy in 1983: coming to terms with the traumatic memories of dictatorship; the transition to a neoliberal economic model and diminishing presence of the State; society's integration into global circuits of both information and capital; more recently, rebuilding a socio-political pact in the wake of the 2001 economic debacle. Chapter 1 looked at how aesthetic performances, such as theatre and cinema, can explore the performativity intrinsic to processes of socialisation; chapter 2 examined the way in which theatre and cinema draw a clear boundary with television in order to underline the detrimental effects of TV spectatorship on the behaviour of

and interaction between its viewers; chapter 3 focused on the role of cinema and theatre as Utopian spaces —a place in which national and individual identities, fragmented within the discourses of failure, can be patched back together; chapter 4 highlighted the importance of the capacity of theatre and cinema to document everyday, micro-political realities, restoring individual identity and social experience to the sphere of the political following the neoliberal Menem years.

In each of these cases, the politics of genre and the strategies of re-politicisation and re-socialisation demonstrate how theatre and cinema re-style themselves after the dictatorship as alternative spaces in which issues of social identity can be addressed. They become spaces of expression in which spectators can be made aware of their lack of agency —that is to say, substantive participation worthy of citizenship— and in which new strategies of 'convivencia' can be tested: 'un lugar para hablar de las cosas trágicas, existenciales, desesperantes, como la locura, la droga, la pobreza, la impotencia, la desesperación', to reiterate the words of Pavlovsky (1997c: 92).

The paradigm of performance is not only the most obvious point of comparison between theatre and cinema, but fundamental when mapping the issue of theatre and cinema's identity as art forms onto broader questions of identity construction. The boundary between aesthetic performance and social performance is constantly at stake in gauging the transactions between theatre, cinema and other performative processes such as the construction of subjectivity and political communication. The works of Solanas and Pavlovsky (dealt with in chapter 1) demonstrated how theatre, cinema and social processes can all be displaced onto a common paradigm of performance, whereupon engagements between their varying notions of performative specificity can be measured. What was also made clear is the importance of poststructuralist theories of performativity in understanding the shift in discourses of identity and genre from static categories, to more fluid, contingent constructs. The fact that the emphasis in theatre has shifted from the static, repeatable dramatic text to the performance echoes the idea that reiteration of a performance should incorporate the possibility, in the Derridean sense, not only of description, but also of transformation. The politics of performance, as exemplified in the works of Solanas, Pavlovsky and Bartís, lie in theatre and cinema's ability to generate change in their actions of *re*iteration and *re*presentation. The concept of performance nevertheless remains slippery and open to controversy. In many ways these artists test the boundaries of performance in a way that feeds back into theories of performance and performativity. Measuring Solanas', Pavlovsky's and Bartís' politics of performance against Derridean ideas once again, the following contradiction emerges: if nothing exists outside context and if everything is contingent, then the dynamic of change signalled in the repetition of the theatrical or cinematic performance is moulded like putty from the outside, rather than taking shape from an internal drive for change, consciously origi-

nating from within. Any sense of agency, in this case, is significantly placed in question.

In *Modernity and Self-Identity* (1991), Anthony Giddens explores the reflexivity implicit in the construction of identities in late modernity. '[I]n the context of a post-traditional order', he suggests, 'the self becomes a *reflexive project*' (32). His use of the term 'reflexivity' largely corresponds to performativity and the idea that identity is a contingent construct constantly being (re)formed, although, as Rejtman's films illustrated, the self-reflexivity of late modernity leads only to minimal changes in his characters' lifestyles. In *Silvia Prieto* and *Los guantes mágicos*, self-medication of antidepressants, purchasing pets and alternative therapy, such as spa trips and yoga classes, provide a poor substitute for any substantive agency. These actions also show that agency is now generated on a micro-political level. Giddens makes the important observation that '[v]irtually all human experience is mediated —through socialisation' (23). What makes theatre and cinema such apt media for exploring issues of identity and replicating processes of socialisation (something that they never fail, in their reflexivity, to illuminate), is their performance base. If sociology is part of late modernity's reflexivity, as Giddens maintains (14), then theatre and cinema, as social art forms, can also be described as part of the same type of reflexivity.

Part of this reflexivity involves illuminating the dominant ideology and, in the case of the texts analysed, its perils. Chapter 2 demonstrated how television is portrayed in certain plays and films as the culturally and ideologically hegemonic medium of postmodernity, interpellating its spectators as subjects of systems of consumption. It is generally accepted among Marxist theorists, such as Slavoj Žižek (1999), that it is impossible to step outside the limits of ideology. Whilst theatre and cinema cannot wholly exist outside ideology, therefore falling short of offering any viable alternative, the lines of combat drawn between television and other media/aesthetics serve to render the dominant ideology visible and thus potentially open to critique. What they draw attention to is an inability, or lack of any political will, to imagine a society outside the processes of consumption. By policing the boundaries they share with television, theatre and cinema work to de-naturalise the Symbolic order and reveal the role of ideology in pasting over the crack between the Real and the distorted and, on occasions, illusory televisual reality we perceive (Žižek 1999: 79). As Maristella Svampa states, the model of citizenship in Argentina is no longer based on the welfare state, but on the market (2005: 73). In what she terms the 'modelo del ciudadano consumidor', to be a citizen, one must necessarily be a consumer (82). What is repeatedly made clear throughout this study is that subjectivity is scripted in relation to a single ideology: neoliberalism. Theatre and cinema set themselves up as spaces in which those who hold a marginal status within the dominant ideology —non-citizens and those without the means to consume— can be represented.

This crack in the social fabric has been brought to the fore particularly in recent cinema. *Fantasma* dealt with this by staging the impossibility of 'convivencia' across the class/ideological divide. Whilst *Fantasma* certainly points up film's limitations in this matter, such films do at least attempt to grant visibility to what Zygmunt Bauman refers to as the human 'waste' of modernity, or 'the "collateral casualties" of progress' (2004: 15). Bauman makes many useful contributions to debates regarding citizenship in the context of late modernity.

> The modern mind was born together with the idea that *the world can be changed*. Modernity is about rejecting the world as it has been thus far and the resolution to change it. The modern way of being consists in compulsive, obsessive change: in the refutation of what 'merely is' in the name of what could, and by the same token ought, to be put in its place. (2004: 23)

Yet, one of the most pressing issues of modernity's drive towards order and progress, according to Bauman, is the waste this produces along the way:

> When it comes to designing the forms of human togetherness, the waste is human beings. Some human beings who do not fit into the designed form nor can be fitted into it. [...] Blots on the otherwise elegant and serene landscape. Flawed beings, from whose absence or obliteration the designed form could only gain, becoming uniform, more harmonious, more secure and altogether more at peace with itself. (30)

The hybridity of recent films and the aesthetic multiplicity/hybridity of recent theatre seem to problematise this sense of 'togetherness' by representing those 'who do not fit into the designed form' of neoliberalism. Such ideas of hybridity and multiplicity echo earlier postcolonial discourse. In *The Location of Culture* (1994), Homi Bhabha addresses the issue of hybridity. His work takes a postcolonial perspective on the problems of forging cultural affiliations and identities in societies characterised by diversity and inequalities. Not only does Bhabha highlight the plethora of different borderlines denoting class, race, gender, sexual orientation or geopolitical locale across which both individual and social identities are negotiated, but he also suggests the ways in which such identities can be mobilised:

> The move away from the singularities of 'class' or 'gender' as primary conceptual and organizational categories, has resulted in an awareness of the subject positions —of race, gender, generation, institutional location, geopolitical locale, sexual orientation— that inhabit any claim to identity in the modern world. What is theoretically innovative and politically crucial, is the need to think beyond narratives of originary and initial subjectivi-

ties and to focus on those moments or processes that are produced in the articulation of cultural differences. These 'in-between' spaces provide the terrain for elaborating strategies of selfhood —singular or communal— that initiate new signs of identity, and innovative sites of collaboration, and contestation in the act of defining the idea of society itself.

It is in the emergence of the interstices —the overlap and displacement of domains of difference— that the intersubjective and collective experiences of *nationness*, community interest, or cultural value are negotiated. (1994: 2, original emphasis)

Other recent theories, such as Michael Hardt and Antonio Negri's *Multitude* (2006), although perhaps rather idealistic, attempt to take account of the multiplicity of different subject positions within society, alongside the need to conceptualise community beyond the confines of the nation, whilst uniting people under a common project.

Whilst the political motivation behind theatre's and cinema's trespassing into territory traditionally belonging to other genres/media or art forms has been foregrounded throughout, each transgression into this other territory is marked by a certain reticence about the possibility of corrupting theatre's and cinema's own identity as autonomous and specific art forms. Given the tensions between the collapsing of generic boundaries and a latent anxiety regarding the loss of artistic specificity and autonomy —something which indicates a further level of hybridity and the impossibility of separating the categories of modernism and postmodernism in the Argentine context— I would suggest that there is a need to relocate the issue of artistic specificity in a more ambiguous position somewhere between essentialism and pure performativity. Once again, parallels between the identity of cultural forms and national identity may be drawn. Facing a similar dilemma in his theorisation of national identity and unsatisfied by the limitations of both essentialist and constructivist approaches to identity construction, Alejandro Grimson moves '[h]acia una concepción experiencialista [de la identidad]' (2004: 181). Identity will inevitably be a contingent experience governed by historical processes, argues Grimson, but the discourses that feed identity-construction rely on the naturalisation of identity as a timeless construct.

Esta tercera versión experiencialista coincide con la segunda, la constructivista, en que 'los argentinos' son un resultado del proceso histórico, contingente como tal. Pero se diferencia porque enfatiza la sedimentación y porque subraya que no se trata sólo de procesos simbólicos resultado de fuerzas simbólicas, sino de lo vivido históricamente en el 'proceso social total'. (181)

Whilst genre should be conceived as historically contingent, if one steps back from this idea of contingency, there nevertheless seem to be certain constants that emerge over time and which relate to Grimson's experiential theory of identity. Rather than being based on essential characteristics, theatre and cinema's identity is generated through the sedimentation of their common social experience since 1983: memory of dictatorship and censorship; the return of many playwrights/filmmakers from exile; negotiating cultural hybridity; engaging with increasing social fragmentation under neoliberalism; not to mention reaffirming their position within a range of national and Western artistic genealogies and intellectual currents. What has been underlined throughout this investigation is that the various appropriations made by theatre and cinema from other sets of conventions are symptomatic of the various social transformations taking place in Argentina after the dictatorship. In order to renew themselves as socially and politically relevant forms, theatre and cinema become more fluid, contingent constructs. However, their sense of agency depends on the assertion of some sense of core identity, reliant on policing the borders that mark out their identity and separate it from those demarcating other art forms.

This is something that Peter Brook confirms in his writings on theatre: '[l]ife is moving', he argues, 'influences are playing on actor and audience, and other plays, other arts, the cinema, television, current events, join the constant rewriting of history and the amending of the daily truth' (1990: 19). He continues:

> In the theatre, every form once born is mortal; every form must be reconceived, and its new conception bear the marks of all the influences that surround it. In this sense, the theatre is relativity. Yet a great theatre is not a fashion house; perpetual elements do recur and certain fundamental issues underlie all dramatic activity. (19)

The need for at least the illusion or myth of some kind of stable/essential identity is most effectively illustrated in chapter 3 in the theatrical and cinematic genealogies set up intertextually in both *Postales argentinas* and *La sonámbula*. Whilst citation of older texts necessarily involves pulling them out of their original context, it is also shown to be an important mechanism in fabricating artistic genealogies that compensate for the melting of specific aesthetic/generic boundaries under the banner of postmodernism.

One of the key features of theatre's specificity which is progressively de-mythified in this study is the question of presence. Given that theatre as we know it today can be traced back via Greek tragedy to the ancient rites of the Dionysian Festival (Schechner 2003: 1), the seemingly timeless attribute of theatre's capacity to bring performer and spectator into each other's presence is easily rendered credible. But whilst both theatre and cinema in chapter

1 were argued to preserve conservatively the aura of presence, the primacy of theatrical presence (or 'convivio') is seriously questioned in both the plays and films analysed in the final chapter, demonstrating a shift in the way in which theatre and cinema are perceived as art forms. Both see themselves as social art forms, but the ways in which they bring people together, be it bringing spectators together, or spectator and actor, have been questioned and have adapted to the disembedding virtual networks that structure postmodern society and culture. Plays such as *Los 8 de julio* demonstrate how, if theatre is to adapt to a society dominated by media networks, it can no longer rely on organic presence to assert its socio-political agency; it remains far too limited and theatre must borrow from audiovisual genres such as video documentary to extend its reach.

A series of biological metaphors (the hybridisation of species, incest, promiscuity and evolution) have entered my analysis at various stages in this study, symbolising the way in which aesthetic hybridisation as a strategy of re-politicisation doubles as a strategy of survival. Just like the dysfunctional family relationships presented in *Postales argentinas*, theatre and cinema become caught in incest and promiscuity. On the one hand, incest represents a turning to look inwards that can be mapped onto attempts to maintain generic purity. In *Postales argentinas* and *La sonámbula* this is played out in a series of intertextual engagements with texts from the same art form. On the other hand incest, despite offering the fantasy of purity, is also biologically associated with a weakening of the species. Incest can of course be defined as promiscuous, but what I am referring to here is promiscuity with an Other which perhaps offers better chances of survival. Promiscuity, in generic terms, can be read as the aesthetic's flirtation with the market (processes of cultural commodification). A more acceptable form of promiscuity and cross-breeding is, however, to be found in the transgressions made across aesthetic boundaries and into the territory of neighbouring art forms and genres. Theatre and cinema's borrowings from other aesthetic types present collaborative means of survival in order to prevent the typically postmodern collapse of the aesthetic into the political and the economic.

The differing nature of the hybrids formed by theatre and cinema also charts what they can reveal about the changing parameters of the processes of constructing political meaning: from an allegorical engagement with macro-political issues to documenting micro-political (or social) issues. Whilst the texts analysed in chapters 1 to 3 rely on the use of allegory, those dealt with in chapter 4 illustrate the changing imperatives governing political engagement at around the time of the Crisis. In recent years, many plays and films have echoed the apparent tendency towards de-politicisation, leaving behind the grand political discourses and allegorical scenarios typical of ideologi-

cally committed theatre and cinema in the 1970s and 1980s, to adopt instead a more private, biopolitical approach to politics.

The appropriation of ground from documentary which is examined in the final chapter invites consideration as to how a film or play can be political if not allegorical. This is a question that Joanna Page (2007) asks of *La ciénaga* (2001) and *La niña santa* (2004), both films by Lucrecia Martel. Examining the way in which the films retreat into private spaces, Page argues that this does not mean that the films relinquish any political engagements, rather that they place in relief the redundancy of allegory as an effective method of artistic engagement with politics. Instead, she draws attention to changes in the field of politics itself (157), arguing that

> lejos de un renunciamiento de lo político, registran una crisis en las estructuras de significación que insertan lo individual y lo privado en el contexto de lo general y lo público. Y en estas estructuras mismas están basados los modos más convencionales de hacer cine político. (165)

In the case of Fernando Solanas, this shift can be charted in the body of work of a single director. In more recent times and in contrast to his films of the 1980s and 1990s (two of which were examined in detail in chapter 1), Solanas has returned to the documentarism he used in his first film *La hora de los hornos*. This is indeed a contrast to films such as *El viaje* (1996), in which the slimy, flipper-clad President 'Dr Rana' provided a damning caricature of President Menem, and the belts given to individuals by (and tightened under demands of) the IMF served as a rather unsubtle allegory of the crippling effects of international intervention. Tired of the political theatricality, invariably associated with artifice during the Menem years, more contemporary plays and films seek to recuperate the real, 'the real' seen in terms of a discourse on truth and authenticity. Certainly in cinema, farce is no longer considered a suitable genre for deconstructing the theatrical shenanigans of Menem's reign, as if this might lead only to an escalation of ridicule. In *Memoria del saqueo* (2004) and *Argentina latente* (2007), both of which examine the effects of neoliberalism and the Crisis, Solanas himself returns to a documentary style of filmmaking. His didacticism remains the same throughout his career as a filmmaker (and politician, one must remember), but the strategies he employs in order to communicate his message are clearly adapted to their context. It is worth pointing out, however, that his later documentary films noticeably lack the Utopian undertones of 'esperanza' that punctuated his earlier fiction films and *La hora de los hornos*; another indication of the collapse of the political Left, as well as a more generalised waning belief in the possibility of change.

What I wish to make clear at this point, however, is that this widespread turn to documentarism is not characteristic of all recent Argentine theatre

and the Proyecto Biodrama which was explored in chapter 4 is by no means indicative of any norm. Certain representations of Menem's presidency choose to draw out the farcical nature of the 1990s and indeed supersede it with an equally farcical production. Rafael Spregelburd's play *Un momento argentino* (2001), which was written explicitly in response to the Crisis for the Old Vic Theatre in London, is a blatant farce. Spregelburd maintains that farce is the only viable genre for capturing the Crisis: 'no he encontrado otra forma posible que no fuera la farsa. La farsa reproduce mejor que cualquier otro género mi desazón y mi sombría sorpresa ante los hechos que vive mi país' (2003: 136).

García Canclini urges that '[l]os pocos fragmentos escritos de una historia de las hibridaciones han puesto en evidencia la productividad y el poder inno-vador de muchas mezclas interculturales' (2001: 16). The aim of this inves-tigation has been to contribute another fragment to Argentina's and indeed Latin America's written history of cultural hybridity, this time through the optic of performance. The politics of genre implicated in each of the aesthetic/generic/media hybrids dealt with in this study report back not only on the status of genre in postmodernism, but on the peculiar way in which modernist imperatives (specificity of genre/autonomy of the art object) become hybrid-ised with postmodernism (melting of the boundaries between aesthetics/poli-tics and the social) in the Argentine context. Caught between Europe and Latin America, First World and Third World, precolonial and postcolonial, the modern and the postmodern, for a nation that was built on waves of immigration the question of hybridity is at the very centre of the discourse on national identity. In theatre and cinema, this hybridity is expressed in generic/media and aesthetic cross-breeds which are symptomatic of the above dichot-omies, although (rather paradoxically) also a reflexively calculated strategy of survival.

Filmography

La antena 2007. Directed by Ernesto Sapir (Argentina: LadobleA), 35mm/BW, 90 mins.

Argentina latente 2007. Directed by Fernando E. Solanas (Argentina: Cinesur/ Instituto Nacional de Cine y Artes Audiovisuales), 35mm/colour, 100 mins.

Blade Runner 1982. Directed by Ridley Scott (USA: The Ladd Company), 35mm/colour, 117 mins.

Bolivia 2002. Directed by Adrián Caetano (Argentina/Netherlands: Fundación PROA), 16mm/BW, 75 mins.

Buenos Aires viceversa 1996. Directed by Alejandro Agresti (Argentina/Netherlands: Agresti Films), 35mm/colour, 95 mins.

La ciénaga 2001. Directed by Lucrecia Martel (Argentina/Spain/France: Lita Stantic Producciones), 35mm/colour, 103 mins.

Deuda 2004. Directed by Jorge Lanata (Argentina: Patagonik Film Group), 35mm/colour, 90 mins.

La dignidad de los nadies 2005. Directed by Fernando E. Solanas (Argentina/ Brazil/ Switzerland: Cinesur/Dezenove som e imagens), 35mm/colour, 120 mins.

Estrellas 2007. Directed by Federico León and Marco Martínez (Argentina: Crudo Films), 35mm/colour, 64 mins.

La familia rodante 2004. Directed by Pablo Trapero (Argentina/Brazil/France/ Germany/UK: Lumina Films), 35mm/colour, 99 mins.

Fantasma 2006. Directed by Lisandro Alonso (Argentina/France/Netherlands: 4L/Slot Machine/Fortuna Films), 35mm/colour, 63 mins.

La fé del volcán 2001. Directed by Ana Poliak (Argentina: Viada Producciones), 35mm/colour, 85 mins.

Geminis 2005. Directed by Albertina Carri (Argentina/France: Fireball Pictures/ Matanza Cine/NQVAC), 35mm/colour, 85 mins.

Los guantes mágicos 2003. Directed by Martín Rejtman (Argentina/France/ Germany/Netherlands: Rizoma Films), 35mm/colour, 90 mins.

Historias mínimas 2002. Directed by Carlos Sorín (Argentina/Spain: Guacamole Films), 35mm/colour, 92 mins.

Hombre mirando al sudeste 1986. Directed by Eliseo Subiela (Argentina: Cinequannon), 35mm/colour, 100 mins.

La libertad 2001. Directed by Lisandro Alonso (Argentina: 4L), 35mm/colour, 73 mins.

Man with a movie camera 1929. Directed by Dziga Vertov (Russia), 16mm/BW, 68 mins.

Memoria del saqueo 2004. Directed by Fernando E. Solanas (Argentina/France/Switzerland: Cinesur/ADR Productions/Thelma Film AG/Instituto Nacional de Cine y Artes Audiovisuales), 35mm/colour, 120 mins.

Metropolis 1927. Directed by Fritz Lang (Germany: Universum Film AG), 35mm/BW, 153 mins.

Moebius 1996. Directed by Gustavo Mosquera (Argentina: Universidad del Cine, Buenos Aires), 35mm/colour, 88 mins.

Los muertos 2004. Directed by Lisandro Alonso (Argentina/France/Netherlands/Switzerland: 4L/Fortuna Films/Slot Machine/Arte France Cinema/Ventura Film), 35mm/colour, 78 mins.

Mundo grúa 1999. Directed by Pablo Trapero (Argentina: Cinema Tropical/Instituto de Cine y Artes Audiovisuales/Lita Stantic Producciones), 35mm/BW, 90 mins.

No te mueras sin decirme adónde vas 1995. Directed by Eliseo Subiela (Argentina: Artear Argentina/Instituto Nacional de Cine y Artes Audiovisuales), 35mm/colour, 130 mins.

La nube 1998. Directed by Fernando E. Solanas (Argentina/France: Cinesur/Les Films du Sud), 35mm/colour, 114 mins.

Pizza, birra, faso 1998. Directed by Adrián Caetano and Bruno Stagnaro (Argentina: Palo y a la Bolsa Cine/Instituto de Cine y Artes Audiovisuales), 35mm/colour, 90 mins.

PyME 2005. Directed by Alejandro Malowicki (Argentina: Cinegrafía/Instituto Nacional de Cine y Artes Audiovisuales), 35mm/colour, 96 mins.

La República perdida 1983. Directed by Miguel Pérez (Argentina: Noran), 35mm/colour, 146 mins.

La República perdida II 1986. Directed by Miguel Pérez (Argentina: Noran), 35mm/colour, 140 mins.

Ronda nocturna 2005. Directed by Edgardo Cozarinsky (Argentina/France: Cine Ojo/Les Films d'Ici), 35mm/colour, 82 mins.

Silvia Prieto 1998. Directed by Martín Rejtman (Argentina: Ateliers des arches), 35mm/colour, 92 mins.

La sonámbula 1998. Directed by Fernando Spiner, screenplay by Ricardo Piglia

and Fabián Bielinsky (Argentina: Sonámbula Producciones), 35mm/BW/colour, 107 mins.

Tan de repente 2002. Directed by Diego Lerman (Argentina/Netherlands: Nylon Cine/Instituto de Cine y Artes Audiovisuales/Hubert Bals Fund), 35mm/BW, 90 mins.

Tangos, el exilio de Gardel 1985. Directed by Fernando E. Solanas (Argentina/France: Terciné/Cinesur/Instituto Nacional De Cinematografía/Ministère de la Culture, France), 35mm/colour, 119 mins.

El viaje 1992. Directed by Fernando E. Solanas (Argentina/France/Spain/Mexico: Cinesur/Les Films du Sud), 35mm/colour, 138 mins.

El viento se llevó lo que 1998. Directed by Alejandro Agresti (Argentina/Spain: Agresti Films/DMVB Films/Studio Nieuwe Gronden/Maestranza Films/Videograbadora), 35mm/colour, 83 mins.

Bibliography

Adorno, Theodor 2001. *The Culture Industry* (London: Routledge).

Adorno, Theodor and Max Horkheimer 1997. *Dialectic of Enlightenment* (London: Verso).

Adorno, Theodor et al. 2007. *Aesthetics and Politics* (London: Verso).

Agamben, Giorgio 1998. *Homo Sacer: Sovereign Power and Bare Life* (Stanford, CA: Stanford University Press).

Aguilar, Gonzalo 2006. *Otros mundos: ensayo sobre el nuevo cine argentino* (Buenos Aires: Santiago Arcos Editor).

Ainsa, Fernando 2000. 'Entre Babel y la Tierra Prometida. Narrativa e inmigración en la Argentina', *Les Cahiers Amérique Latine Histoire et Mémoire*, http://alhim.revues.org/index87.html, last accessed 6 November 2008.

Alberdi, Juan Bautista 1943 [1856]. *Bases y puntos de partida para la organización política de la República Argentina* (Buenos Aires: Ediciones Estrada).

Althusser, Louis 2008. *On Ideology* (London: Verso).

Amado, Ana and Nora Domínguez 2004. 'Figuras y políticas de lo familiar: una introducción', in Ana Amado and Nora Domínguez, eds. *Lazos de familia: herencias, cuerpos, ficciones* (Buenos Aires: Paidós), pp. 13–39.

Anderson, Benedict 2006. *Imagined Communities: Reflections on the Origin and Spread of Nationalism* (London: Verso).

Arias, Lola 2007. *Striptease*, in *Striptease/Sueño con revólver/El amor es un francotirador* (Buenos Aires: Entropía), pp. 11–24.

Artaud, Antonin 1993. *The Theatre and its Double* (London: Calder Publications).

Auslander, Philip 1997. *From Acting to Performance: Essays in Modernism and Postmodernism* (London: Routledge).

Avelar, Idelber 1999. *The Untimely Present: Postdictatorial Latin American Fiction and the Task of Mourning* (Durham, NC: Duke University Press).

Barthes, Roland 1984. 'Death of the Author', in *Image, Music, Text* (London: Flamingo), pp. 142–8.

— 1985. *The Fashion System* (London: Jonathan Cape).

— 1993. *Mythologies* (London: Vintage).

Bartís, Ricardo 2003a. Edited by Jorge Dubatti, *Cancha con niebla: teatro perdido: fragmentos* (Buenos Aires: Atuel).

—2003b [1988]. *Postales argentinas*, in *Cancha con niebla: teatro perdido: fragmentos* (Buenos Aires: Atuel), pp. 41–61.

— 2003c [1990]. *Hamlet o la guerra de los teatros*, in *Cancha con niebla: teatro perdido: fragmentos* (Buenos Aires: Atuel), pp. 95–114.
— 2003d [1994]. *Muñeca*, in *Cancha con niebla: teatro perdido: fragmentos* (Buenos Aires: Atuel), pp. 128–38.
— 2003e [1998]. *El pecado que no se puede nombrar*, in *Cancha con niebla: teatro perdido: fragmentos* (Buenos Aires: Atuel), pp. 189–220.
— 2004. *De mal en peor*. Script unpublished. Performance attended 5 May 2005 at the Maison Pelgrims as part of the Kunsten Festival des Arts, Brussels, Belgium.
Batlle, Diego 2002. 'De la virtual extinción a la nueva ley: el resurgimiento', in Horacio Bernades, Diego Lerer and Sergio Wolf, eds. *El nuevo cine argentino: temas, autores y estilos de una renovación* (Buenos Aires: Fipresci), pp. 17–29.
Baudrillard, Jean 1981. *Simulacres et simulation* (Paris: Galilée).
— 1992. 'Transpolitics, Transsexuality, Transaesthetics', in William Stearns and William Chalpouka, eds. *Jean Baudrillard: The Disappearance of Art and Politics* (London: Macmillan).
— 1998. *The Consumer Society: Myths and Structures* (London: SAGE).
— 2005. *The System of Objects* (London: Verso).
Bauman, Zygmunt 1997. *Postmodernity and its Discontents* (Cambridge: Polity Press).
— 2004. *Wasted Lives: Modernity and its Outcasts* (Cambridge: Polity Press).
— 2000. *Liquid Modernity* (Cambridge: Polity Press).
Bausset, Mónica 2007. *Claves en el teatro de Nora Glickman* (Buenos Aires: Nueva Generación).
Bazin, André 1992. 'Theatre and Cinema *From* What is Cinema?', in Gerald Mast, Marshall Cohen and Leo Braudy, eds. *Film Theory and Criticism: Introductory Readings, Fourth Edition* (Oxford: Oxford University Press), pp. 375–86.
Beber, Neena 2002. 'Some Quick Thoughts on Theatre and its Future', in María M. Delgado and Caridad Svich, eds. *Theatre in Crisis? Performance Manifestos for a New Century: Snapshots of a Time* (Manchester: Manchester University Press), pp. 20–1.
Bell, Daniel 1965. *The End of Ideology: On the Exhaustion of Political Ideas in the Fifties*, revised edition (London: Collier-Macmillan).
Benjamin, Walter 1970. *Illuminations* (London, Jonathon Cape).
Bernades, Horacio 2006. 'Ese intenso acto de mirar', *Página 12*, 29 September, http://www.pagina12.com.ar/diario/suplementos/espectaculos/5-3908-2006-09-23.html, last accessed 3 April 2008.
Bhabha, Homi K. 1994. *The Location of Culture* (London: Routledge).
— 2006. *Nation and Narration* (London: Routledge).
Bioy Casares, Adolfo 2000 [1953]. *La invención de Morel* (Buenos Aires: Editorial Planeta).
Birringer, Johannes 2000. *Performance on the Edge: Transformations of Culture* (London: Continuum).

Bixler, Jacqueline Eyring 1994. 'Signs of Absence in Pavlovsky's "teatro de la memoria"', *Latin American Theatre Review* 28:1, 17–30.

Bloom, Harold 1973. *The Anxiety of Influence: A Theory of Poetry* (New York: Oxford University Press).

Bordwell, David and Noël Carroll, eds. 1996. *Post-Theory: Reconstructing Film Studies* (Madison: University of Wisconsin Press).

Bordwell, David and Kristin Thompson 2004. *Film Art: An Introduction* (New York: McGraw-Hill).

Borges, Jorge Luis 1995 [1944]. *Ficciones* (Madrid: Alianza Editorial).

Borgna, Gabriela 1990. 'La tortura y el dramaturgo', *Página 12*, 24 April, n.p.

Bourdieu, Pierre 1998. *On Television* (New York: The New Press).

Brook, Peter 1990. *The Empty Space* (London: Penguin).

Bulman, Gail A. 2002. 'Humor and National Catharsis in Roberto Cossa's *El saludador*', *Latin American Theatre Review* 36:1, 5–17.

Butler, Judith 1990. *Gender Trouble: Feminism and the Subversion of Identity* (London: Routledge).

Cabrejas, Gabriel 1996. 'Teatro y cine: meditaciones sobre un escenario perpendicular', in Osvaldo Pellettieri, ed. *El teatro y sus claves: estudios sobre teatro iberoamericano y argentino* (Buenos Aires: Editorial Galerna), pp. 279–85.

Cabrera, Hilda 2002. '"En Argentina los ciclos se abortan o se acortan"', in *Página 12*, http://www.pagina12.com.ar/diario/espectaculos/6-8125-2002-07-26.html, last accessed 3 September 2008.

Catani, Beatriz and Mariano Pensotti 2002. 'Los 8 de julio (Experiencia sobre registros de paso del tiempo)', *Hemispheric Institute of Performance and Politics: Forums*, http://hemi.nyu.edu/eng/newsletter/issue6/pages/eventosargentina.sh tml, last accessed 10 December 2008.

Chanan, Michael 1997. 'Rediscovering Documentary: Cultural Context and Intentionality', in Michael T. Martin, ed. *New Latin American Cinema, Volume One: Theories, Practices and Transcontinental Articulations* (Detroit: Wayne State University Press), pp. 201–17.

Chaud, Mariana 2007 [2006]. *Budín inglés: sobre la vida de cuatro lectores porteños* (Buenos Aires: Teatro Vivo).

Clarke, David B. 2003. *The Consumer Society and the Postmodern City* (London: Routledge).

Comolli, Jean-Luc and Jean Narboni 1992. 'Cinema/Ideology/Criticism', in Gerald Mast, Marshall Cohen and Leo Braudy, eds. *Film Theory and Criticism: Introductory Readings, Fourth Edition* (Oxford: Oxford University Press), pp. 682–9.

Cornago, Óscar 2005. 'Biodrama: sobre el teatro de la vida y la vida del teatro', *Latin American Theatre Review*, 39:1, 5–28.

Cossa, Roberto 1989 [1977]. *La nona*, in *Teatro 2* (Buenos Aires: Ediciones de la Flor), pp. 67–136.

— 1999 [1997]. *Años difíciles*, in *Teatro 5* (Buenos Aires: Ediciones de la Flor), pp. 9–40.

Cuaretolo, Andrea 2007. 'Distopías vernáculas. El cine de ciencia ficción en la

Argentina', in María José Moore and Paula Wolkowicz, eds. *Cines al margen: nuevos modos de representación en el cine argentino contemporáneo* (Buenos Aires: Libraria), pp. 81–108.

Darío, Rubén 1996 [1905]. 'Lo fatal', in *Antología poética*. Edited by Alberto Acereda (Buenos Aires: Editorial Sudamericana), p. 168.

Daulte, Javier, Rafael Spregelburd and Alejandro Tantanian 2002 [2001]. *La escala humana* (Buenos Aires: Ediciones Teatro Vivo).

Debord, Guy 2004. *Society of the Spectacle* (London: Rebel Press).

Delgado, María M. and Caridad Svich 2002. 'Theatre in Crisis? Performance Manifestos for a New Century: Snapshots of a Time', in María M. Delgado and Caridad Svich, eds. *Theatre in Crisis? Performance Manifestos for a New Century: Snapshots of a Time* (Manchester: Manchester University Press), pp. 1–15.

Denzin, Norman K. 1991. *Images of Postmodern Society: Social Theory and Contemporary Cinema* (London: SAGE).

Derrida, Jacques 1980. 'The Law of Genre', *Critical Inquiry* 7:1, 55–81.

— 2001 [1978]. 'The Theater of Cruelty and the Closure of Representation', in *Writing and Difference* (London, Routledge), pp. 292–316.

Diamond, Elin, ed. 1996. *Performance and Cultural Politics* (London: Routledge).

Dubatti, Jorge 1997. 'Estudio preliminar', in Eduardo Pavlovsky, *Teatro completo I* (Buenos Aires: Atuel), pp. 7–44.

— 1999. *El teatro laberinto: ensayos sobre el teatro argentino* (Buenos Aires: Atuel).

—, ed. 2000. *Teatro argentino* (Buenos Aires: Libros de Tierra Firme).

— 2002. 'Estudio preliminar', in Eduardo Pavlovsky, *Teatro completo IV* (Buenos Aires: Atuel).

— 2003. 'La escritura teatral: ampliación y cuestionamiento', in *Nuevo teatro argentino* (Buenos Aires: Interzona), pp. 5–18.

— 2005. 'Estudio preliminar', in Eduardo Pavlovsky, *Teatro completo V* (Buenos Aires: Atuel), pp. 5–66.

— 2006. 'El teatro argentino se lleva bien con la insatisfacción', *Clarín*, 5 March, http://www.clarin.com/suplementos/zona/2006/03/05/z-03816.htm, last accessed 12 December 2008.

— 2007. *Filosofía del teatro I: convivio, experiencia, subjetividad* (Buenos Aires: Atuel).

Ellis, John 1982. *Visible Fictions: Cinema, Television, Video* (London: Routledge & Kegan Paul).

Eloy Martínez, Tomás 1988. 'El lenguaje de la inexistencia', in Saúl Sosnowski, *Represión y reconstrucción de una cultura: el caso argentino* (Buenos Aires: EUDEBA), pp. 187–94.

España, Claudio 1997. '"El cine es un espejo: ayuda a vernos"', *La nación*, Section 4 ('Espectáculos'), 29 October, p. 5.

Esslin, Martin 2001. *The Theatre of the Absurd* (London, Eyre Metheun).

Falicov, Tamara L. 2007. *The Cinematic Tango: Contemporary Argentine Film* (London: Wallflower Press).

Filc, Judith 2004. 'Desafiliación, extranjería y relato bibliográfico en la novela de la posdictadura', in Ana Amado and Nora Domínguez, eds. *Lazos de familia: herencias, cuerpos, ficciones* (Buenos Aires: Paidós), pp. 197–229.

Foster, Hal, ed. 1983. *Postmodern Culture* (London: Pluto).

Foster, Thomas 2005. *The Souls of Cyberfolk: Posthumanism as Vernacular Theory* (Minneapolis: University of Minnesota Press).

Foucault, Michel 1979. *The History of Sexuality, Volume One: An Introduction* (London: Random House).

Freedman, Carl 2000. *Critical Theory and Science Fiction* (Hanover, NH: University Press of New England).

Freud, Sigmund 1967. *A General Introduction to Psychoanalysis* (New York: Washington Square Press).

— 2001a [1930]. 'Civilization and its Discontents', in *The Standard Edition of the Complete Psychological Works of Sigmund Freud*, Volume XXI (London: Vintage).

— 2001b [1909]. 'Family Romances', in *The Standard Edition of the Complete Psychological Works of Sigmund Freud*, Volume IX (London: Vintage).

Furedi, Frank 2005. *Politics of Fear: Beyond Left and Right* (London: Continuum).

García, Fabián 1998. 'Una multitud reclamó saber por qué explotó el arsenal', *Clarín*, 4 November, http://www.clarin.com/diario/1998/11/04/e-04801d.htm, last accessed 15 December 2008.

García Canclini, Néstor 2001. *Culturas híbridas: estrategias para entrar y salir de la modernidad* (Buenos Aires: Editorial Paidós).

García Márquez, Gabriel 1981. *El coronel no tiene quién le escriba* (Manchester: Manchester University Press).

Genet, Jean 1949. *Journal du voleur* (Paris: Éditions Gallimard).

Getino, Octavio 1998. *Cine y televisión en América Latina: producción y mercados* (Buenos Aires: Ediciones Ciccus).

Getino, Octavio and Fernando E. Solanas 1997. 'Towards a Third Cinema: Notes and Experiences for the Development of a Cinema of Liberation in the Third World', in Michael T. Martin, ed. *New Latin American Cinema, Volume One: Theories, Practices and Transcontinental Articulations* (Detroit: Wayne State University Press), pp. 33–58.

Giddens, Anthony 1991. *Modernity and Self-Identity: Self and Society in the Late Modern Age* (Cambridge: Polity Press).

Goffman, Erving 1966. *Behavior in Public Places: Notes on the Social Organization of Gatherings* (New York: The Free Press).

— 1990 [1959]. *The Presentation of Self in Everyday Life* (London: Penguin).

Graham-Jones, Jean 2000. *Exorcising History: Argentine Theater under Dictatorship* (London: Associated University Presses).

Gramuglio, María Teresa 2000. 'Políticas del decir y formas de la ficción: novelas de la dictadura militar', *Punto de vista*, 74 9–14.

Grimson, Alejandro, ed. 2004. *La cultura en las crisis latinoamericanas* (Buenos Aires: CLASCO).

Gunderman, Christian 2004. '"Filmar como la gente": la *imagen-afección* y el resurgimiento del pasado en *Buenos Aires viceversa* (1996) de Alejandro Agresti', in Ana Amado and Nora Domínguez, eds. *Lazos de familia: herencias, cuerpos, ficciones* (Buenos Aires: Paidós), pp. 83–109.

Hammer, Espen 2006. *Adorno and the Political* (London: Routledge).

Hardt, Michael and Antonio Negri 2006. *Multitude* (London: Penguin).

Hassan, Ihab Habib 1982. *The Dismemberment of Orpheus: Toward a Postmodern Literature* (Madison/London: University of Wisconsin Press).

Hayward, Susan 2000. *Cinema Studies: The Key Concepts* (London: Routledge).

Heker, Liliana 1988. 'Los intelectuales ante la instancia del exilio: militancia y creación', in Saúl Sosnowski, *Represión y reconstrucción de una cultura: el caso argentino* (Buenos Aires: EUDEBA), pp. 195–202.

Holderness, Graham, ed. 1992. *The Poltics of Theatre and Drama* (London: Macmillan).

Hopenhayn, Martín 1994. *Ni apocalípticos ni integrados: aventuras de la modernidad en América latina* (Santiago: Fondo de Cultura Económica).

Hutcheon, Linda 2002. *The Politics of Postmodernism* (London: Routledge).

Huyssen, Andreas 2003. *Present Pasts: Urban Palimpsests and the Politics of Memory* (Stanford, CA: Stanford University Press).

Jameson, Fredric 1991. *Postmodernism, or, The Cultural Logic of Late Capitalism* (London: Verso).

— 1992a. *The Geopolitical Aesthetic: Cinema and Space in the World System* (London: British Film Institute).

— 1992b. *Signatures of the Visible* (London: Routledge).

— 1998. *The Cultural Turn: Selected Writings on the Postmodern 1983–1998* (London: Verso).

— 2002. *The Political Unconscious* (London: Routledge).

— 2004. 'The Politics of Utopia', *New Left Review* 25, January–February, http://www.newleftreview.org/?view=2489, last accessed 16 December 2008.

— 2007. *Archaeologies of the Future: The Desire Called Utopia and Other Science Fictions* (London: Verso).

Jaroslavsky, Sonia 2006. 'El gesto del intento es lo que produce vida: reportaje a Beatriz Catani', in *Alternativa teatral*, http://www.alternativateatral.com/ver_nota=100, last accessed 8 September 2008.

Kantaris, Geoffrey 1995. *The Subversive Psyche: Contemporary Women's Narrative from Argentina and Uruguay* (Oxford: Clarendon Press).

— 2008. 'Cyborgs, Cities, and Celluloid: Memory Machines in Two Latin American Cyborg Films', in Claire Taylor and Thea Pitman, eds. *Latin American Cyberculture and Cyberliterature* (Liverpool: Liverpool University Press), pp. 50–69.

Kesselman, Hernán and Eduardo Pavlovsky 2006. *La multiplicación dramática* (Buenos Aires: Atuel).

Levitow, Roberta 2002. 'Some Words about the Theatre Today', in María M. Delgado and Caridad Svich, eds. *Theatre in Crisis? Performance Manifestos for a New Century: Snapshots of a Time* (Manchester: Manchester University Press), pp. 25–31.

Marcus, Millicent Joy 1993. *Filmmaking by the Book: Italian Cinema and Literary Adaptation* (Baltimore: Johns Hopkins University Press).

Marks, Laura 2000. *The Skin of the Film: Intercultural Cinema, Embodiment, and the Senses* (Durham, NC and London: Duke University Press).

Martín Barbero, Jesús 2000. 'La ciudad: entre medios y miedos', in Susana Rotker, ed. *Ciudadanías del miedo* (Caracas: Nueva Sociedad), pp. 29–35.

Martínez Estrada, Ezequiel 2001 [1933]. *Radiografía de la pampa* (Buenos Aires: Editorial Losada).

McLuhan, Marshall 2001. *Understanding Media: The Extensions of Man* (London: Routledge).

Metz, Christian 1992. '*From* The Imaginary Signifier', in Gerald Mast, Marshall Cohen and Leo Braudy, eds. *Film Theory and Criticism: Introductory Readings*, fourth edition (Oxford: Oxford University Press), pp. 730–45.

Michelson, Annette, ed. 1984. *Kino-eye: The Writings of Dziga Vertov* (Berkeley: University of California Press).

Mogliana, Laura 1996. 'El punto de vista teatral y cinematográfico en las dos versiones de *Convivencia* de Oscar Viale', in Osvaldo Pellettieri, ed. *El teatro y sus claves: estudios sobre teatro iberoamericano y argentino* (Buenos Aires: Editorial Galerna), pp. 293–9.

Mulvey, Laura 1992. 'Visual Pleasure and Narrative Cinema', in Gerald Mast, Marshall Cohen and Leo Braudy, eds. *Film Theory and Criticism: Introductory Readings*, Fourth Edition (Oxford: Oxford University Press), pp. 746–57.

Obersztern, Mariana 2004 [2003]. *El aire alrededor: sobre la vida de Mónica Martínez*, in *Lengua madre sobre fondo blanco/El aire alrededor: sobre la vida de Mónica Martínez* (Buenos Aires: Teatro Vivo), pp. 46–85.

Page, Joanna 2007. 'Espacio privado y significación política en el cine de Lucrecia Martel', in Victoria Rangil, ed. *El cine argentino de hoy: entre el arte y la política* (Buenos Aires: Editorial Biblos), pp. 157–68.

— 2009. *Crisis and Capitalism in Contemporary Argentine Cinema* (Durham, NC and London: Duke University Press).

Pavlovsky, Eduardo 1998 [1977]. *Telerañas*, in *Teatro completo II* (Buenos Aires: Atuel), pp. 111–52.

— 1997a [1985]. *Potestad*, in *Teatro completo I* (Buenos Aires: Atuel), pp. 169–89.

— 1997b [1990]. *Paso de dos*, in *Teatro completo I* (Buenos Aires: Atuel), pp. 103–20.

— 1997c [1994]. *Rojos globos rojos*, in *Teatro completo I* (Buenos Aires: Atuel), pp. 75–101.

— 2000. *Teatro completo III* (Buenos Aires: Atuel).

— 2001. *La ética del cuerpo: nuevas conversaciones* (Buenos Aires: Atuel).

— 2002. 'Micropolítica', *Página 12*, 6 January, http://www.pagina12.com.ar/ diario/ sociedad/subnotas/3-322-2002-01-06.html, last accessed 13 December 2008.

— 2004. *La voz del cuerpo: notas sobre teatro, política y subjetividad* (Buenos Aires: Astralib).

— 2006a. 'Masseritas', *Página 12*, 27 March, http://www.pagina12.com.ar/ diario/ elpais/subnotas/1-21334-2006-03-27.html, last accessed 10 December 2008.

— 2006b. *Resistir Cholo: cultura y polítca en el capitalismo* (Buenos Aires: Editorial Topía).

Pavlovsky, Eduardo and Hernán Kesselman 2006. *La multiplicación dramática* (Buenos Aires: Atuel).

Pellettieri, Osvaldo, ed. 1989. *Teatro argentino de los '60: polémica, continuidad, ruptura* (Buenos Aires: Corregidor), pp. 75–97.

— 1995. *Teatro latinoamericano de los 70: autoritarismo, cuestionamiento y cambio* (Buenos Aires: Corregidor).

Pensa, Mariana n.d. 'La ciudad después de la ciudad: un análisis de *Postales argentinas* de Ricardo Bartís', *Dram@teatro Revista Digital*, http://www. drama teatro.arts.ve/ensayos/n_0016/margulis.htm, last accessed 16 December 2008.

Piglia, Ricardo 1993. 'Sarmiento's Vision', in Joseph T. Criscenti, ed. *Sarmiento and his Argentina* (London: Lynne Rienner), pp. 71–6.

— 2001a. *Crítica y ficción* (Barcelona: Editorial Anagrama).

— 2001b. *Respiración artificial* (Buenos Aires: Grupo Editorial Planeta).

Pigna, Felipe n.d. 'Entrevista a Juan Gelman', *El Historiador*, http://www.elhistoria dor.com.ar/entrevistas/g/gelman.php, last accessed 18 December 2008.

Postman, Neil 2005. *Amusing Ourselves to Death: Public Discourse in the Age of Show Business* (London: Penguin Books).

Puig, Manuel 1992. *Boquitas pintadas* (Barcelona: Seix Barral)

— 1997.*Bajo un manto de estrellas; El misterio del ramo de rosas* (Buenos Aires: Beatriz Viterbo)

— 1987. *La traición de Rita Hayworth* (Barcelona: Seix Barral)

Reati, Fernando 1989. 'Argentine Political Violence and Artistic Representation in Films of the 1980s', *Latin American Literary Review* 17:34, 24–39.

Rejtman, Martín 1999. 'La importancia de llamarse Silvia Prieto', *Página 12 (Radar)*, 23 May, http://www.pagina12.com.ar/1999/suple/radar/99-05/99-05-23/nota1. htm, last accessed 3 September 2008.

Rock, David 1987. *Argentina 1516–1987: From Spanish Colonization to the Falklands War and Alfonsín* (London: I. B. Tauris).

Rojas, Mauricio 2004. *Historia de la crisis argentina* (Buenos Aires: Distal).

Rowe, William and Vivian Schelling 1991. *Memory and Modernity: Popular Culture in Latin America* (London: Verso).

Sábato, Ernesto 2003. 'Prologo', *Nunca más: informe de la Comisión Nacional sobre la Desaparición de Personas* (Buenos Aires: EUDEBA), pp. 7–11.
Sarlo, Beatriz 1988. 'El campo intelectual: un espacio doblemente fracturado', in Saúl Sosnowski, *Represión y reconstrucción de una cultura: el caso argentino* (Buenos Aires: EUDEBA), pp. 95–107.
— 2004. *Escenas de la vida posmoderna* (Buenos Aires: Seix Barral).
Sarmiento, Domingo Faustino 2005 [1845]. *Facundo* (Buenos Aires: Biblioteca Ayacucho).
Sartre, Jean-Paul 1992. *Un théâtre de situations* (Paris: Gallimard).
Scarry, Elaine 1985. *The Body in Pain: The Making and Unmaking of the World* (Oxford: Oxford University Press).
Schaub, Joseph Christopher 1998. 'Presenting the Cyborg's Futurist Past: An Analysis of Dziga Vertov's Kino-Eye', *Postmodern Culture* 8:2, http://muse.jhu.edu/login? uri=/journals/pmc/v008/8.2schaub.html, last accessed 16 December 2008.
Schechner, Richard 2003. *Performance Theory* (London: Routledge).
Scheines, Graciela 1993. *Las metáforas del fracas: desencuentros y utopías en la cultura argentina* (Buenos Aires: Editorial Sudamericana).
Scholtz, Pablo O. 1999. 'El nombre es lo de menos', *Clarín*, 27 May, http://www.clarin.com/diario/1999/05/27/c-00904d.htm, last accessed 3 September 2008.
— 2003. 'Festival de San Sebastián: Distinatas miradas sobre la Argentina', *Clarín*, 25 September, www.alejandromalowicki.com.ar/eindex.htm, last accessed 5 March 2011.
Shumway, Nicolas 1993. *The Invention of Argentina* (Berkeley: University of California Press).
Sontag, Susan 1992. 'Film and Theatre', in Gerald Mast, Marshall Cohen and Leo Braudy, eds. *Film Theory and Criticism: Introductory Readings*, Fourth Edition (Oxford: Oxford University Press), pp. 362–74.
Spregelburd, Rafael 2003 [2001]. 'Un momento argentino', in Jorge Dubatti, *Nuevo teatro argentino* (Buenos Aires: Interzona), pp. 133–80.
Stam, Robert 2000. *Film Theory: An Introduction* (Oxford: Blackwell).
Stanislavski, Constantin 1980. *An Actor Prepares* (London: Methuen).
Suardi, Luciano and Alejandro Tantanian 2003 [2002]. 'Temperley', in Jorge Dubatti, *Nuevo teatro argentino* (Buenos Aires: Interzona), pp. 181–220.
Svampa, Maristella 2005. *La sociedad excluyente: la Argentina bajo el signo del neoliberalismo* (Buenos Aires: Taurus).

Taylor, Diana 1997. *Disappearing Acts: Spectacles of Gender and Nationalism in Argentina's 'Dirty War'* (London: Duke University Press).
Tellas, Vivi 2001 to 2008. *Proyecto Biodrama* (Teatro Sarmiento). A recording of the performance of each of the *biodramas* listed below can be viewed in

the Centro de Documetación de Teatro y Danza in the Complejo Teatral San Martín, Avenida Corrientes 1530, Ciudad Autónoma de Buenos Aires.

— 2001. *Barrocos retratos de una papa*. Directed by Analía Couceyro. Script unpublished, obtained informally from director.

— 2002a. *Los 8 de julio*. Directed by Beatriz Catani and Mariano Pensotti. No existing script, quotations from the play are transcribed from the video recording.

— 2002b. *Temperley*. Directed by Luciano Suardi. Script by Alejandro Tantanian. See other entry in bibliography.

— 2003a. *¡Sentáte!* Directed by Stefan Kaegi. No existing script.

— 2003b. *El aire alrededor: sobre la vida de Mónica Martínez*. Directed by Mariana Obersztern. See other entry in bibliography.

— 2004. *Nunca estuviste tan adorable*. Directed by Javier Daulte. Script unavailable at time of fieldwork.

— 2005. *Squash: escenas de la vida de un actor*. Directed by Edgardo Cozarinsky. Script unpublished, obtained informally from director.

— 2006. *Budín inglés*. Directed by Mariana Chaud. See other entry in bibliography.

— 2007. 'Proyecto Biodrama: sobre la vida de las personas', *GEOteatral*, http://www.geoteatral.com.ar/frontend/nota.php?seccion_id=10&contenido_id=1051, last accessed 16 December 2008.

Ventura, Adrián 1997. 'Sospechan que la explosión de Río Tercero fue planeada', *La nación*, 25 March, https://www.lanacion.com.ar/nota.asp?nota_id=65840, last accessed 16 December 2008.

Walger, Silvia and Carlos Ulanovsky, eds. 1974. *TV guía negra: una época de la televisión en otra época* (Buenos Aires: Ediciones de la Flor).

White, Hayden 2003. 'Anomalies of Genre: The Utility of Theory and History for the Study of Literary Genres', *New Literary History* 34: 597–615.

Willet, John, ed. 2001. *Brecht On Theatre: The Development of an Aesthetic* (London: Methuen Drama).

Wolf, Sergio 2002. 'Las estéticas del nuevo cine argentino: el mapa es el territorio', in Horacio Bernades, Diego Lerer and Sergio Wolf, eds. *El nuevo cine argentino: temas, autores y estilos de una renovación* (Buenos Aires: Fipresci), pp. 29–43.

Žižek, Slavoj 1999. Edited by Elizabeth Wright and Edmond Wright, *The Žižek Reader* (Oxford: Blackwell).

— 2002. *Welcome to the Desert of the Real* (London: Verso).

Index